DRAWING
CARTOONS

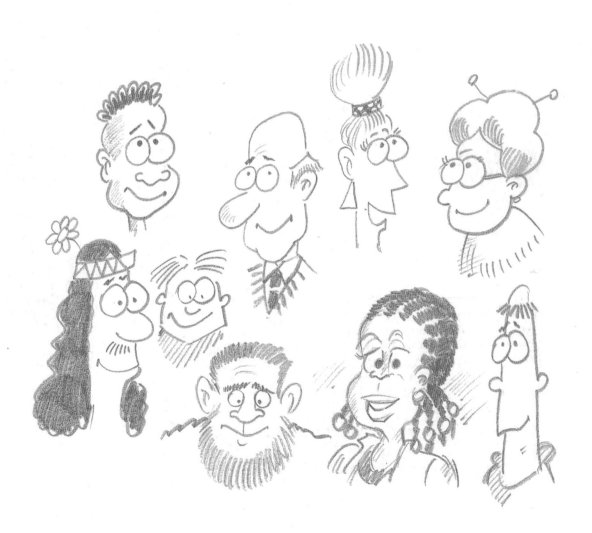

DRAWING CARTOONS

A complete guide

John Byrne, Alex Hughes, Janet Nunn

with Graham Garside

Collins

First published in this edition in 2002, this paperback edition
published in 2006 by Collins, an imprint of
HarperCollins Publishers Ltd
77-85 Fulham Palace Road
London
W6 8JB

The Collins website address is:
www.collins.co.uk

Collins is a registered trademark of
HarperCollins Publishers Ltd

Most of the text and illustrations in this book previously published by Collins as:
Learn to Draw Cartoons, Learn to Draw Caricatures,
Learn to Draw Comics, Learn to Draw Animated Cartoons

09 08 07 06
9 8 7 6 5 4 3 2 1

Produced by Kingfisher Design, London
Editor: Geraldine Christy
Art Director: Pedro Prá-Lopez
Designer: Frances Prá-Lopez
Text and illustrations for Tools and Equipment (pp8-15): Valerie Wiffen, A.R.C.A

Contributing artists:
Cartoons: John Clube (page 33 top right), Joel Mishon (pages 33 bottom, 35 top right),
Janet Nunn (pages 33 top left, 35 bottom right, 39 top and bottom left)
Caricatures: Femi Adetunji (pages 74 bottom right, 76 left, 90 top left, 95 bottom right),
Jonathon Cusick (pages 71 bottom right, 77 bottom left, 94 bottom right, 95 top left, 96 top left and bottom right),
Gary Dillon (pages 76 right, 94 top), Andy Lawson (pages 59 right, 74 bottom left),
John Leer (pages 58 left, 77 bottom right, 95 bottom left, 101),
Janet Nunn (pages 77 top, 97 top left, 98 bottom left);
Laughing Gravy Design: caricature by Gary Dillon courtesy of Cargill plc (page 97 bottom left);
the caricature of Jeremy Paxman on pages 6 and 92 first appeared in *The Big Issue*;
the caricature of Eric Cantona on page 93 first appeared in advertisements for *New Internationalist*;
the caricature of Gordon Brown on page 100 first appeared in *Red Pepper*.
Comics: Leonard Noel White (pages 104, 107 top, centre, bottom left, 108 right,
109 bottom left, 112, 113 top, 114 top left, 115 top, 116 top, bottom left, 117, 118 top left, bottom left,
121 top left, 125 bottom left, 128 bottom, 129, 131, 135 bottom, 137 right, 139, 140 bottom centre)
Animated Cartoons: Graham Garside (all Artist's Tip box characters; pages 149, 152, 154-5, 158 top,
161 bottom centre and right, 163 top and centre, 186 bottom right (cat), 187 bottom, 188)

ISBN-10 0 00 724332 4
ISBN-13 978 0 00 724332 7

Printed and bound by Printing Express, Hong Kong

CONTENTS

Introduction

Everyone can learn to draw cartoons, caricatures and comic characters. All you need are the basic techniques, a sense of adventure, belief in your own creativity and a willingness to practise, practise, practise. In the world of cartoons and comics even the practice is exciting and fun.

Cartoons

You can soon build up a whole cartoon world from a few basic shapes (most of which you can probably draw already). Adding the appropriate clothes, expressions, backgrounds and settings will turn your cartoon people and animals into individual characters. In this book there are lots of ideas and tips to help you do this.

Try to collect as many other cartoons as you can. You'll laugh a lot and also learn a lot by seeing how different cartoonists put the various techniques into practice – before you know it, you'll have developed your own unique and recognizable style of cartoon drawing.

One secret that cannot be taught, however, is which sort of joke works best in your cartoons. This is something you will discover as your drawing style evolves. There are no golden rules for making people laugh: everyone has a different idea of what is funny. The best solution usually is to draw cartoons that make *you* laugh. If your friends and family enjoy them as well it is quite likely that other people will too.

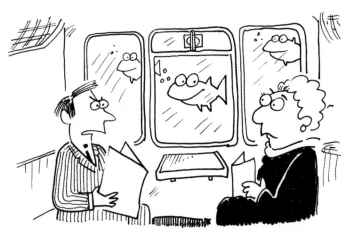

'I wish you'd stop asking if this is the right train.'

Caricatures

While cartoons tend to feature generalized subjects caricatures are based on real people. A successful caricature involves reproducing and exaggerating the features that are most prominent or obvious.

It is important to remember, however, that caricature is not just about someone's physical appearance but also their personality. There is no 'right' or 'wrong' way to draw caricatures, as they are as much about your own gut instincts as they are about drawing skills. You need to pour in what you feel about your subject for the drawing to work well on the page. You also need to consider carefully the most appropriate medium to use for your drawing.

Follow the step-by-step approach to start, but then develop your own methods if you find them more effective for you. Do not expect to become an ace caricaturist overnight. If there is a secret to caricature it must definitely be the keyword 'practice' – but don't forget, caricatures are supposed to be fun. If you are not enjoying drawing it, the caricature will not work. It is also advisable not to try out your caricaturing skills on your friends and family straightaway unless you are extremely confident: some people just cannot take a joke. Remember, too, if you are going to 'dish out' a humorous interpretation of others, you may have to be on the receiving end of one. Caricature can make you friends, but it can also make you enemies.

Comics

If you try all the tips and tricks for yourself as you read through this book you'll soon have a battery of cartooning skills to call on. The end results may not look exactly like the pictures in the book, but that is fine. After all, if everyone drew exactly alike, the results wouldn't be nearly so fascinating.

You can take your cartoons a stage further by turning them into comic characters. This section in the book looks at lots of techniques and ideas for using your talents in comic strip form: how to come up with stories, how to develop characters, how to make use of a whole array of clever comic book special effects. It shows you how to plan out a story using a grid, from pencil 'roughs' to finished ink drawings. Whether you want to draw 'gag' strips or epic super-hero adventures, all the tips and ideas you'll need to bring your own comics to life are provided. The only way to find out which ones work best for you is to try them all at least once.

The great beauty of a really good comic strip is that you have the scope to switch from humour to drama and back again whenever you wish. Speech bubbles are used in some cartoons, but they are even more important in comic strips. They're a neat device for telling a complete story in a few words and there are many different ways to use them.

Animated cartoons

Of course, you might like to take your drawings a few steps further – literally! Here you will find the first few simple techniques that will help you give your characters a life of their own, and bring an extra dimension to your work.

When we consider movement in drawing, we naturally think of animated cartoons. These provide the 'missing link' between the lively drawing and the 'living' one. Not everyone wants to get involved in the technology of actual animation and there is no doubt that an aspiring animator has to make a considerable financial outlay in order to 'tool up' his studio with all the necessary equipment. However, it's possible to enjoy making your drawn characters move without breaking the bank.

This section of the book helps you to turn your 'static' drawings into small animated sequences. These can be produced in flip book form, or perhaps, if you are more ambitious, translated onto computer disk.

The art of animation is very complex, but as with many other skills, it's built upon learning quite simple procedures one at a time. This book cannot deal with the whole process of animation, but it will enable you to make a start – and the great thing is that *anyone can make a drawing move!* You don't even have to be particularly good at drawing, but if you are really interested and want to do it, you can!

Tools and Equipment

PENCILS AND GRAPHITE MEDIA

Types of pencil

Pencil leads contain a combination of graphite for blackness and clay as a binder. The greater the graphite content, the softer and darker the pencil. More clay gives a firmer point but sacrifices blackness. Pencils are graded: B for black and H for hard. Artists and designers use grades up to the softest 8B. H pencils are used for accuracy in technical work. F, or fine, grade is a black pencil with a durable point. Coloured pencils have a waxy content, sealing the paper, and are best used separately.

Using graphite media

Drawings made with soft graphite media above grade 2B require a minimal spray with fixative to protect against smudging. Grades B and F may be left unfixed, or sprayed lightly with clean water from a plant mister to set them.

Paper surfaces

Pencil points are hard to control on heavily textured paper, called Rough. They work well on papers with subtle textures, called Not; on hot-pressed (smooth) surfaces; or on cartridge paper. Polished or glossy surfaces are unsuitable; the point skids, distributing graphite unevenly. Avoid soft-surfaced paper, too, as pressure creates grooves that are apparent after erasures.

Drawing effects

Fine and firm leads are best used lightly until accuracy is established; if you are too emphatic in pressing the graphite into the paper surface, erasing becomes difficult.

Soft pencil smudges easily. To avoid brushing your drawing, keep your wrist high; the alternative, to mask your work with loose paper, will obscure your view.

Technical pencil leads are round and sold in widths to fit the gauge of the aperture. Sharpening is minimal. The range of soft grades is limited, however.

Used sideways, graphite sticks allow you to cover broad areas and to make larger marks on the paper. Soft grades of graphite may develop helpful points or sharp edges as they wear down with use.

1 HB pencils, though too firm for expressive work, are widely available and retain their points well.

2 The F grade is recommended if you require rich tone combined with a fine point.

3 2B is the best average grade to use, because it combines tonal depth with a durable point and minimal smudging.

All marks are shown on Not paper (left) and Rough paper (right).

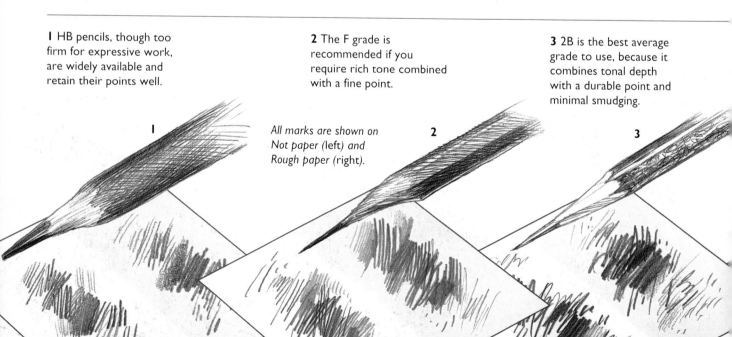

Left: Clutch pencil (*top*) and propelling pencil (*bottom*).

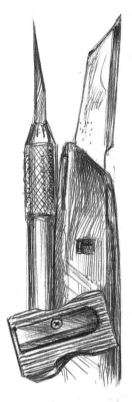

Clutch or propelling pencils

Clutch, technical and propelling pencils with round leads are convenient to use, especially while travelling. However, they are designed for making marks of a designated width and call for some ingenuity on the part of the artist to lend interest to their unvarying quality. Hatching, when areas of juxtaposed linear shading are laid parallel, or cross-hatching, when these are superimposed, enlivens their effect; as do variations of drawing pressure. Buy replacement leads in soft (drawing) not hard (technical) grades; see types of pencil, opposite.

Graphite sticks

These resemble large-scale pencil leads without a wooden casing. The round-sectioned types are usually coated with sealer for cleanliness. The hexagonal or faceted types are lacquer-free and so they are best used wrapped in foil or paper which will prevent too much graphite transferring to your hands. Drawing with either type will eventually wear an edge which can be very useful for fine work. Both types of graphite stick come in all drawing grades from hard to soft.

Hard grades of graphite have a high clay content and make silver-grey marks which lack impact from a distance.

Use the broad side of a graphite stick to make bold marks, which are not possible to achieve with a pencil.

Erasers for correcting pencil

Graphite is easily erased provided it has not been forced into the paper by excessive pressure. Avoid gritty erasers that chafe paper fibres. Modern plastic erasers will remove errors without damage and can be sharpened to an edge with a knife for precise use if worn to a rounded profile.

Sharpening pencils

Taking great care, sharpen with a craft knife, paring away the wood with long strokes. Supporting the lead against any flat surface prevents snapping whilst sharpening to a final point. Pencil sharpeners make short points that blunt easily.

4 4B pencils blunt and smear easily, but are pleasantly soft and manageable if sharpened frequently.

5 As your soft high B grade graphite wears down with use, a sharp edge will develop, allowing fine lines to be drawn.

6 Traditional coloured pencils offer alternatives to black, but are not as easily erased completely. Mix colours by cross-hatching.

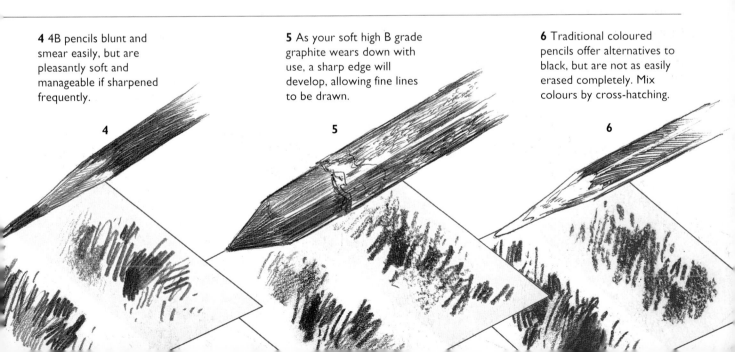

PEN AND INK

Types of pen

Dip pens are fitted with cut steel drawing nibs with a long profile. Reservoirs, designed to retain ink in the hollow of nibs, will extend drawing time between dipping. Reed and bamboo pens and other natural nibs – such as quills cut from goose feathers – also give flexible and responsive marks. Technical pens, roller balls and markers are designed to make constant marks; inventive mark making is required to compensate for their lack of variety. Brush pens, another type of marker with a long tip, make variable marks but, like many markers, contain impermanent inks and fade fast.

Using pen and ink

Pen work cannot be erased easily. Some corrections are possible (see opposite) but all are obtrusive, so pen drawing calls for a tentative approach. By using diluted ink or broken lines, a drawing can be done faintly first. Alterations can then be made by continuous lines of greater thickness or tonal strength.

Paper surfaces

A rough surface texture will deflect fine nibs. Choose smooth or hot-pressed watercolour paper or cartridge with a firm surface, as the nib may pierce the fibres of softer surfaces.

Ink density

Weak ink dilutions are recommended for making an initial statement in your drawing. Waterproof inks contain a varnish that curdles when diluted with tap water; always use distilled.

Beautiful medium tones can be obtained from varying the dilution of non-waterproof inks, such as calligraphy or Chinese drawing ink. Test for strength on scrap paper.

Strong ink solutions are useful for creating subtle variations in tonal depth, or for overriding weak dilutions when correcting. Label any stored surplus to distinguish it from full-strength ink.

Tonal density can be built up by multiple linear cross-hatching with a pen nib, or overlaying weak wash dilutions when drawing with a brush. Pen lines are easier to add with confidence to a drawing already defined by washes.

I Drawing nibs for dip pens are slightly flexible, with more pressure allowing a broader stroke.

2 Every side of a reed nib will draw; the mark depends on which is used.

3 Bamboo pens are robust and make even bigger marks when used at a shallow angle.

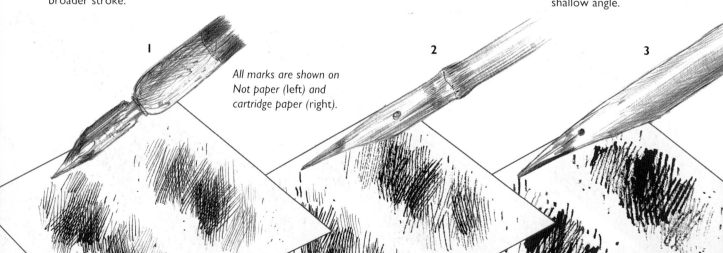

All marks are shown on Not paper (left) and cartridge paper (right).

Inks
Most coloured inks will fade, but liquid acrylics are more permanent, as are some black inks. Stick ink (shown behind the ink bottle, *above*) must be ground wet in a stone dish.

Quill pens
Use a sharp blade to cut quill pens (*top*), preferably from goose feathers, and a hot wire to burn a hole near the tip for ink release. Sharpened stick pens are used as dip pens but may need reservoirs, contrived by tying a flat sponge around the stick, then loosely wrapping it with waterproof material. Load the ink by brush and release it by squeezing.

Quill pen marks (*above*) are variable from delicate to robust. The quill's durable yet flexible tip allows great definition and precision.

Stick pens (marks shown *above*) allow work on any scale; long sticks give an extended reach that is useful for large-scale drawings.

Corrections
It is impossible to disguise a correction completely in an ink drawing, but the attempt is better than an obvious mistake. If you make a mistake, try whiting out with gouache or liquid acrylics, cutting in a patch stuck from behind with conservation tape or glued on, or, as a last resort, scratching out gently with a sharp blade.

Whiting out
Gouache leaves a deposit on the paper surface that enables drawing over the correction. Liquid acrylics, while impermeable, affect ink absorption.

Cutting in
Place paper behind your error, then cut carefully through both sheets with a sharp blade to create a matching insert and secure with tape from behind.

Patching over
Sticking in a patch of matching paper is obtrusive in small drawings, but effective on a larger scale.

Scratching out
Scratching out errors with the tip or scraping with the side of a scalpel blade abrades the paper. A chafed surface will always break up further lines.

4 Modern technical pens, whether refillable or disposable, combine marks of a uniform width with convenience.

5 Many handy writing pens, including gel writers and roller balls, may contain impermanent inks.

6 For drawing, technical pens with dual-prong nibs can be filled with coloured washes by filling the reservoir between the prongs with a soft brush.

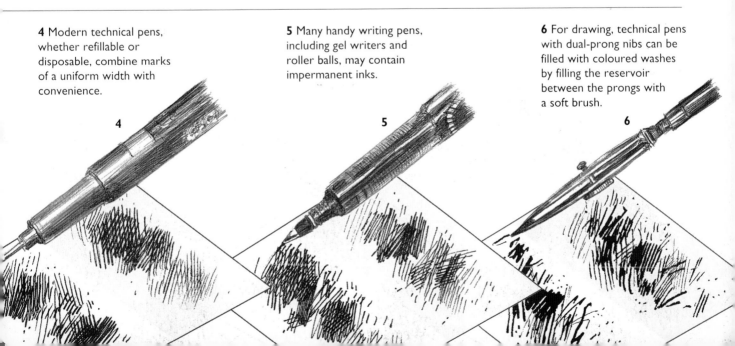

CHARCOAL AND PASTELS

Types of dusty media

Charcoal sticks are simply wood, usually willow, charred in low-oxygen conditions to retain the carbon. They erase completely, but charcoal and carbon pencils and compressed charcoal are denser and leave traces. Soft pastels contain only pigment and binder and deposit minute particles onto the picture surface. Conté pastels, the common name for hard pastels, contain clay and are lightly baked, making them crisper.

Using dusty media

Charcoal, soft pastels and other dusty media do not penetrate paper, remaining a vulnerable surface layer that is prone to smudging. Avoid rubbing the surface when drawing. Preserve your work by spraying lightly with fixative (see opposite) and store interleaved with clean paper to prevent transfers of remaining dust.

Paper surfaces

Dusty media need a light-textured paper to hold them and they work well on Not papers. Coloured pastel papers are not all lightfast, but durable colour can be achieved by staining stretched paper (see page 15) with a watercolour wash. Oil pastels require smooth surfaces and are removable with white spirit from stretched papers sealed by brushing with diluted gum.

Drawing effects

Charcoal sticks and pencils graded 'hard' make crisp, clear marks but are less rich than soft grades. Graded pencils are also available, for example 2H.

Charcoal sold as 'medium' is a predictable category in stick form, but medium pencils vary from near soft to approaching hard unless defined by grade.

Sticks defined as 'soft' are liable to snap more easily and create more dust, but have good, rich tonal depth, as do soft charcoal pencils.

For the deepest blacks, compressed charcoal or extra soft charcoal pencils are unrivalled. The dust spreads, so cover carpets and furniture in a domestic setting.

1 Tip and side use, plus the changeable qualities of natural charcoal sticks, provide expressive marks.

2 A rich core allows charcoal pencil marks to register from further away than silver-toned graphite.

3 Carbon pencils have a tonal depth similar to charcoal, but their smooth quality resembles graphite.

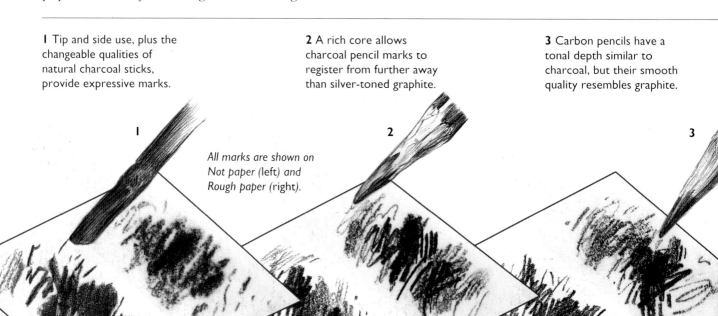

All marks are shown on Not paper (left) and Rough paper (right).

Using oil pastels

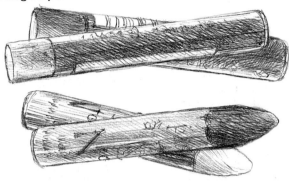

The exact degree of softness or hardness of oil pastels varies from one brand to another. Those with a harder consistency allow for better definition, but clog the paper surface easily. All are smooth and can be blended or mixed by using a little turpentine. You can scratch into layers of oil pastel to create texture and a variety of colour effects. Scrape the pastels back carefully with the flat of a blade for a fresh surface. Oil pastels contain no dryers, in order to remain usable permanently. Drawings stay tacky too and special fixative should be used to seal them.

Oil pastel marks

The animal fat base of softer oil pastels (*above left*) allows for glowing colour, but small, precise marks are hard to make. Fine marks are made with the edges of harder oil pastels (*above right*) or by scraping them back with a craft knife.

Erasing using a putty eraser

Use a putty eraser to remove dusty media. Knead it into the best shape to approach the area and tap to absorb surplus dust before rubbing off remaining material. The soiled eraser can be reworked many times before requiring replacement.

Using fixative

Fix and protect dusty media work with a proprietary fixative. Fixative contains modern acrylic varnish in a spirit base. It is available in bottles for diffusion with a mouth spray, or more convenient aerosol sprays. Follow the manufacturer's instructions, and avoid over-spraying by using light, even coats. Stay up wind, because varnish is dangerous by inhalation.

4 Used broadly, soft pastels allow a rapid response, and marks can be redrawn without rubbing out.

5 Traditionally black, white, sanguine (terracotta) and bistre (brown), hard pastels are now available in a full range of colours.

6 Pastel pencils have a core similar to hard pastels, allowing fine work in full colour.

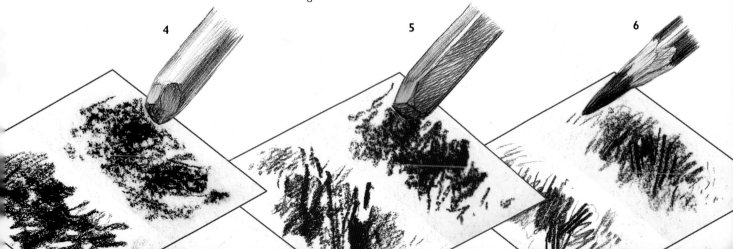

MARKERS

Types of marker

Take care when buying from stationers, because many water-soluble markers are playthings and fade rapidly. Some spirit-ink pens intended for office work and graphics may not be lightfast enough to allow work to be hung in daylight, obliging drawings to be viewed in albums.

Types of tip and nib

Water-based pens often have tapered tips and will make broader marks if used at a shallow angle. Some water-soluble ink is set when dry; other types remain soluble into subsequent washes. Spirit markers may have tubular, chisel- or wedge-shaped tips, requiring some care to offer the correct facet for an appropriately sized mark. Like technical pens, markers with tubular nibs make invariable marks, calling for ingenuity to overcome their mechanical quality in expressive work. Markers manufactured for calligraphers have precisely chisel-shaped tips and may contain lightfast ink.

Paper surfaces

Photocopying paper is non-yellowing and good for small roughs and experimenting. Layout pads offer larger sheets of smooth paper for full-scale trials and final versions. Hot-pressed papers or acid-free smooth cartridge are suitable for work meant to last. Spirit inks will work on many surfaces but easily scratch off shiny ones.

I	**2**	**3**	**4**

Drawing effects

I Extra-fine tips are useful for delicate additions, stippling to create texture, or making a light framework for a complex drawing.

2 Fine tips are used for preliminary marks, details and cross-hatching delicate tones. They allow you to refine and correct drawings.

3 Medium tips are used for making bold corrections and hatching strong tones. They can also be used for adding emphasis to small fine-line drawings and strengthening fine lines in large drawings.

4 Broad tips are the last resort for corrections. Also use them for blocking in solid dark tone, and making strong lines and bold, textured hatching.

Corrections

Disguise unwanted water-based effects with opaque white gouache paint; spray solvent will facilitate the softening of spirit-ink marks beforehand.

Using washes over markers

On stretched paper (see opposite) watercolours can be applied over spirit-based markers, but water-based ink types will bleed into washes.

I Extra-fine tips are for small-scale work and for creating delicate tones and textural effects.

2 Fine tips vary depending on the manufacturer from very fine to widths approaching medium sized.

3 Medium tips are best employed confidently; beware of slavishly reiterating finer marks, which sacrifices freshness.

4 Broad tips enable areas to be toned fast and marks to register from a distance.

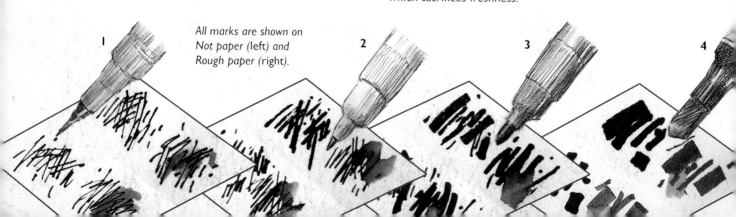

All marks are shown on Not paper (left) and Rough paper (right).

WET MEDIA

Types of wet media

Watercolour adds colour to pen drawings, called line and wash. Buy pans for small-scale work, but tubes for large quantities of wash. Coloured inks contain varnish and make vibrant washes, but clean the brush well. Water-soluble pencils are faint and moveable if used dry and washed over, but strong and fixed on wet paper.

Using wet media

Paper should be stretched (see below) to avoid washes pooling. Paper is graded by weight and heavy types are easier to stretch. Rough surfaces show colour washes off to advantage, reflecting light from the facets, but smooth papers make colours appear slightly dull. A good synthetic, sable or Oriental brush is also essential.

Watercolour washes

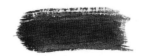

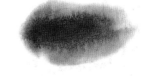

Washes laid on dry paper have clear edges, but set at once, not allowing corrections.

Washes floated on wet paper are easier to lift off if required, but will have diffused edges.

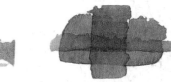

Use a brush to pre-damp the surface to specific edges to lay even washes with defined limits.

Overlaying washes builds strong colour depth gradually, as the pale paper surface is steadily obscured.

Stretching paper

A bare wooden board or unvarnished thick plywood is required, paper to fit and brown water-gummed tape lengths cut over-sized for securing the edges.

Use a wet sponge to damp the paper lightly and evenly without rubbing, then smooth it into position on the board as fast as possible.

Grip a tape length by one end, using the other forefinger to press it against the sponge. Press evenly while pulling the dampened strip through.

Stick damp strips on without delay, rubbing down and checking for adhesion. The paper dries flat, and is cut off on completion of the picture.

5 A fine-pointed big brush covers large areas when used broadly, or creates detail when used lightly.

6 Mop brushes are best acquired large; they are for shedding wash quickly on broad areas.

7 Water-soluble pencils allow confidently drawn details and make vibrant, fixed marks on damp, stretched paper.

8 Soluble wax crayons are usable dry, or they can be brushed or sponged after application.

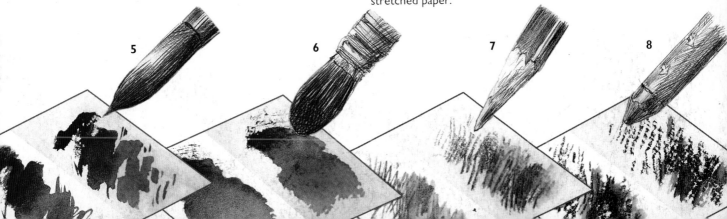

CARTOONS

John Byrne

Basic Shapes

Drawing any figure, from a cartoon character to the Mona Lisa, can be a bit daunting if you try to do it all in one go – but build your figure up from simple shapes and the job becomes a lot easier.

Take a look at some cartoon characters from newspapers, books or television. What basic shapes do you think the artist used to draw these cartoons? Can you make your own, different characters from the same shapes?

Keep it light
When putting together your own basic shapes, don't worry if your circles and ovals don't look exactly the same as mine. They are guidelines to help you draw your finished picture. Draw them lightly in pencil, so you can play around with them as much as you want before drawing over them to create your finished cartoon.

You'll enjoy cartooning much more and produce much nicer-looking cartoons if you can learn to draw with an easy, flowing line. Doing light preliminary drawings will help you relax when you are doing your final drawing. Remember also that big shapes are much easier to draw. Give yourself plenty of space and try to fill the whole page with your cartoon.

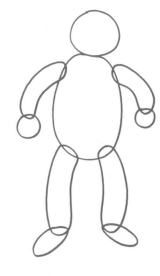

1 Which bit of the body you start with depends on you. I usually begin with a large oval shape for the torso, and then add a smaller circle for the head.

2 I then add 'sausages' for the arms and legs, with some smaller ovals and sausages on the ends for hands and feet.

Artist's Tip

When you first start drawing like this, you may have trouble with arms and legs going off the page. Drawing your basic figure in very light pencil at first will help solve this problem.

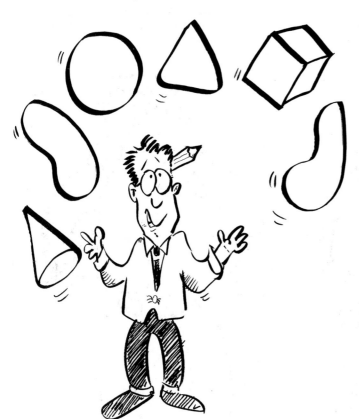

Almost everyone can already draw simple circles and ovals, triangles and squares like these, so once you've practised drawing a few of the all-important 'sausages', you'll have all the tools you need to begin.

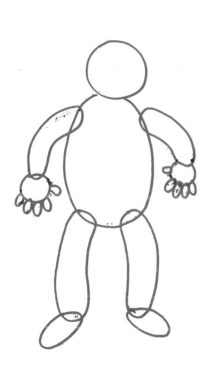

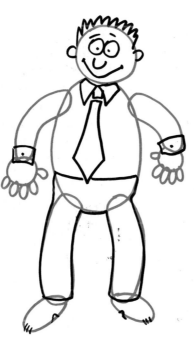

3 Add some fingers and you now have a basic figure shape to which you can add hair, facial features and clothes.

4 Draw the preliminary figure in pencil. When you've added all the extra bits, only ink over the lines you want to keep in your cartoon.

5 Any remaining pencil construction lines can be rubbed out.

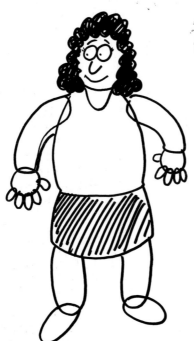

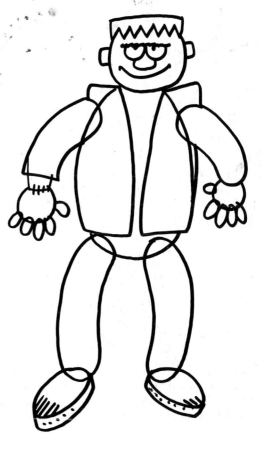

Using the same figure, practise turning it into different characters.

Drawing Animals

Drawing animals

The same shapes we've used for people can be used for animals, too. With one or two simple additions you can create a whole menagerie of cartoon creatures.

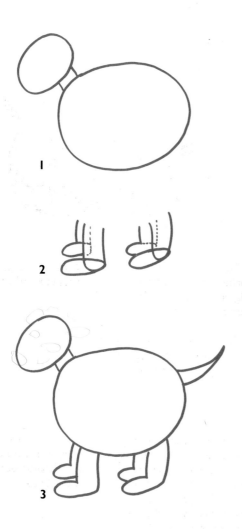

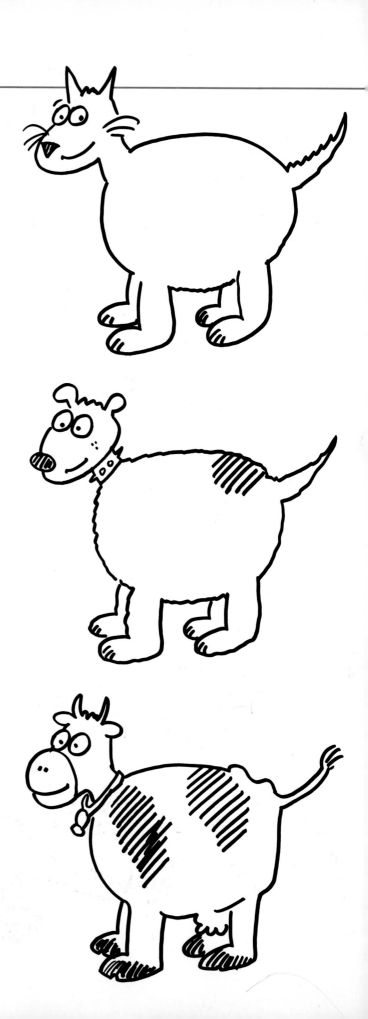

1 To draw a basic animal body, use the same shapes you used for humans.

2 Leaving the legs on the far side incomplete makes them look further away.

3 Don't forget the tail!

Adding whiskers, collars, horns and hooves to your basic shape turns it into these three very different animals *(right)*.

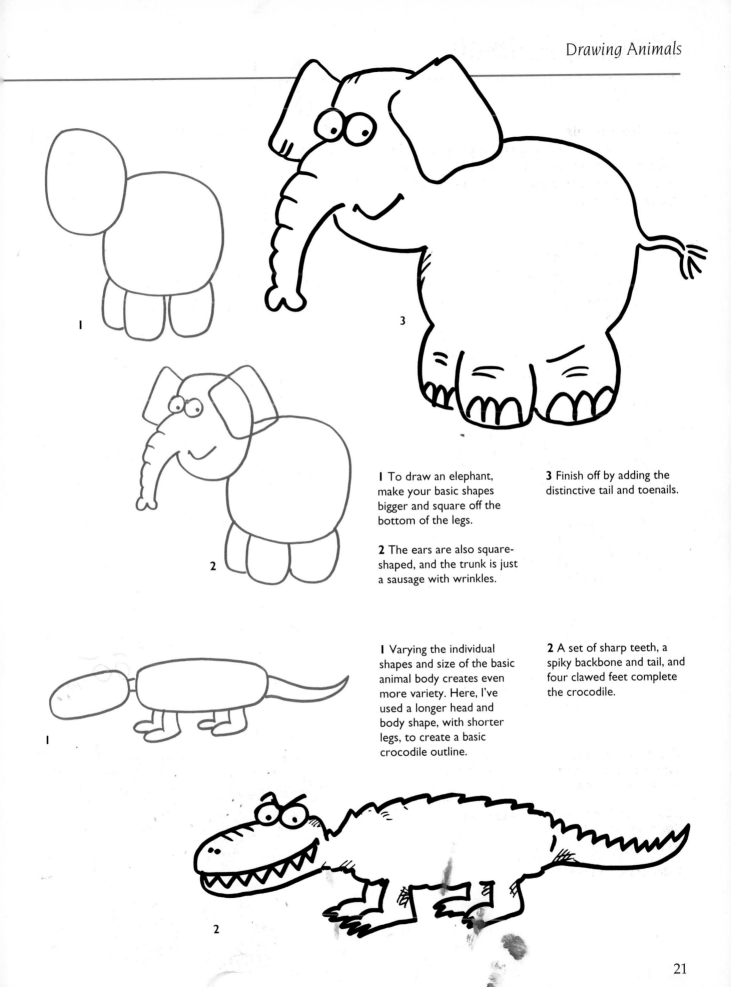

1

3

2

1 To draw an elephant, make your basic shapes bigger and square off the bottom of the legs.

2 The ears are also square-shaped, and the trunk is just a sausage with wrinkles.

3 Finish off by adding the distinctive tail and toenails.

1 Varying the individual shapes and size of the basic animal body creates even more variety. Here, I've used a longer head and body shape, with shorter legs, to create a basic crocodile outline.

2 A set of sharp teeth, a spiky backbone and tail, and four clawed feet complete the crocodile.

1

2

Proportion

It's good to know the rules of proportion – the sizes that different parts of the body should be in relation to each other. With cartoons, though, you don't always have to stick to these rules. Have fun experimenting with the sizes of your basic shapes. What happens if you make the head bigger, or the legs shorter? Can you make the figure look older by making all the shapes thinner and curving the body slightly? How much can you exaggerate your drawing and still keep the basic shape right?

Children and babies

You can play around with proportion in cartoons as much as you like, but there is one occasion when you do need to stick to the rules, and that is when drawing children and babies – an essential part of any cartoon cast.

One of the most common mistakes artists make is drawing children to look like small adults. You can see below that it's the *proportions* of the body, rather than the *size*, which hold the key.

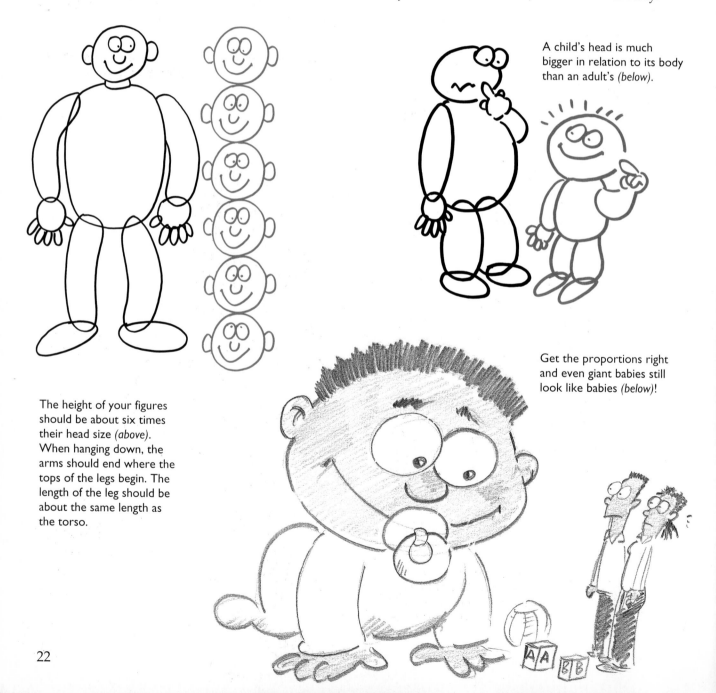

A child's head is much bigger in relation to its body than an adult's *(below)*.

The height of your figures should be about six times their head size *(above)*. When hanging down, the arms should end where the tops of the legs begin. The length of the leg should be about the same length as the torso.

Get the proportions right and even giant babies still look like babies *(below)*!

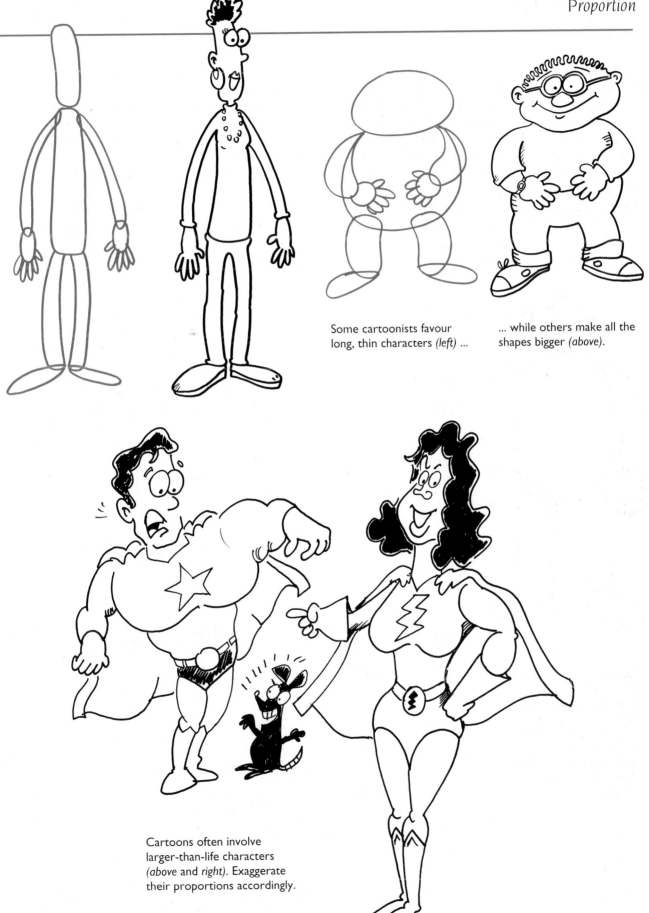

Some cartoonists favour long, thin characters *(left)* ...

... while others make all the shapes bigger *(above)*.

Cartoons often involve larger-than-life characters *(above* and *right)*. Exaggerate their proportions accordingly.

Character

Once you can draw the basic body shape, the next step is to try to create individual characters. The easiest way to do this is to add a wide selection of eyes, ears, noses and other physical features to your cartoon 'toolbox'. It's surprising how many different ways you can combine these features to give your cartoon characters distinctive personalities.

Eyes, ears and noses

Drawing eyes, ears and noses can also play an important part in developing your own cartoon style. A cartoonist may draw lots of very different characters but, by always drawing

the eyes, nose or some other feature in the same way, the artist's work develops its own individual personality, instantly recognizable to fans and admirers everywhere.

Until you evolve your own style, try to vary the appearance of your characters' features. You can get ideas by observing the people around you, the faces you see in magazines or on television. Young, old, male, female, black, white, Asian ... everyone has their own unique combination of physical characteristics. Remember the features you find particularly interesting and try to add them to your own characters.

1 Start off with a basic head shape in pencil. The cross will help you keep all the bits and pieces in the right places, and in proportion.

2 Now add simple eyes, ears, nose and mouth.

3 Finish off with eyebrows, lashes and a suitable hairstyle.

4 You can rub out the guidelines before drawing in your finished cartoon.

As we did with the basic body, the real fun starts when you change different parts of the cartoon face to create different characters (*above* and *right*). See what happens when you make

the eyes bigger; the nose wider; or leave out certain features altogether. You can create even more variety by making the shape of the head wider or narrower.

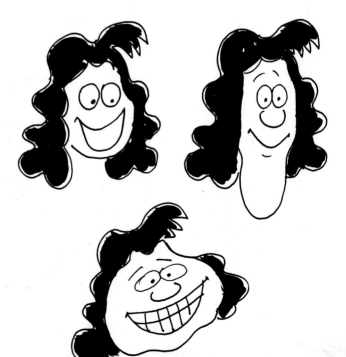

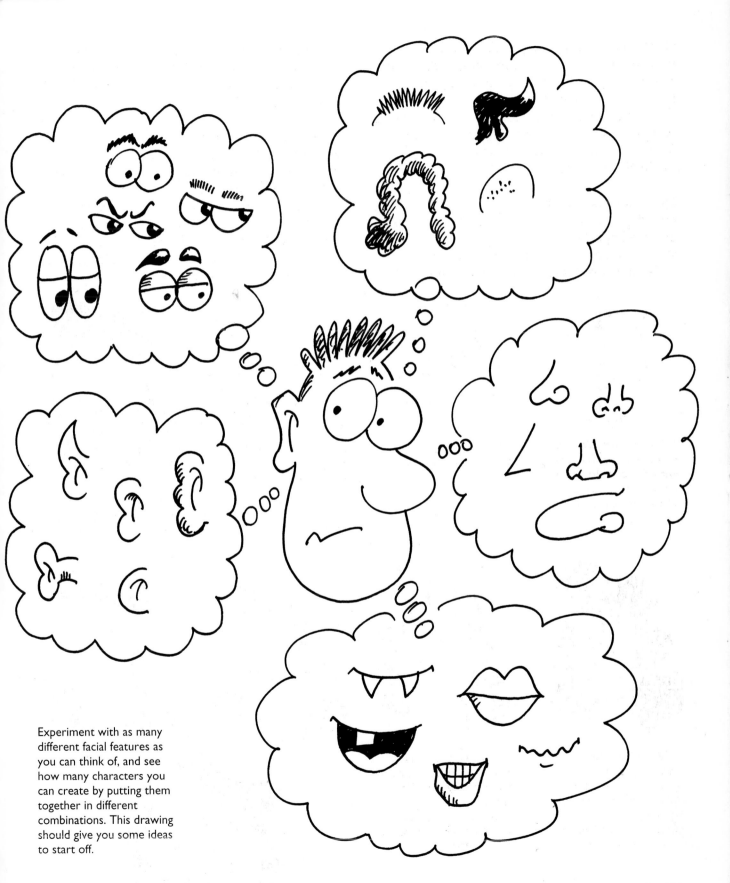

Experiment with as many different facial features as you can think of, and see how many characters you can create by putting them together in different combinations. This drawing should give you some ideas to start off.

Hands and feet

A person's hands can tell you a lot about them – a vampire's claws can tell you even more! As you can see below, changing the size or shape of a figure's hands and feet can change the whole character.

When giving your characters hands and feet, do try to give them different things to do with their right and left hands, and think about how they will stand on their feet. Always having both hands do the same thing can make your cartoon figures look very boring and symmetrical.

Age differences

Look closely at the differences between the hair, hands and feet of younger and older people. For instance, younger people, especially babies, tend to have short, fat fingers, while older hands may have longer, more wrinkled fingers.

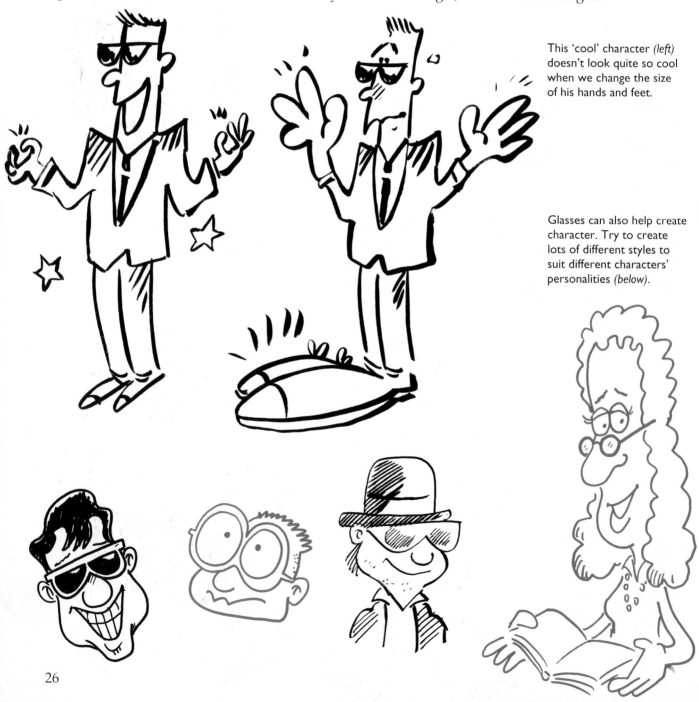

This 'cool' character *(left)* doesn't look quite so cool when we change the size of his hands and feet.

Glasses can also help create character. Try to create lots of different styles to suit different characters' personalities *(below)*.

The basic hand shape is just a circle with the thumb starting about halfway down *(left)*.

Many cartoon characters have only three fingers – making it easier to move the hand around without getting the dreaded 'bunch-of-bananas' effect *(right)*.

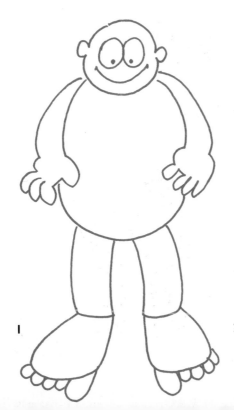

If you construct the hands from basic shapes, it should be easy to move them into different positions *(left)*.

1 Feet are narrower at the end where they join the leg. Making each foot point to the side a little will help your character stand more firmly on the ground.

2 The shape of the finished feet is squarer at the heel than in the rough drawing, and now there are only four toes on each foot – five can look a bit crowded. Don't forget to put in the big toenails.

1

2

Expressions and Gestures

Once you've made your characters look interesting, now is the time to really bring them to life by providing them with a full range of facial expressions and gestures. You'll be surprised at how many different moods you can create just by making a few changes to your characters' features, movements and posture. Look in a mirror and see how many of your own expressions and gestures can be translated into cartoons.

Larger than life

Remember that cartoon characters have exaggerated emotions: when they are sad, they howl; when they are surprised, their eyes pop out of their heads; when they are angry, steam comes out of their ears. Sometimes all these things happen at once! Many cartoonists use a mirror to look at their own expressions, and then see just how far they can exaggerate them in cartoon form.

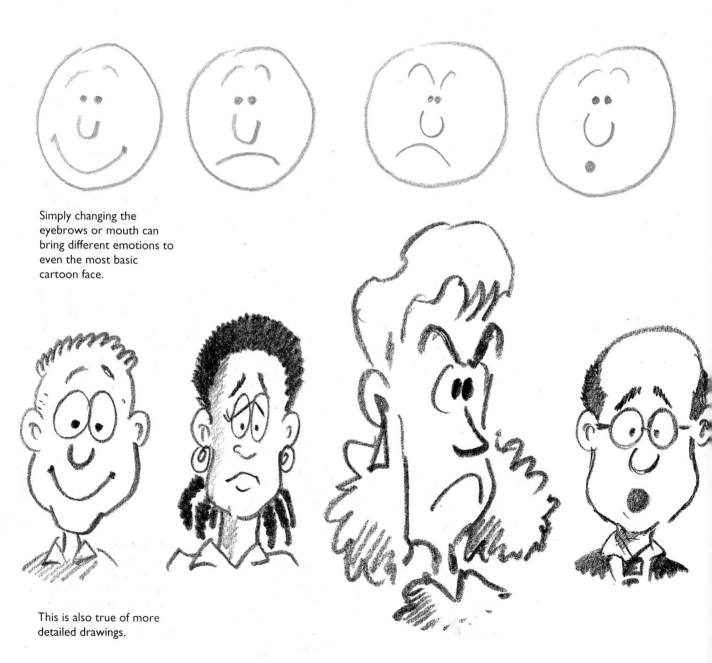

Simply changing the eyebrows or mouth can bring different emotions to even the most basic cartoon face.

This is also true of more detailed drawings.

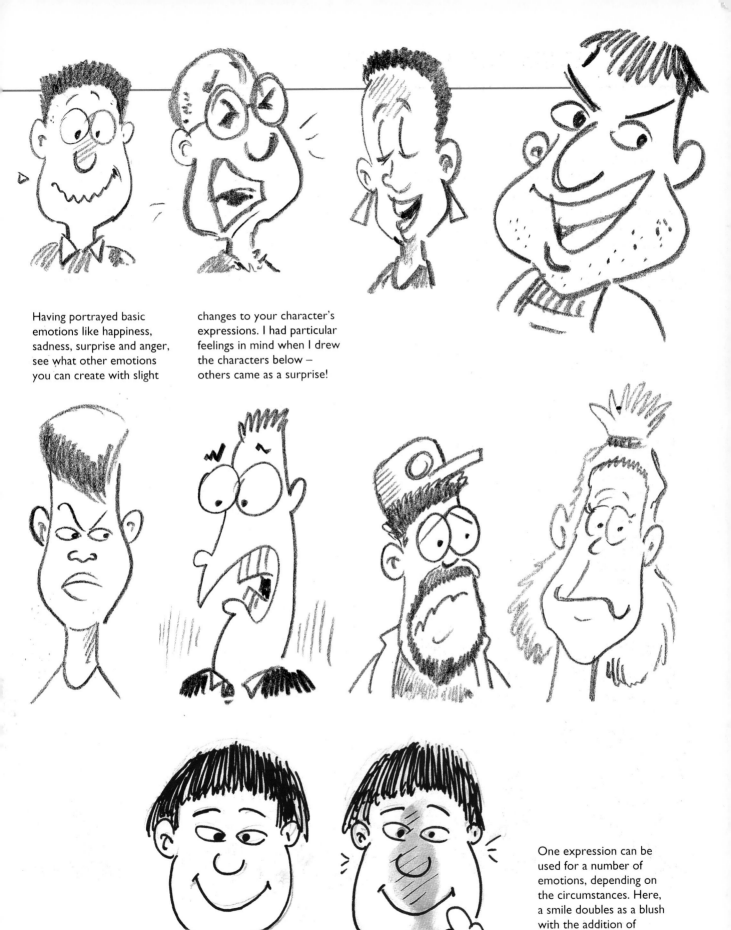

Having portrayed basic emotions like happiness, sadness, surprise and anger, see what other emotions you can create with slight changes to your character's expressions. I had particular feelings in mind when I drew the characters below – others came as a surprise!

One expression can be used for a number of emotions, depending on the circumstances. Here, a smile doubles as a blush with the addition of some wash *(left)*.

Silent language

As well as watching yourself in the mirror, another excellent way of studying the way people express their feelings is to watch television with the sound turned down. Can you work out what people are saying, and how they are feeling, from their gestures and facial expressions? Your cartoon characters should be able to communicate in the same way.

Creating the mood

When you are showing your character's feelings, choose a drawing medium and colours that will help set the mood. Soft pencils and bright colours can be used to create the impression of peace and happiness; a scratchy pen, giving a jagged line, can make an angry character look even fiercer; while lots of grey tones can be used for a sad picture.

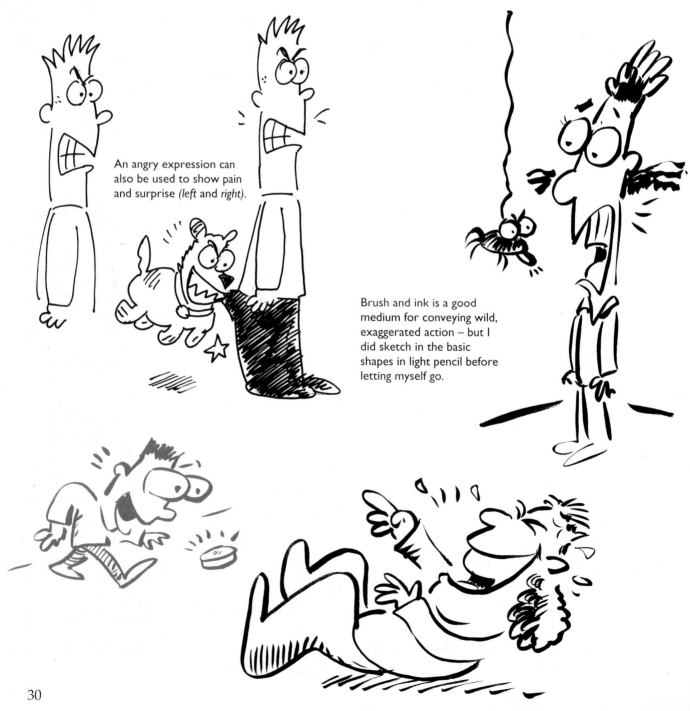

An angry expression can also be used to show pain and surprise (*left* and *right*).

Brush and ink is a good medium for conveying wild, exaggerated action – but I did sketch in the basic shapes in light pencil before letting myself go.

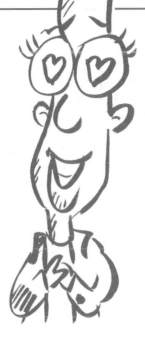

While you can make your cartoon characters run through a whole range of emotions by altering eyes, mouths and eyebrows, cartoonists have also

evolved a language of symbols which you can add to your drawings to emphasize feelings even more. Here are: Greed ($ or £ signs in eyes);

Gloom (under a cloud); Love (hearts in eyes); and Inspiration (light bulb lights up above head). Can you invent some symbols of your own?

If these figures could speak, this might be what they were saying:

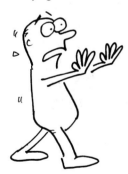

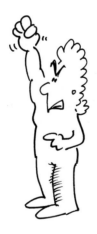

'Please don't hit me!'

'I'll get you for this!'

'Who? Me?'

'How should I know?'

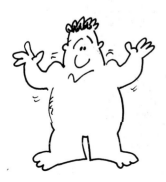

'I want to be alone!'

Artist's Tip

The same gesture can mean different things to different people ... it's best to check first to avoid giving offence!

Clothing and Props

Do you have a favourite suit? A pair of jeans you've worn long past their throwing-away date? A hat that all your friends instantly recognize as belonging to you? Your choice of clothes can reveal a lot about your personality, and the same goes for your cartoon characters.

The language of clothes

Cartoonists often rely on instantly recognizable uniforms to denote a character's nationality or profession. Clothes can also place characters in a certain period of history – although some continue to wear distinctive uniforms long after they are out-of-date. Getting the message across matters more than historical accuracy.

Neat or sloppy?

Adding clothes to the basic figure shape isn't difficult, but do look closely at how they 'hang' on people's bodies. How we wear our clothes says as much about us as the styles we choose.

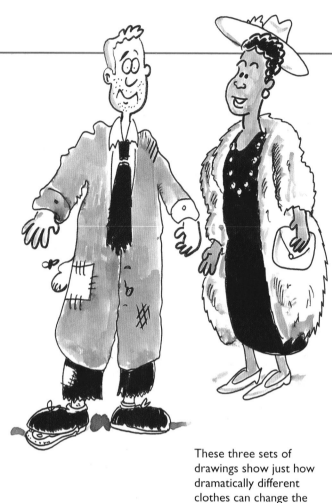

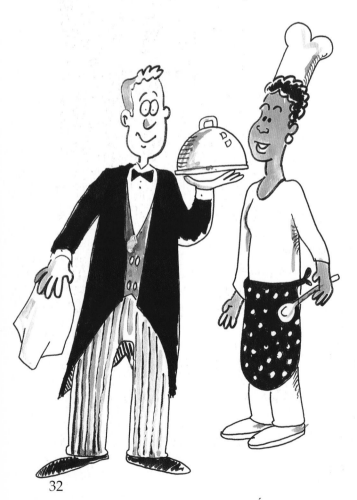

These three sets of drawings show just how dramatically different clothes can change the identity of the same cartoon character.

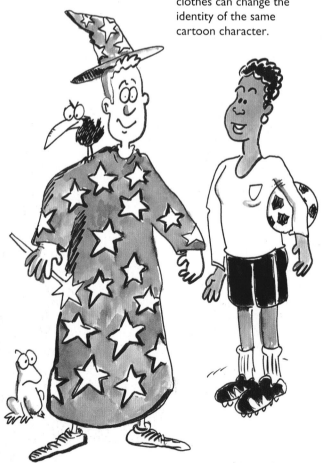

Fashion up-date

Try to keep up-to-date on fashions for men, women, and on the way young people dress. If you still draw people in clothes that were out-of-date 20 years ago, your cartoons may get laughed at for all the wrong reasons!

Keep an eye out for fashion articles and photos in newspapers and magazines. As well as showing you lots of different clothes to draw, they are also good for practice in cartooning the human figure. Supermodels will look even more super after you've given them the cartoon treatment!

This elderly bear looks very comfortable in his carpet slippers and 'fez' hat, staring quizzically through his spectacles at the small print in the newspaper.

As well as keeping up-to-date with current fashions, be aware of the changing styles of the past. The library is a good place to start looking.

You can have fun drawing way-out fashions, such as the 'cool dude' in the cartoon above. But beware. Getting the current fashions wrong could start people laughing *at* your cartoons, instead of along with them.

Props

'Props' are another important tool for telling us all about a character's position in life. As with costume, many cartoon characters continue using the same props long after their real-life counterparts have stopped – like the pipe and magnifying glass of the Sherlock Holmes lookalike opposite.

Getting the props to look right can add a great deal to a cartoon's authenticity. Many cartoonists keep large supplies of old magazines as reference material, but if you're short on living space, a good library should fulfil the task just as well.

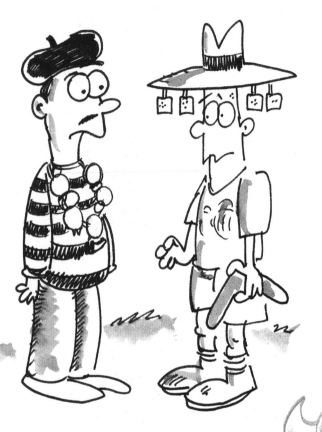

Most teachers don't dress like this any more *(right)*, but it's a cartoon image that seems to live on forever.

France and Australia: two nationalities that have their 'standard' cartoon costume *(above)*. How many others can you think of?

'It's for you.'

Period costume like the Vikings' distinctive helmets are good for creating joke ideas *(right)*.

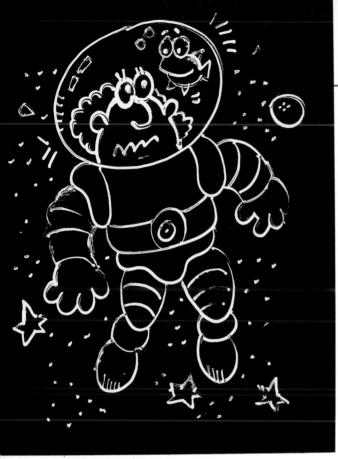

Futuristic costumes like this spacesuit *(left)* often owe more to science fiction than the real thing.

Note how many small details have gone to make up this authentic-looking military costume *(right)*. Besides the boots, holster, braids and medals, the shape of the hat and trousers must also be right.

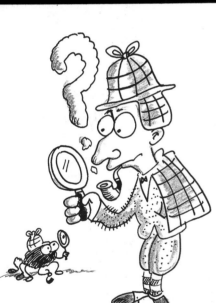

Where would the cartoon detective be without pipe and magnifying glass *(above)*?

Getting the correct props, such as these cooking utensils *(right)*, can greatly increase the humorous content of your cartoons.

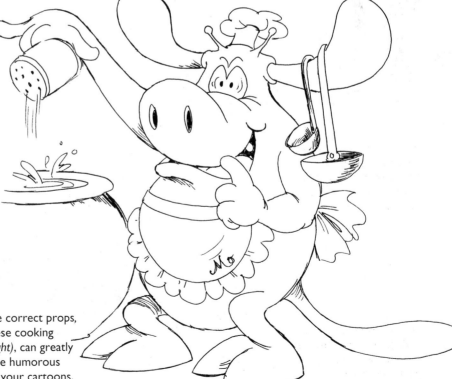

Turning Animals into People

One of the most common cartoon techniques is 'anthropomorphism' – a big word that simply means giving animals and objects human characteristics. Many animated cartoon stars are humanized animals and you should have no problem combining the drawing skills you've already learned to create your own characters.

Choosing your subject

As with drawing cartoon people, your humanized animals will look a lot more realistic if you spend some time studying their real-life counterparts. Have your sketchbook ready next time you visit a wildlife park or even when you are watching nature programmes on TV. Don't just stick to the usual cartoon menagerie of dogs, cats, mice, etc. You've got the whole insect, bird and undersea world to explore, too. Do a little research and you'll be amazed at the variety of creatures that live with us on the planet – some are even stranger than anything a cartoonist might think of!

But just as it's important to give your human characters individual personalities, you'll need to make your cartoon creatures distinctive, too. Remember that many funny cartoon characters are created by giving a particular animal or object a personality that's completely different from the one we would normally associate with it. For instance, you could make a lion cowardly instead of brave, or turn a fluffy rabbit into a bad-tempered bully.

Altering an animal's usual size and proportions can increase the comic effect still further – enlarging that rabbit to giant size will make it look much fiercer and more threatening.

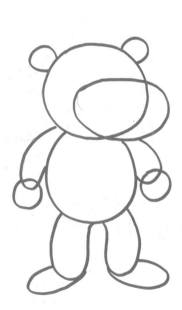 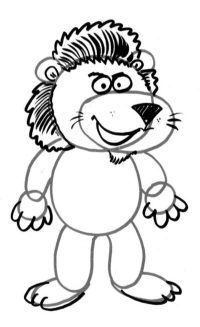 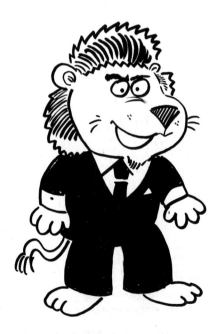

1 I've pencilled in my basic human shape again, but added a lion's head. As I've chosen quite a big animal, I've made my basic shapes big and fat.

2 Even though I'm doing a cartoon lion, I've tried to keep some realistic features, such as the tuft of hair under the chin.

3 Finally, a smart suit for the king of beasts ... but I haven't forgotten to leave room at the back for a tail.

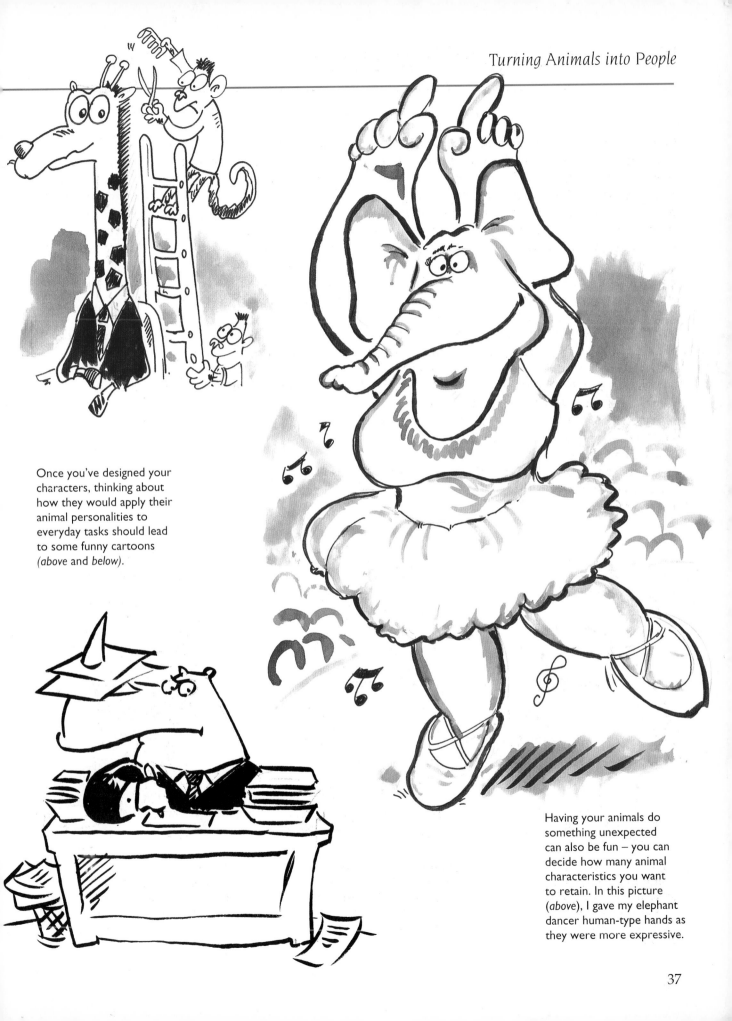

Once you've designed your characters, thinking about how they would apply their animal personalities to everyday tasks should lead to some funny cartoons (*above* and *below*).

Having your animals do something unexpected can also be fun – you can decide how many animal characteristics you want to retain. In this picture (*above*), I gave my elephant dancer human-type hands as they were more expressive.

Living objects

Just as you can turn animals into personalities you can also use your cartoon skills to bring inanimate objects to life, again giving them appropriate characteristics. As with animals, you'll find that objects look most effective if you try to sketch the real thing first and identify its unique features.

When you add features to your cartoon objects, think about the kind of personality or expression you want them to have. For example, if you have drawn a big, powerful-looking limousine, why not make it very nervous about speeding?

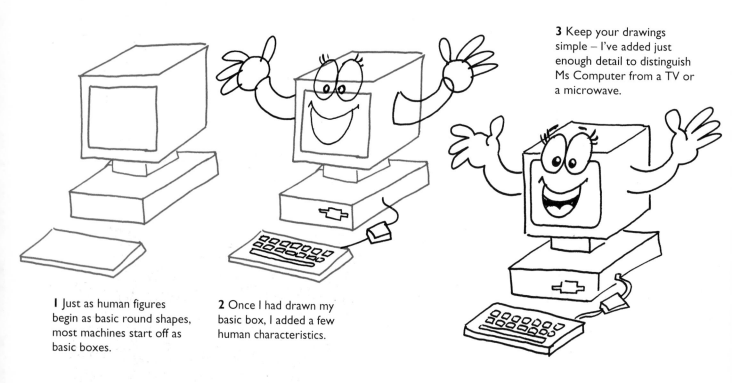

3 Keep your drawings simple – I've added just enough detail to distinguish Ms Computer from a TV or a microwave.

I Just as human figures begin as basic round shapes, most machines start off as basic boxes.

2 Once I had drawn my basic box, I added a few human characteristics.

With the addition of cartoon eyes, almost anything can be brought to life (*left*).

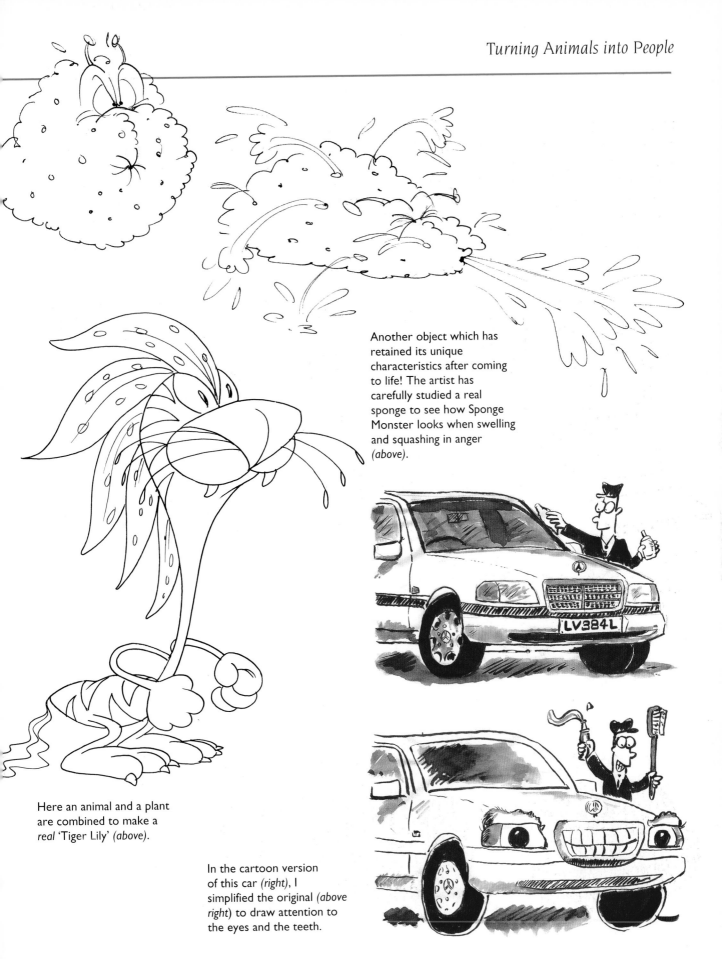

Another object which has retained its unique characteristics after coming to life! The artist has carefully studied a real sponge to see how Sponge Monster looks when swelling and squashing in anger *(above)*.

Here an animal and a plant are combined to make a *real* 'Tiger Lily' *(above)*.

In the cartoon version of this car *(right)*, I simplified the original *(above right)* to draw attention to the eyes and the teeth.

Perspective

All artists need to know about perspective. In fact, whole books have been written on this important subject. Luckily you'll only need to learn a little about perspective to make a big difference to the success of your cartoons.

Knowing about perspective will not only make your cartoons look more 'real' (even the crazy ones!) but will help you add depth to your cartoon world.

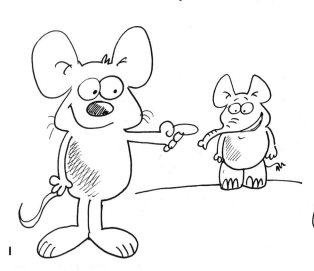

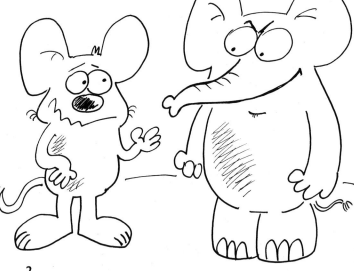

1 The near-and-far rule applies whenever you are drawing a character or object in perspective: parts that are nearest will be bigger than parts that are further away – as you can see from this giant mouse and tiny elephant.

2 In this picture, we know that both animals are the same distance away because their feet are at the same level in the drawing – now the elephant is bigger than the mouse, as it would be in real life.

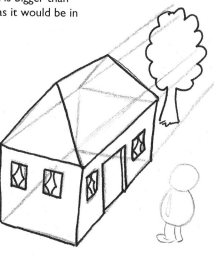

1 I start all of my buildings as simple block shapes. The shape of each side slants inwards as it gets further away. As we are looking from above, we can also see the top of the shape.

2 Lightly extending the lines of my drawing gives me guidelines to make sure that other objects, like the tree in the background, are in the same perspective as the house.

3 To give an idea of scale, we need to put something of known size in the cartoon for comparison. In my finished drawing, the normal-sized person, house and tree emphasize the fact

that someone has been overfeeding the canary on the roof!

I've explained the basic rules of perspective opposite. With a little practice you'll soon be able to try out further experiments for yourself.

Adding distance

A simple way of showing how far or near objects in your cartoons are is to remember that the further away an object is, the smaller it will be on your page. Faraway objects will also be higher up on the page.

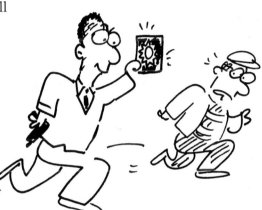

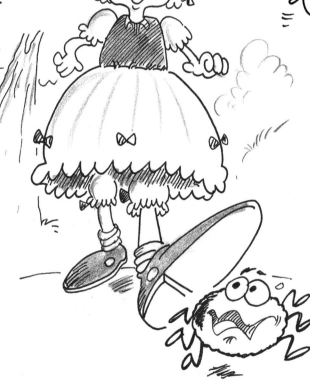

Objects tend to become lighter as they recede into the distance. The black areas on the robber's clothes in the first picture *(top)* become lighter cross-hatched areas as he tries to escape *(above)*, making him look further away.

Artist's Tip

You can practise perspective drawing by sketching a block or other object from different angles. Which sides can you see from each angle? Which parts look smaller or bigger as you change the viewpoint?

When using perspective in a cartoon, it is important to decide which eye level we will view the picture from. In this picture, our eye level is the same as the spider's on the ground, so the parts of Little Miss Muffet which are close to us are drawn much bigger, while her head and shoulders are smaller and further away. This trick is called 'foreshortening'.

Movement and Action

Once you start moving your cartoon characters around, you'll see the big advantage of building them up from basic shapes. As well as making even the most complicated movements easy to draw, basing your characters on the same simple shapes will make them recognizable as the same individuals, no matter how many different poses you draw them in.

Strike a pose

If you can find a full-length mirror, you can strike some poses yourself and see what happens to the different parts of your body every time you move. You may even be able to persuade a friend to model for you – after all, who would turn down a cartoon original as a reward?

If you study your own movements carefully, or those of your 'model', you will notice that it isn't just the arms that change position with each new pose – the whole body is involved. Does the body lean forward or backward slightly? Does the head drop down or stretch upwards?

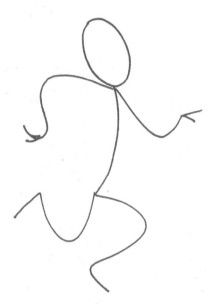

1 I usually start a movement drawing by trying lots of different matchstick figures until I draw one that best suits the pose I want.

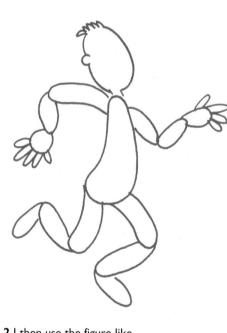

2 I then use the figure like a frame and build my basic shapes on top of it.

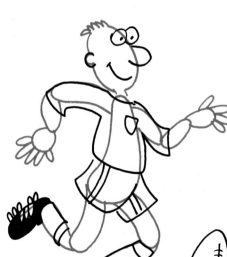

3 To complete my character, I add clothes and other details to the figure.

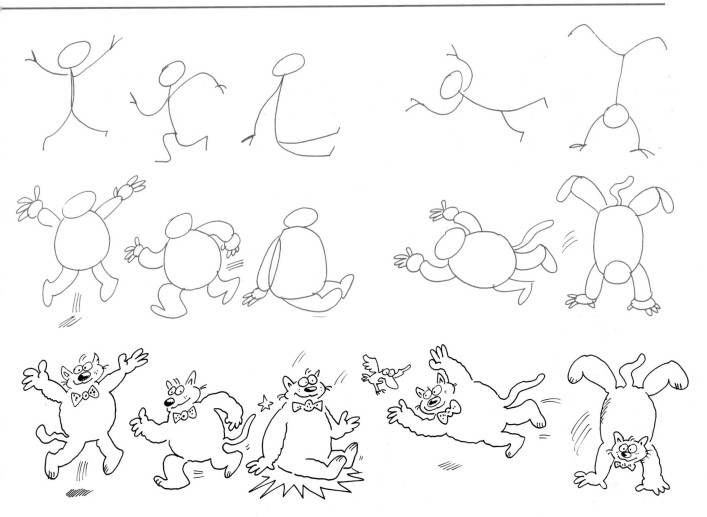

Try making one of your cartoon characters perform as many different movements as you can think of (above). If you have used simple shapes to build your character, you will find that you can draw it in any position you like and it will always look the same. This is particularly useful in story sequences, as in the comic strips on pages 130–39 and simple animation on page 55.

In the first drawing (right), this character appears to be jogging slowly. Lifting him off the ground and adding a puff of steam, a bead of sweat, and some movement lines (far right) makes him appear to run much faster. Notice that his body pose hasn't changed at all.

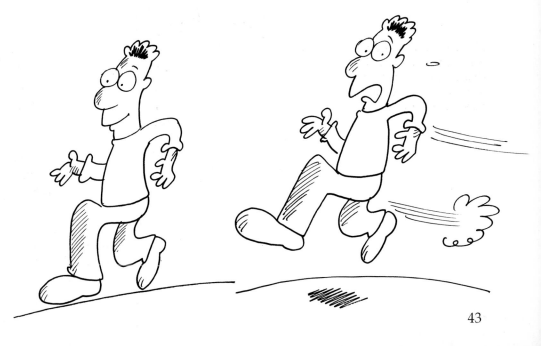

Larger than life

Exaggeration is an important part of cartoon action – our heroes and heroines don't always do things like real people – they run faster, hit harder and jump higher. See how far you can stretch each movement, but don't overdo it: remember each action still has to be recognizable for the cartoon to work.

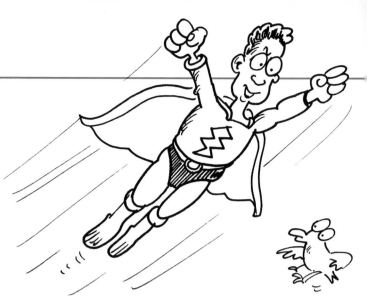

Take-off! Movement lines blast this character into flight (*above*). Notice the two small lines near the bird's feet which tell us that she has literally stopped in mid-air, in her surprise at this flying figure.

The movement line helps us follow the path of the peas. Here it is the expression on the victim's face that shows us that they have hit their target (*above*).

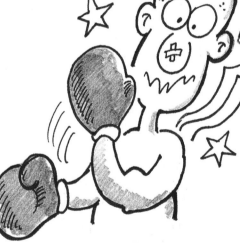

Two cartoonist's symbols: the repeated lines around the head create a vibration effect, while the stars exaggerate the impact of the glove (*above*).

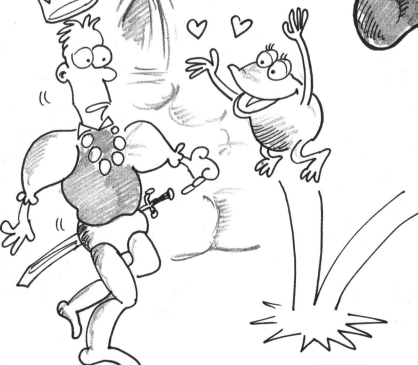

Here (*left*), movement lines are combined with a star shape to create a frog who can really BOUNCE!

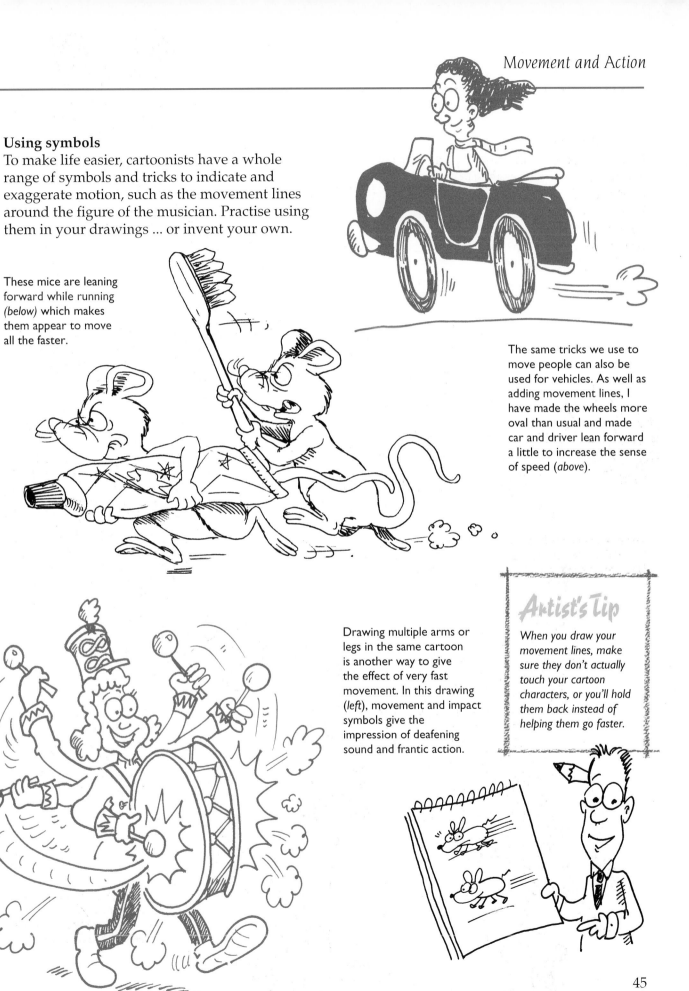

Using symbols

To make life easier, cartoonists have a whole range of symbols and tricks to indicate and exaggerate motion, such as the movement lines around the figure of the musician. Practise using them in your drawings ... or invent your own.

These mice are leaning forward while running *(below)* which makes them appear to move all the faster.

The same tricks we use to move people can also be used for vehicles. As well as adding movement lines, I have made the wheels more oval than usual and made car and driver lean forward a little to increase the sense of speed *(above)*.

Drawing multiple arms or legs in the same cartoon is another way to give the effect of very fast movement. In this drawing *(left)*, movement and impact symbols give the impression of deafening sound and frantic action.

Artist's Tip

When you draw your movement lines, make sure they don't actually touch your cartoon characters, or you'll hold them back instead of helping them go faster.

Backgrounds and Scenery

Once you've created a cast of cartoon characters, you need a world for them to live in. Cartoon backgrounds can be simple or complicated, but the main thing to bear in mind is that they must never distract from the main 'actors' in your drawings. That's why so many cartoons and comic strips have little or no background detail. However, the right setting can be a big help in creating atmosphere in your cartoons and jokes.

Selecting the detail
On these pages you'll see how one or two carefully chosen details can stand in for a complete scene, a city – or even a country. The trick is to choose the right details to give the impression of a particular scene or background.

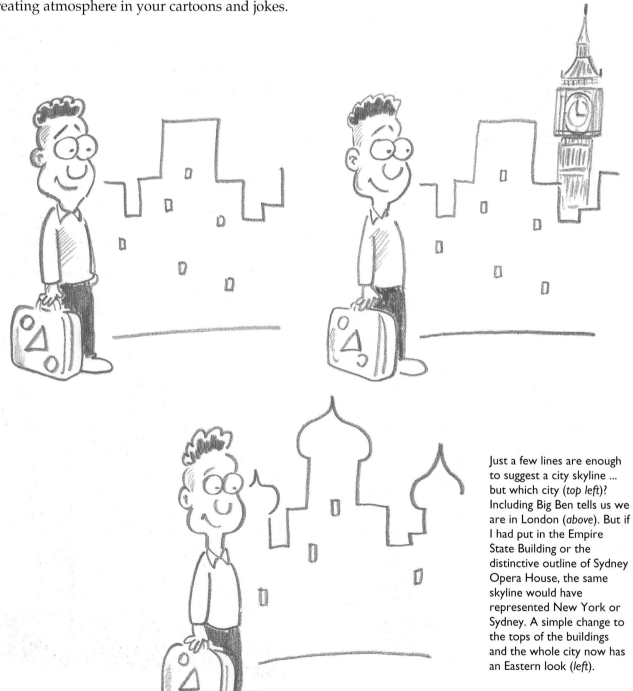

Just a few lines are enough to suggest a city skyline ... but which city (*top left*)? Including Big Ben tells us we are in London (*above*). But if I had put in the Empire State Building or the distinctive outline of Sydney Opera House, the same skyline would have represented New York or Sydney. A simple change to the tops of the buildings and the whole city now has an Eastern look (*left*).

Real-life backgrounds

Look around you as you read this book. Whether you are indoors or outdoors, most rooms, streets and even areas of countryside look basically the same. It's the details that make the difference. For instance, you will usually find a filing cabinet in an office rather than a living room. The main street of a city has the big stores and restaurants – you are more likely to find smaller, more unusual shops in the back streets. The plants and trees that grow in the desert will be very different from the ones that grow in the Arctic.

When you are drawing such scenes, it helps to find pictures of the details you want so that you can copy them.

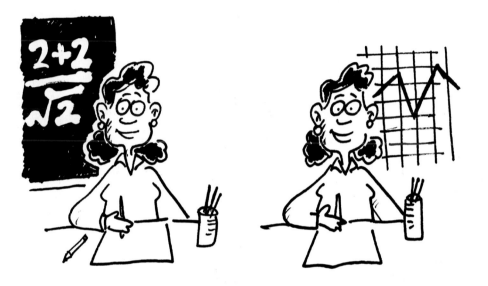

The same woman sitting behind the same desk – but the blackboard in the first drawing *(far left)* suggests a classroom scene. Replacing it with a graph in the second drawing *(left)* moves the cartoon to an office setting.

Different background details can tell us just as much about cartoon characters as their costumes can. The windows in these pictures are in very different types of home – and tell us a lot about the income of the person who lives there *(below left* and *below right).*

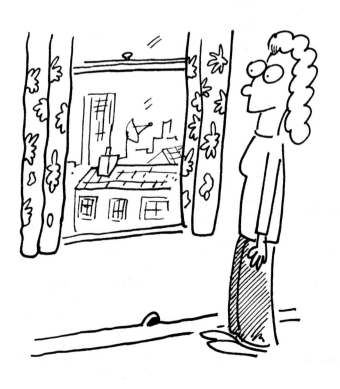

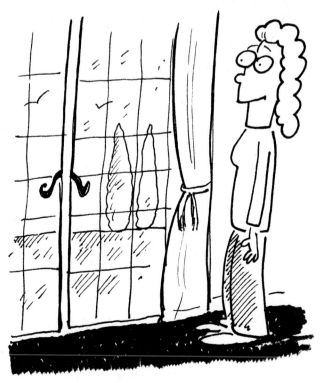

Speech Bubbles

Everyone knows that cartoon characters speak in 'bubbles' or 'balloons'. But, as your characters come to life, you'll want them to do a whole lot more than just speak – you may want them to shout, scream, or sing as well. Luckily, cartoonists have worked out their own 'sound effects' system. There are a whole range of special speech bubbles to show whether your characters are whispering, shouting, or just silently thinking to themselves. You can also use the balloons as another way of showing how your characters are feeling. Here, you can see some examples of how speech balloons can be used to 'add sound' to your cartoons.

Creating your own bubbles

If you have come up with some unusual characters of your own, perhaps you can design appropriate speech balloons to make them even more individual.

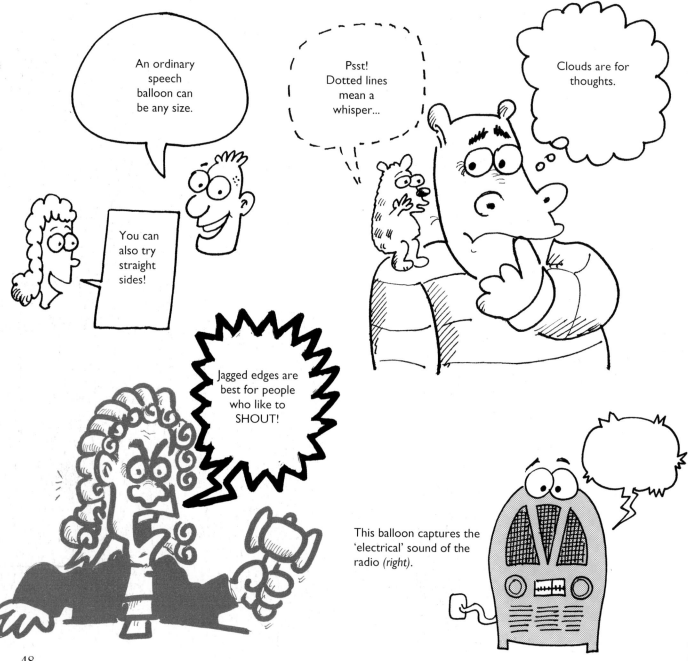

This balloon captures the 'electrical' sound of the radio (right).

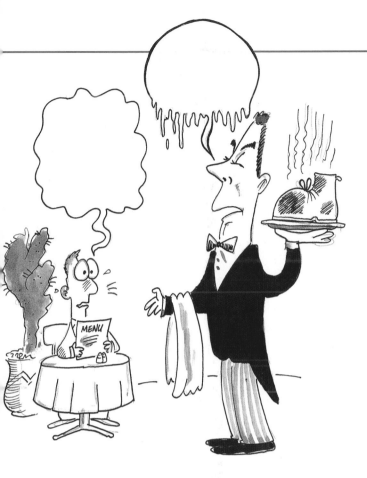

In this cartoon (*above*), the wavy lines on the diner's speech balloon make his words seem very weak and embarrassed. The waiter's balloon is perfect for saying something cold and unhelpful. What do you think they are saying to each other?

Here is LOUD music (*above*) ...

... and this is how to show that someone is saying something best left to the imagination (*left*)!

Artist's Tip

Oops! To avoid this problem, write your speeches first and then draw the balloon shape around them!

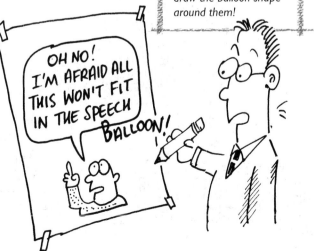

Lettering

Although a picture may be worth a thousand words, one or two words added to your cartoon drawings can make them work even better. In cartoons, you can use just as much imagination, energy and liveliness in drawing the lettering as in drawing the characters – and you don't need to worry too much about straight lines!

Styles of lettering
On these pages I've given some examples of some of the most popular types of lettering used in cartoons and comics, as well as some you could use for special occasions, or just for fun. Try writing your own name in some of the styles below or make up some styles of your own.

Keep it simple
As with drawings, simplicity works best for lettering – one or two special effects on every page is more than enough! Remember that no matter how wild or exaggerated the lettering style you choose for your cartoons, lettering works best when it's still possible to read it.

Always sketch your letters out roughly first to make sure they will fit your cartoon, and remember to check your spelling – when you're working on each letter one by one it's very easy to get them in the wrong order.

1 You can build up your cartoon letters from basic shapes, exactly as you do with your characters. Start off by pencilling in some ovals. You can 'bend' the letters when necessary and the top and bottom guidelines will still keep everything straight.

'Dripping' letters are very handy when you want to tell a horror story ... just make sure that they don't drip so much that you can't make out what they are (*above*). When you have inked the letters in, rub out the pencilled guidelines underneath.

2 Now you can complete the letter shapes in darker pen. Rub out the guidelines to finish off.

For a Western, the letters can be made out of wood ... or cactus (*above*).

Big block letters with lots of shadow mean that this is a job for Super-Cartoonist (*left*)!

A 'dropped shadow' behind your letters makes them seem to float above the page (*below*).

A little snow on top of a letter creates a seasonal effect (*below*).

Drawing a flash and adding a few stars behind your letters is good for magic ... or superhero punches (*above*).

When you've finished lettering all your cartoon drawings, you can turn the letters themselves into cartoons (*below*).

You can also try replacing one of the letters in your word with a suitable drawing – snakes are particularly obliging animals for this (*above*).

Using Your Sketchbook

Cartoon ideas can come from anywhere. Buy yourself a small sketchbook or notebook, and carry it everywhere. An ordinary pencil or ball-point pen is fine for sketching.

Finding your subjects

Keep an eye out for interesting people who can become your cartoon characters. You'll find lots of subjects on the street, in restaurants, or on trains and buses. You'll soon get in the habit of doing quick sketches of people you meet – you'll have to be quick because your models are not going to stay in one place for very long.

Don't be too shy about cartooning in public. Some artists are a bit reluctant to let the public see them at work in case they get funny looks. But being funny is what cartooning is all about, and you'll usually find people are too busy laughing at your cartoons to bother laughing at you. Keep practising and it won't be too long before someone looks over your shoulder and says, 'I wish I could do that.'

If you prefer, you needn't even step outside your house to practise sketching. You'll find lots of funny things to draw in pictures from newspapers and magazines or people you draw from the television.

Quick technique

You'll find the same 'basic shapes' techniques we have used in cartooning just as useful in sketching real people. Concentrate on getting a quick, overall picture of the person, paying special attention to any interesting physical features or clothes to use in your cartoons.

I sketched this woman at work in a clothes shop ...

... and invented a difficult customer for her. The caption might read: 'Sorry madam – I don't think we have it in size 200.'

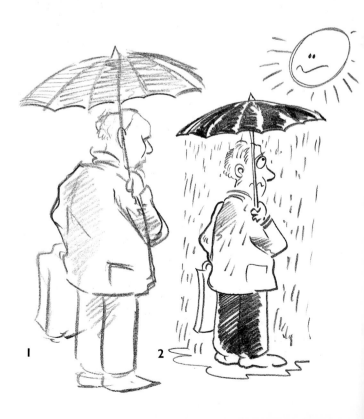

1 I saw this man while I was standing in the rain.

2 I didn't have an umbrella so I used the cartoon to take a little harmless revenge.

1

2

52

Using your sketches

Among the drawings on these pages, you will see some sketches from a shopping trip to my local town and the cartoons I turned them into when I got home.

One good way to make a cartoon is to choose two sketches you have done of different people and see what would happen if you put them together. Another trick is to sketch a person and then turn them into the cartoon animal you think they resemble. You can also try sketching everyday situations and then asking yourself what could happen next to make a funny cartoon.

Here's an interesting face I drew from a magazine (*right*). I decided that he needed a body – and turned him into an animal while I was at it.

I sketched this beaver from a wildlife show on TV (*far left*). The animal looked a bit annoyed to be disturbed by the camera so I kept the grumpy expression for the cartoon version (*left*).

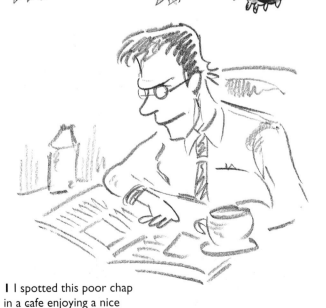

1 I spotted this poor chap in a cafe enjoying a nice quiet cup of coffee ...

2 ... but nobody relaxes for long when there's a cartoonist about!

Using Your Cartoons

This book is just the beginning of your cartoon adventure. As you keep practising your cartooning skills, your work will continue to improve, and you'll come up with lots of new ideas. You'll also come up with lots of new ways to use your cartoons. You'll certainly never be at a loss for interesting gifts to amuse your family and friends.

Earlier in this book we looked at some of the different drawing media from pen and ink to brush and crayon. We've also looked at the effects of drawing on different types of paper. But when you are thinking of ways to use your cartoons, there is only one basic rule you have to remember: if you can make a mark with something, you can draw a cartoon with it, and if anything stands still long enough you can draw a cartoon of it! On these pages I've suggested a few ways to put your cartoons to work – but with a little imagination, you will be able to come up with lots more.

Holidays, birthdays, get well soon – there are lots of cartoon characters to suit every occasion (*left* and *below*).

On special occasions such as graduation day, your greeting will be even more effective if you use your caricature skills to make the character on the card look like the person you are sending it to (*above*).

Greetings cards

Finding appropriate greetings cards for friends and family can often be a problem. Not any more – now you can produce them yourself. There are lots of attractive coloured cards and papers available for you to use.

T-shirts

You can make your own T-shirts by painting cartoons on to them with fabric paints or waterproof markers. It makes drawing easier if you pin the front of the shirt on to a sheet of stiff cardboard while you are drawing. If you like, you can draw your preliminary sketch lightly with chalk.

Letters and notes

Notes and letters with cartoons are guaranteed to get noticed. Now that you are a cartoonist, why not design your own notepaper? A simple design works best and is easy and cheap to print or photocopy.

Animation

Making animated cartoons can be an expensive and complicated business – it takes 24 different drawings to make every second of film! But you can animate your drawings very simply by using the technique shown below.

You can bind some photocopied cartoons together to make a notebook *(left)*.

Big, simple designs work best for T-shirt decoration, and are much easier to draw on the fabric *(right)*.

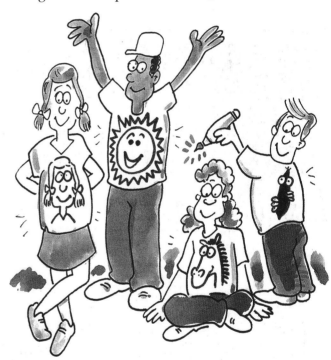

I Fold a sheet of paper in two and draw a simple cartoon on the bottom half.

2 Fold the top half down and trace the cartoon exactly, but change one or two things. In this example, the position of the wings and tongue have been changed.

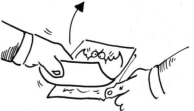

3 & 4 When you flip the top page quickly back and forth, your cartoon will appear to move. Now try a different 'cartoon movie' of your own!

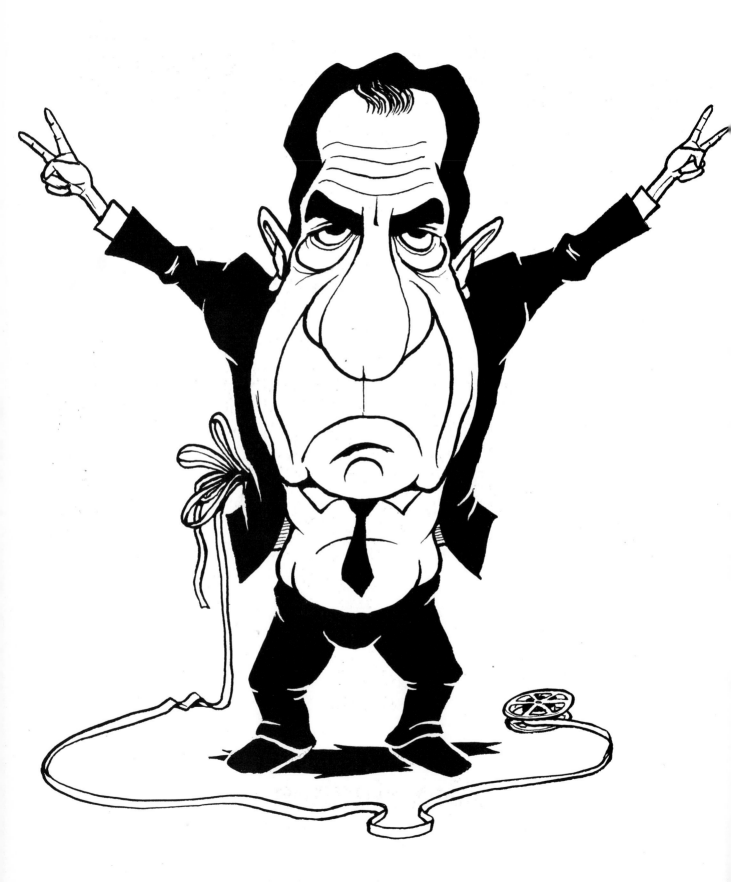

CARICATURES

Alex Hughes

What Is Caricature?

What we now know as caricature began in Renaissance Italy, where artists such as Annibale Carracci first drew exaggerated portraits (from where we get the word 'caricature', a derivation of the Italian *caricare*, meaning to exaggerate or load). Caricature can be seen as the art of capturing the essence of someone's personality through an exaggerated likeness, to create a portrait that is ultimately more true to life than life itself. A caricature should be more than just a likeness which merely stretches someone's nose or gives them big ears – it needs to reveal something of the personality behind the face.

The caricaturist's role is to study the subject and discover what makes him or her unique, a combination of appearance and character. Often a caricature is seen as a cruel or grotesque representation, but this misses the point. A caricature does not have to be ugly unless the subject deserves to be ugly; many caricatures can be very subtle and restrained.

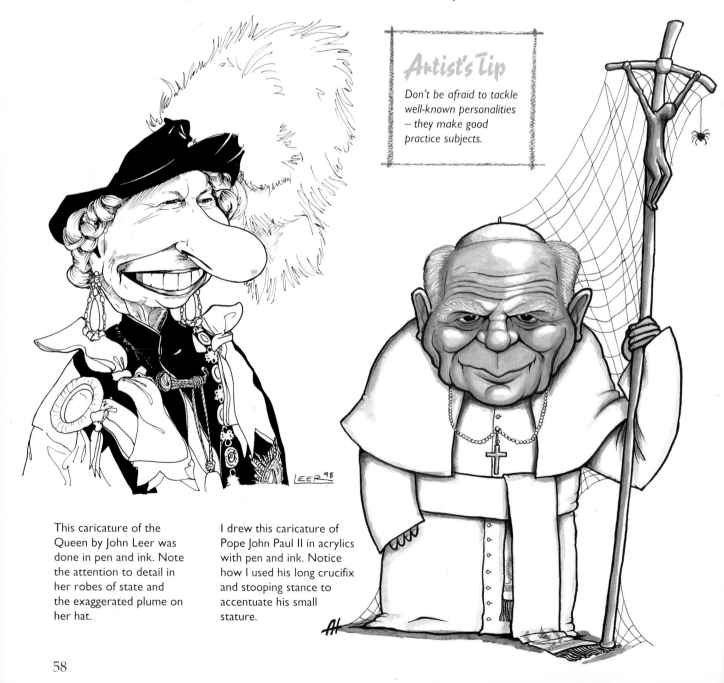

Artist's Tip

Don't be afraid to tackle well-known personalities – they make good practice subjects.

This caricature of the Queen by John Leer was done in pen and ink. Note the attention to detail in her robes of state and the exaggerated plume on her hat.

I drew this caricature of Pope John Paul II in acrylics with pen and ink. Notice how I used his long crucifix and stooping stance to accentuate his small stature.

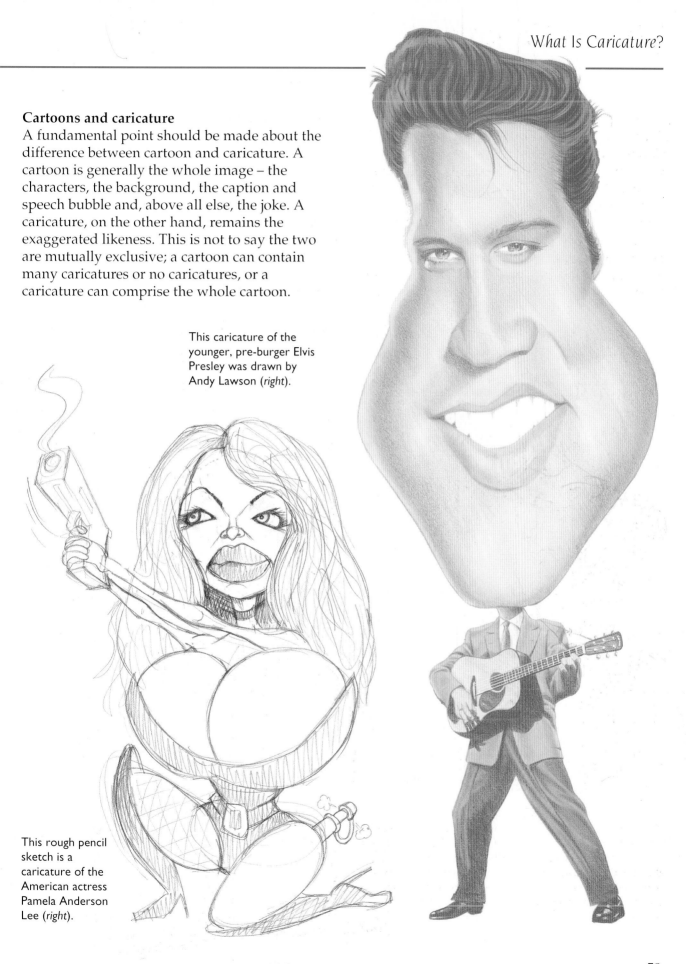

Cartoons and caricature

A fundamental point should be made about the difference between cartoon and caricature. A cartoon is generally the whole image – the characters, the background, the caption and speech bubble and, above all else, the joke. A caricature, on the other hand, remains the exaggerated likeness. This is not to say the two are mutually exclusive; a cartoon can contain many caricatures or no caricatures, or a caricature can comprise the whole cartoon.

This caricature of the younger, pre-burger Elvis Presley was drawn by Andy Lawson (*right*).

This rough pencil sketch is a caricature of the American actress Pamela Anderson Lee (*right*).

Types of Caricature

There are broadly four main styles of caricature: portrait, stylized, quick sketch and political. Each style of drawing has its strengths and weaknesses and you should take care to choose the right style to represent your subject.

Portrait caricature is the most straightforward form of caricature – you just take your subject and draw an exaggerated portrait. This is often the starting point for other styles – your simple portrait caricature can be used as a basis for a political caricature, for example. With political caricature you are attempting to make a joke or comment about your subject. The style of caricature allows you the freedom to be much more malicious about your subject.

Caricatures of celebrities are often highly stylized. Effectively a portrait caricature reduced to simple shapes and lines, this is a tricky but effective form of caricature. Quick sketch or 'live' caricature is more a form of entertainment. The caricaturist usually sketches guests at a party or function. You have to work quickly – there's no room for error.

Stylized caricatures work particularly well with well-known faces, such as Charlie Chaplin, where you can render a simple likeness with the minimum of line (right).

Portrait caricatures such as this one of a friend can be very detailed, and a good caricaturist can bring out the sitter's personality (above).

Quick-sketch caricatures such as this one of a friend require practice, but the results are rarely as well observed as a studied portrait caricature (right).

Artist's Tip

When drawing people from life, you might find it useful to carry a camera with which to record their likeness as a means of cross-checking your sketches.

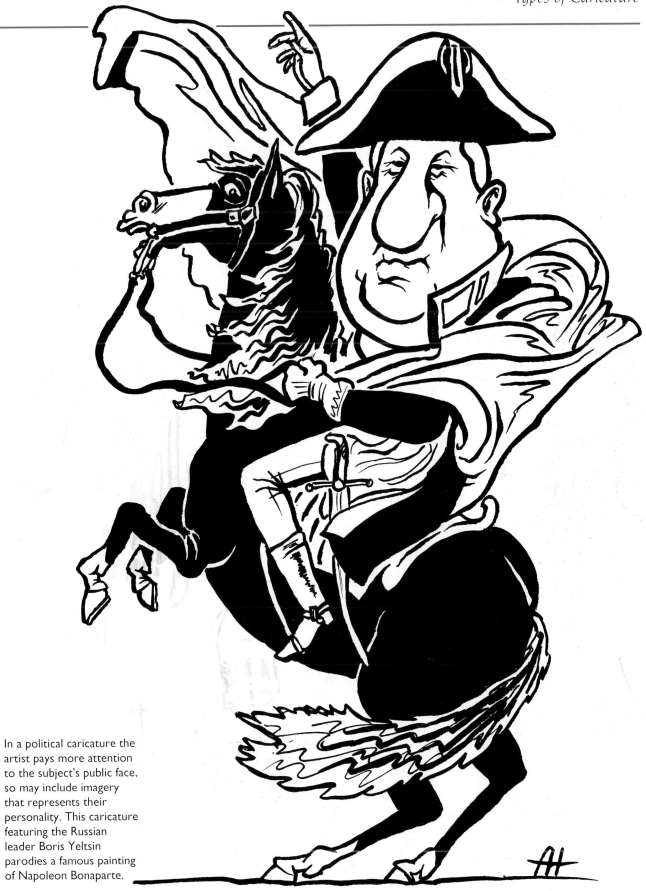

In a political caricature the artist pays more attention to the subject's public face, so may include imagery that represents their personality. This caricature featuring the Russian leader Boris Yeltsin parodies a famous painting of Napoleon Bonaparte.

The Whole Face

Before we move on to specific facial features it would be helpful to understand how these features relate to each other on the face. To see where they fit together normally should help you see how to distort them. After all, a caricature is not just about exaggerating or shrinking those features, but also about the space between them. Bear in mind that most faces are broadly symmetrical and that these proportions are only rough rule-of-thumb measures.

Standard proportions

The width of the whole head is roughly two-thirds the length of the head (A). A line drawn across the face halfway down the head forms a line across the tops of the eyes. The eyes are placed the equivalent of one 'eye' apart, which is also the width of the nose at its widest point across the nostrils. The whole face is also five 'eyes' wide (B). The distance from the brow to the base of the nose is equivalent to the distance

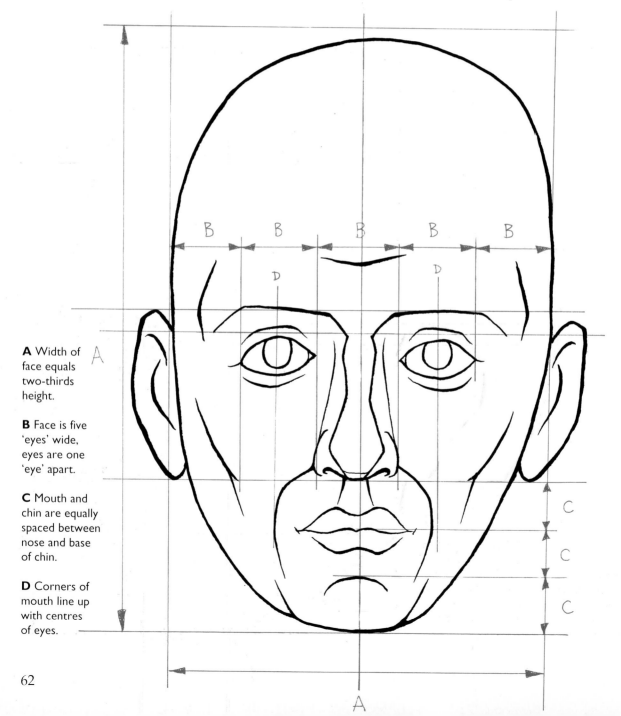

A Width of face equals two-thirds height.

B Face is five 'eyes' wide, eyes are one 'eye' apart.

C Mouth and chin are equally spaced between nose and base of chin.

D Corners of mouth line up with centres of eyes.

from the base of the nose to the base of the chin (E), while the corner of the jawbone is in line with the corner of the mouth (G).

This space from the base of the nose to the base of the chin can be split equally into thirds (C), the upper third being the upper lip, the middle being from the upper lip to the top of the chin prominence, the lower being to the base of the chin. Also note that a line drawn from the centre of the pupils straight down lines up with the corners of the mouth (D), and a horizontal line drawn from the corner of the mouth will meet the corner of the jaw.

The ear is bounded at the top by a line drawn straight across from the brow, and at the bottom by a line straight from the base of the nose (F). This latter line also crosses the base of the cheek and the base of skull where it meets the neck (H).

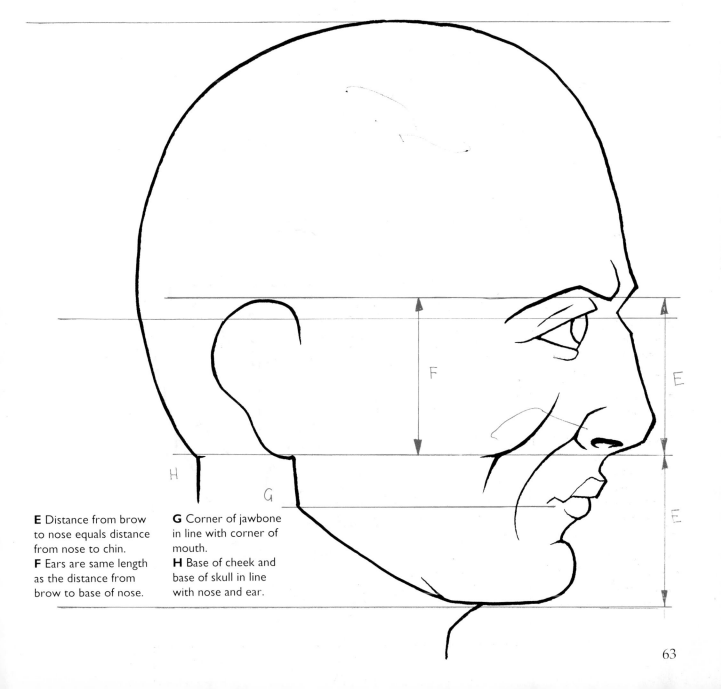

E Distance from brow to nose equals distance from nose to chin.
F Ears are same length as the distance from brow to base of nose.

G Corner of jawbone in line with corner of mouth.
H Base of cheek and base of skull in line with nose and ear.

Face Shapes

Over the next few pages I have illustrated the basic forms and features a caricaturist needs to work with. These will be your fundamental building blocks with which you should be able to construct your finished caricature. I have not listed these as an identikit set, where you pick and mix the features you wish to use. I merely hope to show you the sort of things you should be looking for when studying your subject; the things that make for an interesting caricature.

One of the most obvious characteristics of the human face is its overall shape. For many caricatures this will be your starting point, so it's a good idea to familiarize yourself with a handful of the more common shapes you may encounter.

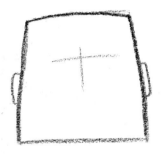

A square-shaped face normally implies a stocky, solid build.

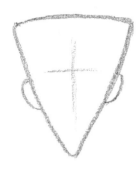

Someone with a triangular face such as this is likely to have sharp, pointed features.

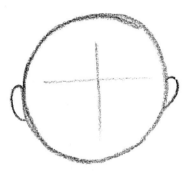

A round face such as this is normally associated with a cheerful personality.

A diamond shape is similar to a triangular face but with a more pointed forehead.

This long, thin face would probably belong to a tall, thin person.

A hexagon such as this can form another stockily built face.

This inverted egg-shape indicates a fat, jowly, double-chinned sort of face.

A trapezoid-shaped face such as this normally goes with a stocky, bull neck.

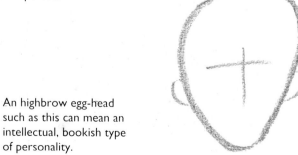

An highbrow egg-head such as this can mean an intellectual, bookish type of personality.

The owner of a flat, ovoid head such as this may be rather short and a bit fat.

Head angles

There are three basic views one can take of the head, shown here. There are obviously other possible views, but for the caricaturist these are largely going to be irrelevant – it's much trickier to caricature someone from the back of the head, for example. It is important to choose which view to take early on – though this may be decided by circumstances, as it is tricky, if not impossible, to picture someone's profile from a photograph of their full face.

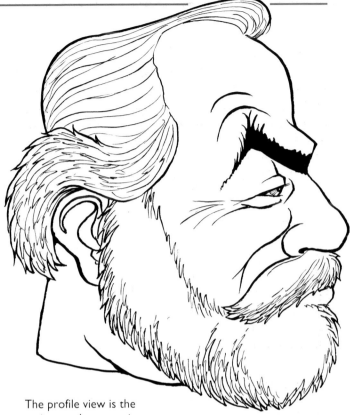

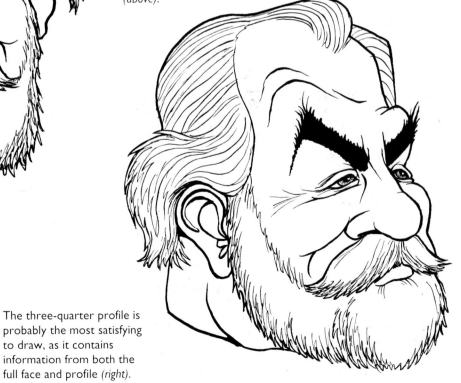

The profile view is the easiest to draw a caricature from as the features are laid bare, but ultimately the results are a little flat *(above)*.

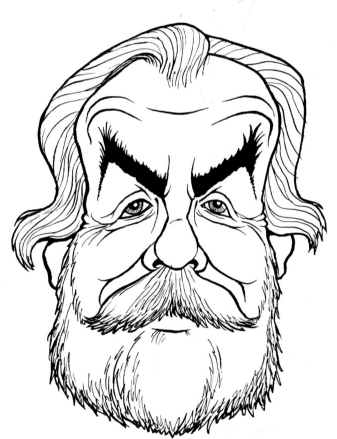

The full face (here of my father) is the most straightforward pose and the easiest to plan out but gives no real scope for depth *(above)*.

The three-quarter profile is probably the most satisfying to draw, as it contains information from both the full face and profile *(right)*.

Facial Features

Because the eyes can tell you an awful lot about a person's character and mood they are often the first thing you look at on meeting someone, and they are therefore the feature it is important to get right. Large irises make the eyes look soft and docile, whereas a small iris surrounded by white can make the subject of the caricature appear surprised, or even mad. Be aware of different kinds of eyelids; some are heavy and overhung, particularly in older people, and will darken the rest of the eye.

Bags, wrinkles and crow's feet can be used to great effect around the eyes. Look out for the way the wrinkles crease across the bridge of the nose, as they are normally quite distinctive. Eyebrows are also important, be they thick and bushy or high fine lines. Remember a lot of expression can be put into eyebrows alone by virtue of their position.

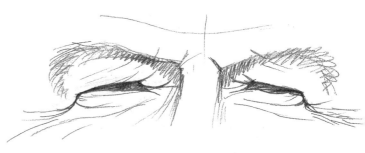

While most eyes appear symmetrical, small imbalances in detail can be played to your advantage *(below)*.

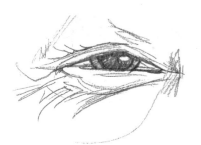
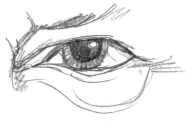

Some eyes are reduced to little more than slits, and you draw them through the wrinkles and crow's feet *(above)*.

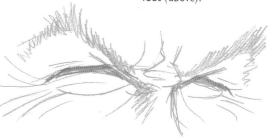

A steely gaze like this combined with a frown presents quite a mean-looking expression *(above)*.

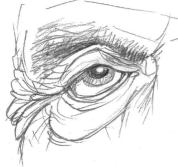
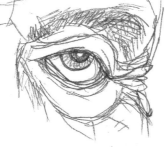

Sometimes bags, eyelids and wrinkles around the eyes can be more interesting than the eyes themselves *(above)*.

With heavy bags under the eyes, most other wrinkles are lost in the sagging skin *(right)*.

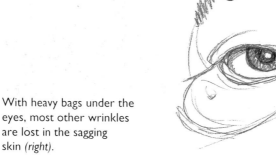
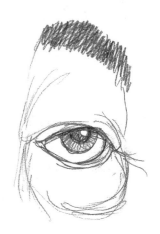

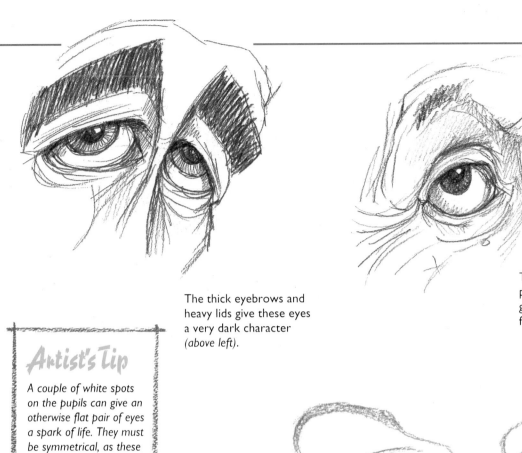

The thick eyebrows and heavy lids give these eyes a very dark character *(above left)*.

The direction that these pupils appear to be gazing give the eyes a distant, faraway look *(above)*.

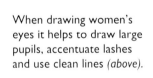

Artist's Tip

A couple of white spots on the pupils can give an otherwise flat pair of eyes a spark of life. They must be symmetrical, as these 'catchlights' reflect light from a particular source.

When drawing women's eyes it helps to draw large pupils, accentuate lashes and use clean lines *(above)*.

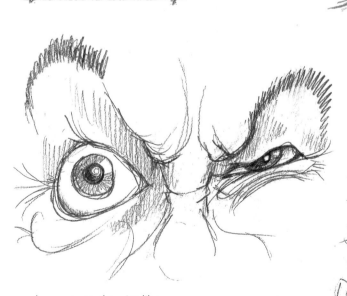

A pronounced squint like this can add a little bit of personality and expression to the caricature *(above)*.

Huge bushy eyebrows such as these are a boon to the caricaturist – they should dominate the whole portrait *(below)*.

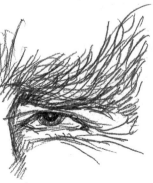

Eyes and glasses

A section on eyes would not be complete without mentioning glasses, which of course can have a dramatic effect on a caricature. Remember that thick lenses can magnify or reduce the apparent size of the eyes behind the glasses, and this can be caricatured accordingly.

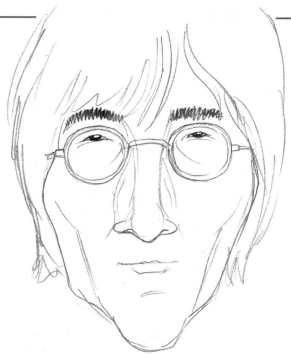

Small, round glasses such as John Lennon's can reduce the eye size in relation to the rest of the face *(above)*.

Bear in mind the relation between eyebrows and glasses; some people's brows rise above the frames *(right)*.

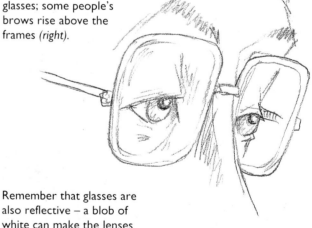

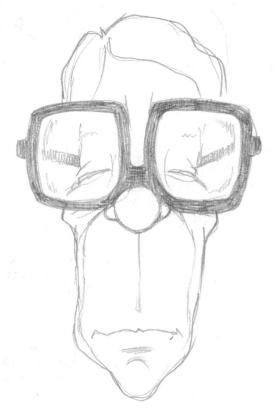

Glasses with thick frames and lenses such as John Major's dominate the face, so a caricaturist can make them much bigger *(above)*.

Half-moon spectacles such as these can make the wearer appear to be looking down on people in disdain *(below)*.

Remember that glasses are also reflective – a blob of white can make the lenses appear a bit more lifelike *(below)*.

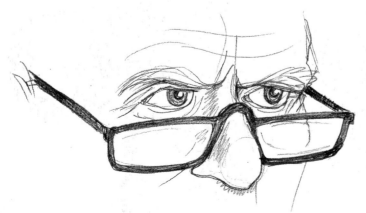

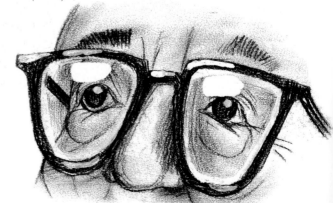

Noses

The nose is often the most strikingly obvious feature on someone's face. From long aquiline beaks to fat bulbous blobs, there is tremendous scope in the nose for the caricaturist. If you are drawing someone who is particularly famous for their nose, it can be worth exaggerating it a little further to comic effect.

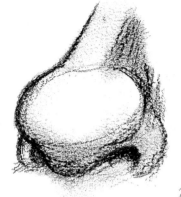

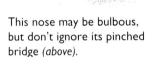

A large, bulbous nose can dominate your caricature *(above)*.

This nose may be bulbous, but don't ignore its pinched bridge *(above)*.

Broken and crooked noses are interesting features to work with *(below)*.

Some people have small, insignificant snub noses such as this *(above)*.

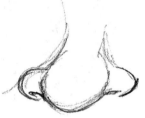

A long ski-slope of a nose sticks out quite prominently *(above)*.

Nostrils can be an especially interesting feature on some noses *(above)*.

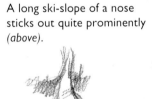

Note the triangular form of the nose; there are fleshier bits to the side above the nostrils *(left)*.

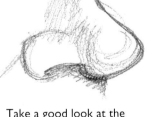

Take a good look at the bridge of the nose – it can hold some interesting features *(above)*.

In these two sketches of Charles de Gaulle you can see how a fairly straight caricature of his large nose *(right)* can be extended into a far more caricatured hooter *(far right)*.

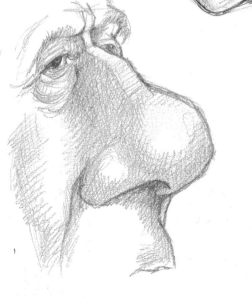

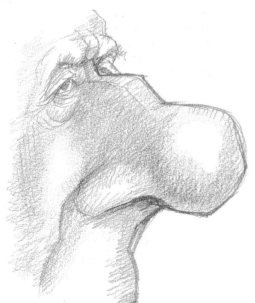

Mouths

You can communicate a lot with your mouth without actually speaking. The shape of someone's mouth can express a lot about their mood, be it happy, sad, angry or thoughtful.

The lower lip is generally more prominent than the upper. The teeth are generally less than perfectly arranged. A crooked incisor, a gap between the front two teeth or even a whole graveyard to bad dental hygiene are worth homing in on for the caricaturist.

The lines and dimples that frame the mouth are worth paying attention to. A prominent *philtrum* (the lines from below the nose to the upper lip) should be played up. Notice the distances between the base of the nose and upper lip and between the lower lip and base of the chin to get accurate placement of the mouth.

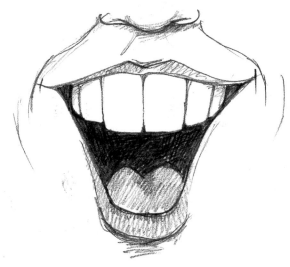

When drawing an open mouth, pay attention to the appearance of the tongue.

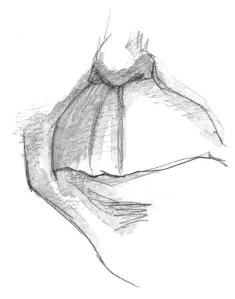

In rare cases the upper lip is non-existent. Note the prominent philtrum.

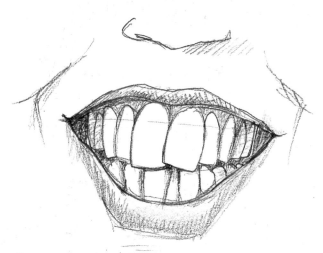

Even an otherwise perfect smile may be blighted by a crooked tooth.

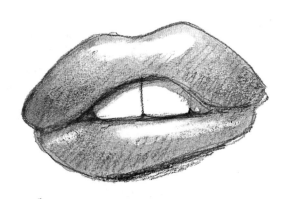

Lipstick gives women's lips a tone and sheen, not to mention body.

Jaws, chins and necks

To round off the lower part of the face we come to jaws, chins and necks. The jaw seems to take more of a battering by nature than other features, developing saggy jowls or double chins. Some men try to hide this by covering their lower face with beards and moustaches.

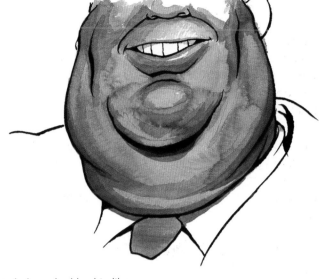

A deep double chin like this makes the whole face look round or even oval *(above)*.

A bushy or unusual moustache can act as an identifying feature in its own right *(above)*.

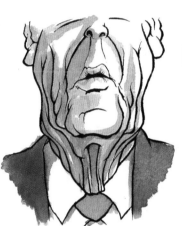

A broad, powerful neck like this supports a chiselled chin and jutting jaw *(right)*.

Older men can tend towards deep folds of wrinkled jowls or even dewlaps around the chin *(above)*.

A bushy beard such as this example dominates the lower face and should be exaggerated *(below)*.

A goatee such as this usually fails to cover the wrinkles around the chin *(above)*.

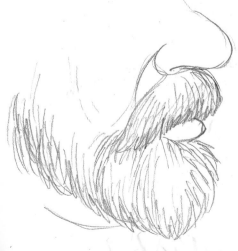

This caricature of television presenter Jeremy Beadle by Jonathon Cusick plays up his neatly trimmed beard *(right)*.

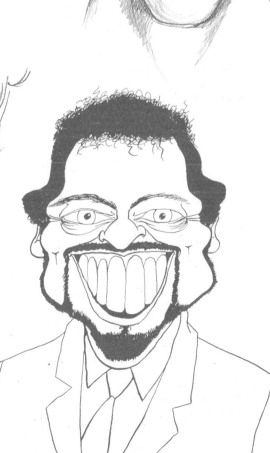

Ears

From the point of view of the caricaturist, most ears fall broadly into two categories: big, sticking-out jug ears, and small insignificant ones. There can be a wide range of shapes and forms within these categories, with pointed ears, large fleshy lobes and so forth, but ears are only of particular interest to the caricaturist when they jut out prominently.

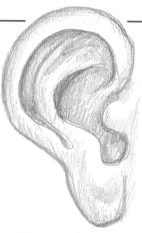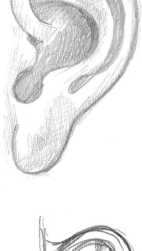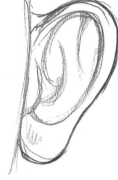

Big ears such as these *(above)* deserve attention to detail.

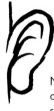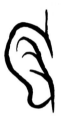

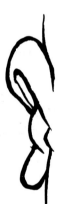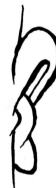

Most ears need no more detail than these fairly standard forms *(left)*.

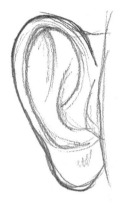

Sticking-out ears can have different shapes *(above)* –

compare these with the pair at the top, for example.

Cartoon-style ears such as these can be quick and easy to draw *(above)*.

Remember that some people wear their hair over their ears *(above)*.

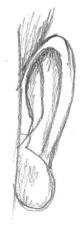

Lobes can be large even if the rest of the ear does not protrude *(above)*.

Another aspect of ears that should concern the caricaturist is that of earrings and studs such as these examples *(right)*.

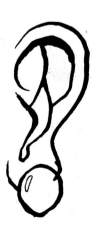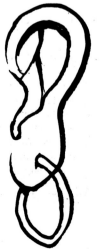

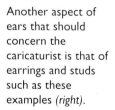

Some ears can be virtually flat against the side of the head *(left)*.

Hair

Finally, we come to hair. Because of the wide range of potential styles and cuts it would be foolish to try to cover this subject in depth. However, wild, ridiculous and unusual styles are worth picking out for particular attention, and can form the most significant feature of an otherwise bland face.

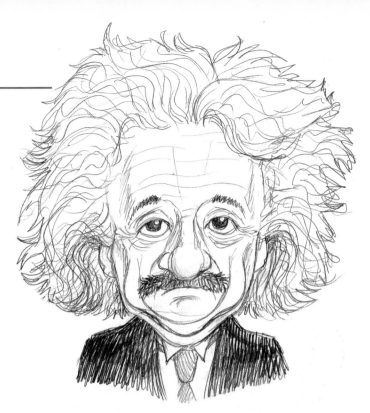

I have used Albert Einstein's notoriously wild hair and high forehead as dominating features in this caricature.

Baldness is a style in itself — note how on some people it elongates the forehead (above) while in others it visibly squashes it (below). Try to highlight embarrassing styles; 'combovers' and wigs should be accentuated.

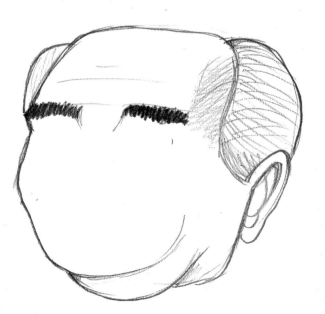

With some women's styles such as perms, following the exact shape and line of the hair can be complicated.

Portraying Personality

A good caricature should amount to more than the sum of its parts. What distinguishes a good caricature from a well-observed portrait is some acknowledgement of the subject's personality. If there is a trick to caricature, then it is capturing that particular spark of life that uniquely summarizes the subject's character. How you do this is harder to quantify, but it involves studying your subjects very carefully.

Watch for the quirks when they express themselves, look out for the way they hold their heads and note the expression that they use most often. You could even try to do impressions in front of a mirror to help you to understand how their face moves.

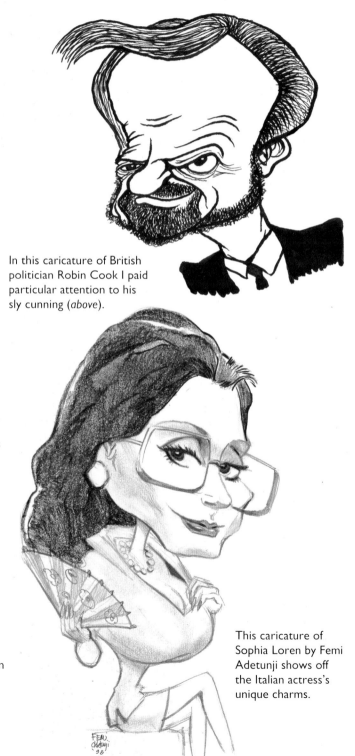

In this caricature of British politician Robin Cook I paid particular attention to his sly cunning (*above*).

In this caricature Andy Lawson captures American movie star Bruce Willis's trademark laidback smirk.

This caricature of Sophia Loren by Femi Adetunji shows off the Italian actress's unique charms.

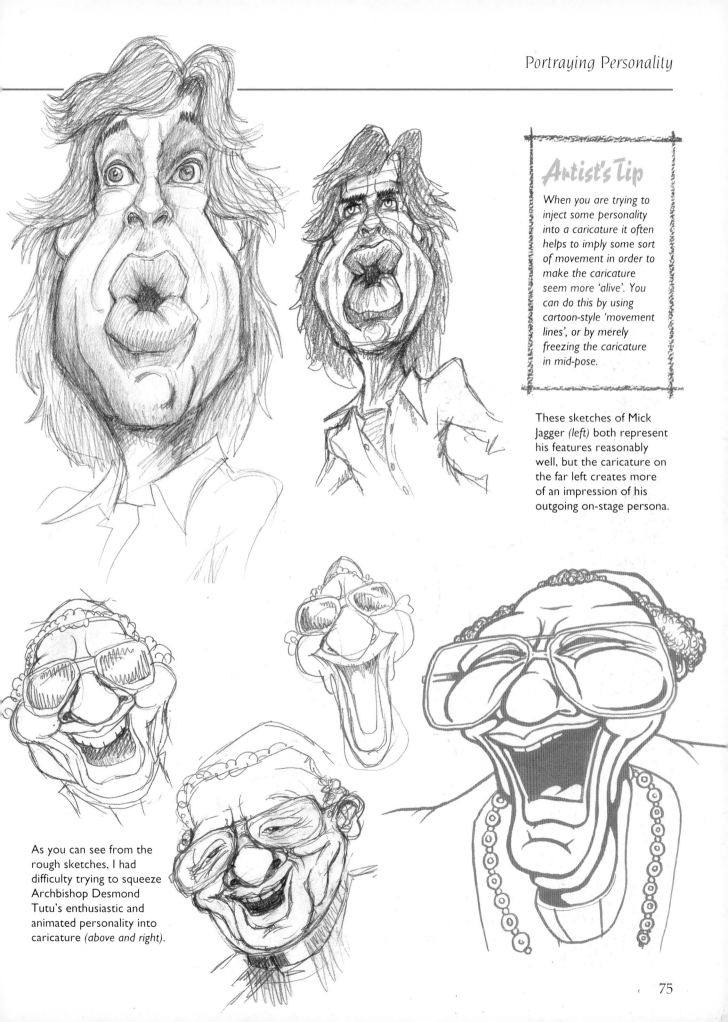

Artist's Tip

When you are trying to inject some personality into a caricature it often helps to imply some sort of movement in order to make the caricature seem more 'alive'. You can do this by using cartoon-style 'movement lines', or by merely freezing the caricature in mid-pose.

These sketches of Mick Jagger *(left)* both represent his features reasonably well, but the caricature on the far left creates more of an impression of his outgoing on-stage persona.

As you can see from the rough sketches, I had difficulty trying to squeeze Archbishop Desmond Tutu's enthusiastic and animated personality into caricature *(above and right)*.

When you are drawing a caricature you rarely get the luxury of working with a live model. While this can be a handicap, at the same time it can be a bonus; photographs can't look the wrong way or complain that you've made their nose too big or eyes too small. However, it is important to pick your source material carefully. As a caricaturist, you should maintain an extensive file of newspaper and magazine photographs of the politicians and celebrities you are called upon to draw.

The best advice is to collect as many pictures as possible of the subject and select the cream of these to work from. Often you will find yourself working from one or two pictures for the larger part of a caricature, using other photographs just to pick out specific details and features.

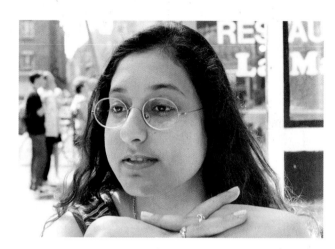

For this section I gave these photographs of a friend (who probably regrets it now) to some of the other contributors to this book to see how different caricaturists would approach a portrait of the same person.

In this portrait Femi Adetunji delivers a bright, lively caricature of my friend *(below left)*.

Here, Gary Dillon chose to do a relatively studied caricature. Note the attention to detail in the hair *(right)*.

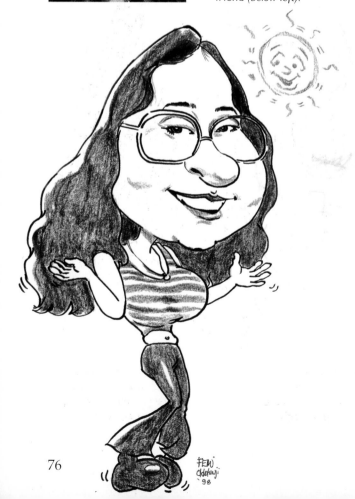

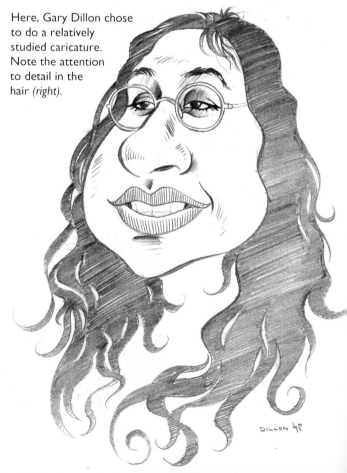

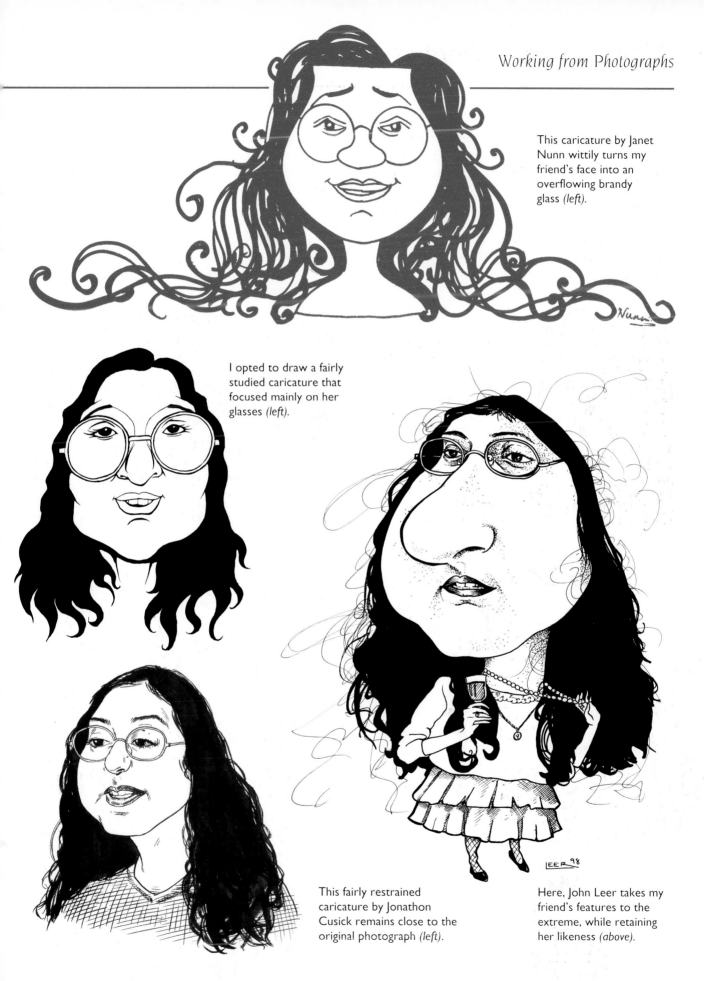

This caricature by Janet Nunn wittily turns my friend's face into an overflowing brandy glass *(left)*.

I opted to draw a fairly studied caricature that focused mainly on her glasses *(left)*.

This fairly restrained caricature by Jonathon Cusick remains close to the original photograph *(left)*.

Here, John Leer takes my friend's features to the extreme, while retaining her likeness *(above)*.

Getting Started

The profile is probably the easiest place of all for a beginner to embark upon doing a caricature because the features can be more or less exaggerated straight out from the normal silhouette outline. However, as is demonstrated in the two sequences of drawings shown below, there is a crucial difference between drawing a true caricature and just 'stretching' someone's facial features.

It is a useful exercise to practise this method of distorting a face. Take a photograph showing

1 This straight profile portrait is the starting sketch.

2 This profile has been stretched a little, but it nevertheless closely resembles the original.

3 The stretching seems to be working – the nose is certainly sticking out prominently. The brow and lips are a bit pronounced.

4 Here the nose still looks good, but the eyes and mouth are overstretched.

5 Here I've reattached the back of the head. As you can see, the portrait works after a fashion, but it feels a little odd.

1 In this version I'm attempting a less linear stretching – again a gradual start that would pass as a portrait.

2 I'm still using the nose more or less as above, but I've added a bit of a curl to the lips.

3 Here I've exaggerated the height of the hairline and given a bit more shape to the end of the nose.

4 The finished caricature. In contrast with the final sketch in the sequence above, this one still looks like the subject.

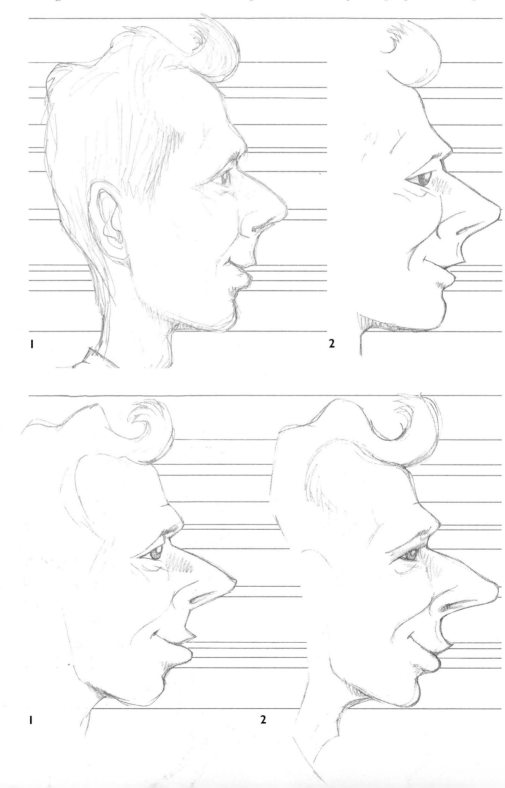

someone in profile, place some tracing paper over it and draw parallel lines across from the key intersection points. Next draw ever-more extreme versions across the page, based on the initial profile. With a bit of practice you will soon see that some features benefit by not

being stretched as far, while some features are improved upon for your purposes by being squashed back. However, this method still does not actually produce a 'true' caricature, because the stretching of the features remains quite linear.

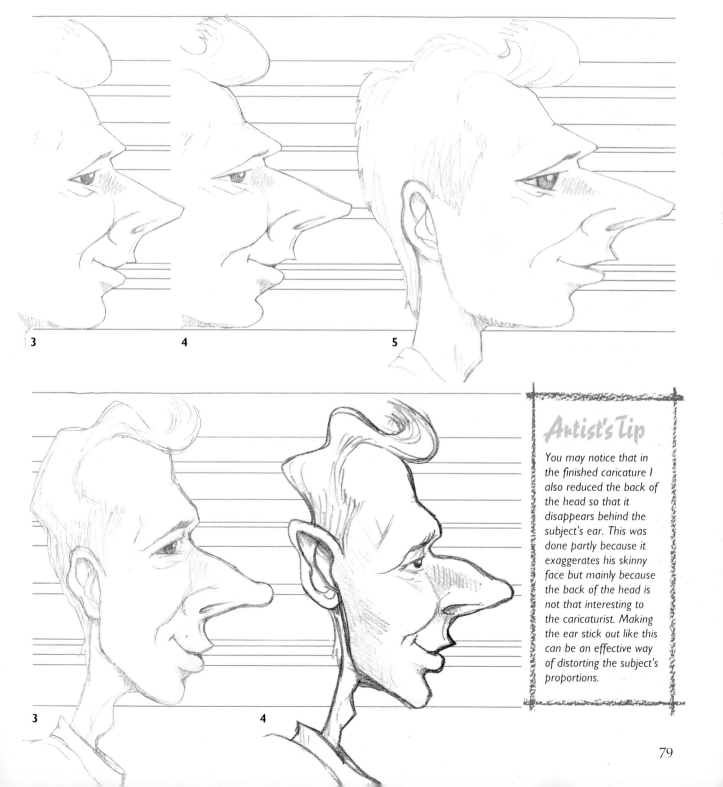

3

4

5

3

4

Three-quarter view

The three-quarter view is probably the most satisfying to draw for a caricaturist as it is this view that gives a truly three-dimensional feel to a face. Here I show how far you can take a caricature by exaggerating a face stage by stage.

This is not necessarily how you would work, but these drawings do demonstrate the choices you could make in creating a caricature. Note not only the differences in size of the features, but their positioning on the face and the distance between them, which can be as important.

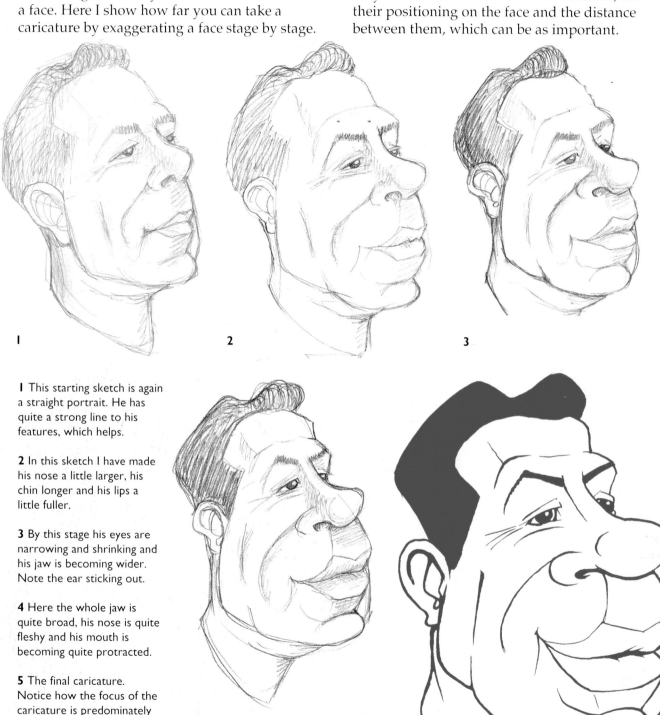

1 This starting sketch is again a straight portrait. He has quite a strong line to his features, which helps.

2 In this sketch I have made his nose a little larger, his chin longer and his lips a little fuller.

3 By this stage his eyes are narrowing and shrinking and his jaw is becoming wider. Note the ear sticking out.

4 Here the whole jaw is quite broad, his nose is quite fleshy and his mouth is becoming quite protracted.

5 The final caricature. Notice how the focus of the caricature is predominately on the lower half of the face and jaw.

Full face

The caricature you will probably be most often called upon to draw is the full-face portrait. It is important to remember that in full face most of the features tend to flatten back, so it is difficult to give that truly rounded form to the caricature.

Still, there is much that can be done from this angle, and it can in fact be somewhat easier to position the various features more effectively than in a profile drawing. As before, I have produced a series of ever-more extreme caricatures as an example.

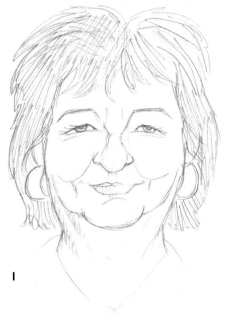

1 Starting as before, with a fairly straight portrait (this time of my mum, so I hope she won't be too offended).

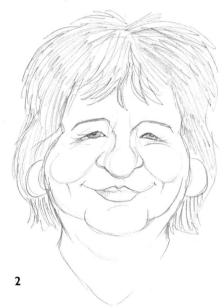

2 Not far in, but already I have narrowed her forehead and widened her cheeks. Her nose is a little fleshier, too.

1

2

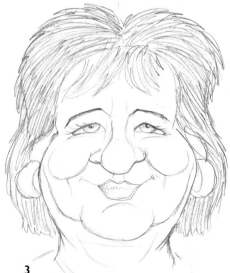

3

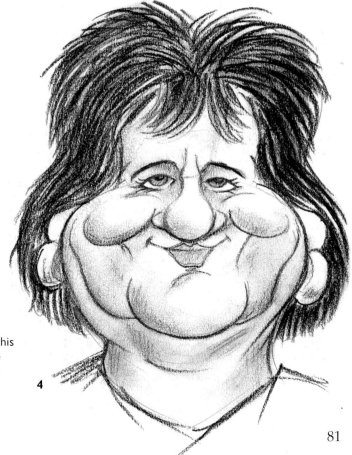

3 Here I am a bit further on. The lips are a little more pronounced and I am also exaggerating her double chin (sorry mum!).

4 The final caricature. I have possibly taken this a little too far, but the likeness still stands up quite well.

4

Approaches to Caricature

Over the course of the next few pages I shall take you through three of the most commonly used approaches to drawing a caricature from scratch. The first method is outline-led, which takes its lead from basic portrait drawing by starting with just the bare outline of the subject's face.

First you need to decide upon the shape of your intended subject's face. Next, following the proportions given on pages 62–3, pencil in approximately where the features should go, bearing in mind that this is a caricature rather than a true-to-life portrait.

Now roughly outline the eyes, nose, ears, hair and mouth. By this stage you should have a fairly reasonable sketch portrait that is slightly exaggerated. Now attack it with an eraser. You should have a good idea what to move and where to move it, so don't be afraid to break the outline rules you drew in earlier.

1 For this example I caricatured Prince Charles. He has a long, thin face, so I started with a corresponding outline.

2 Next I added his features, paying special attention to those famous ears. Notice they are still in proportion to his nose.

3 Fleshing it all out a little, I obtained a portrait with his ears, nose and hairstyle somewhat exaggerated.

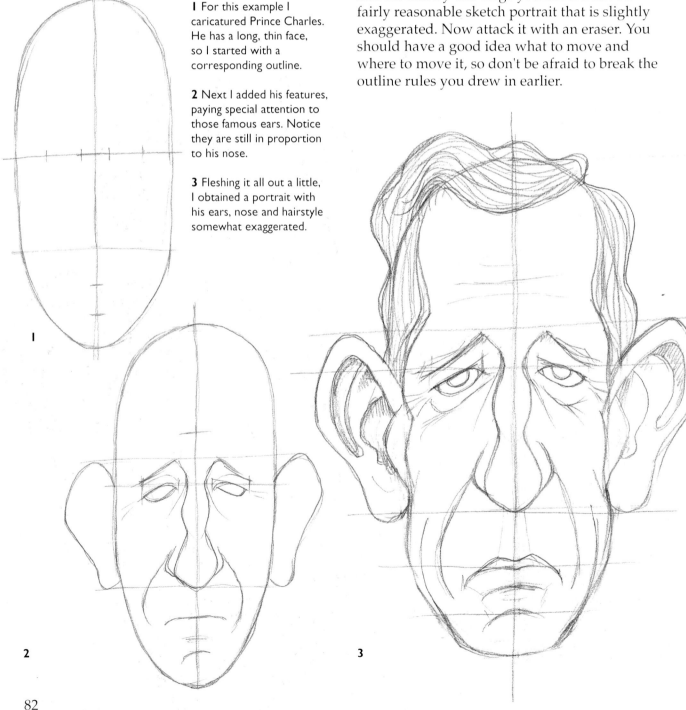

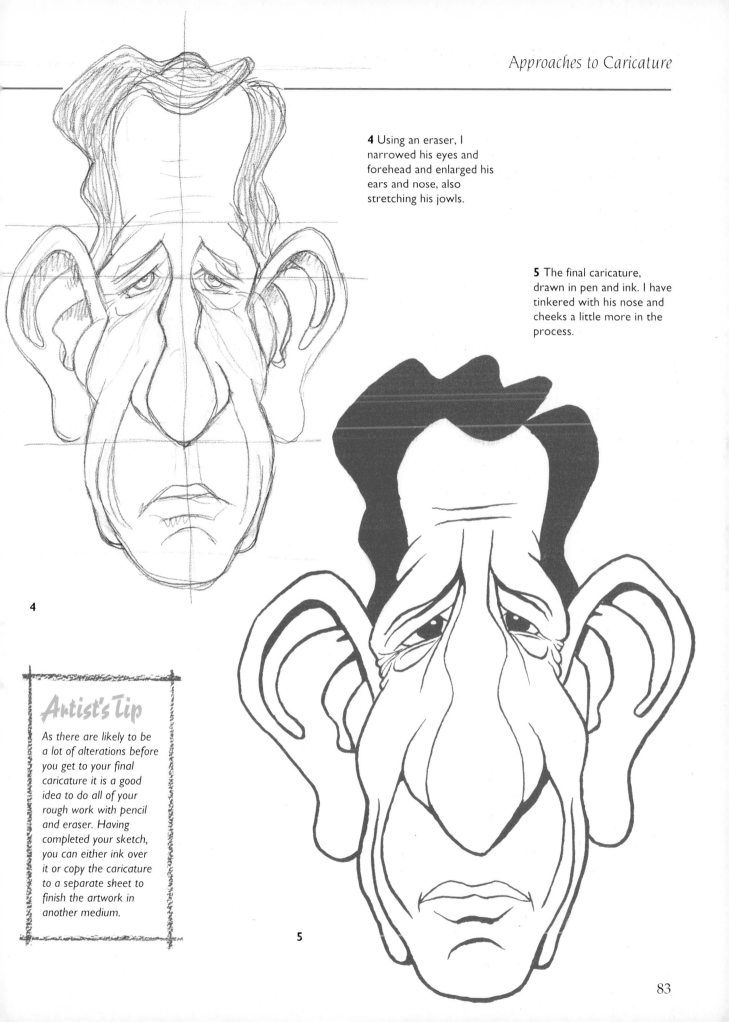

4 Using an eraser, I narrowed his eyes and forehead and enlarged his ears and nose, also stretching his jowls.

5 The final caricature, drawn in pen and ink. I have tinkered with his nose and cheeks a little more in the process.

4

Artist's Tip

As there are likely to be a lot of alterations before you get to your final caricature it is a good idea to do all of your rough work with pencil and eraser. Having completed your sketch, you can either ink over it or copy the caricature to a separate sheet to finish the artwork in another medium.

5

Feature-led caricatures

For this method, rather than beginning with the whole face I start with an individual feature and work out from it. Some people have one facial characteristic that stands out more than any other, and it sometimes helps to start there. Big noses, heavy-framed glasses and wide, expressive mouths are good starting points, whereas features such as ears or hair are tricky to build out from.

You will still need to tinker as you go on, though, and it helps to bear in mind the ratios and proportions for the rest of the face. This is more of a trial and error method of drawing a caricature than the outline-led method.

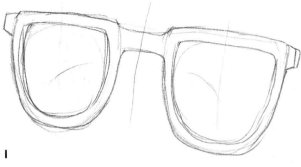

I

1 For this caricature of Woody Allen I started with his distinctive, heavy framed glasses.

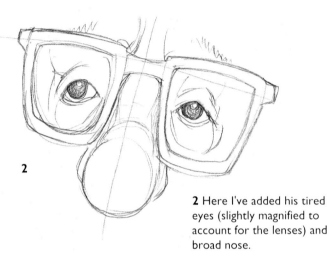

2

2 Here I've added his tired eyes (slightly magnified to account for the lenses) and broad nose.

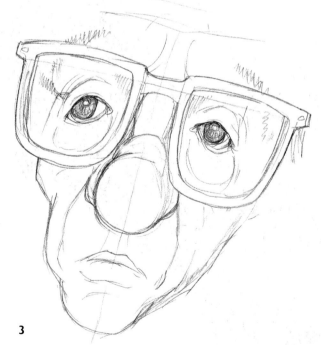

3

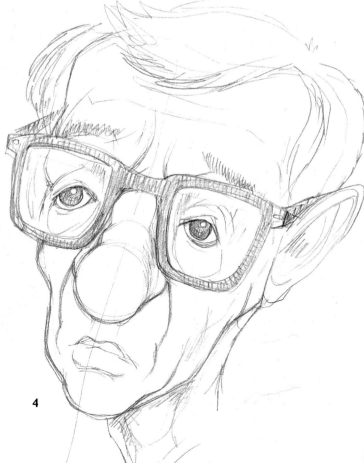

4

3 The next step in the caricature was to flesh out Woody's craggy yet skinny mouth and chin.

4 I then topped it all off with a broad forehead. Note the triangular form to his face.

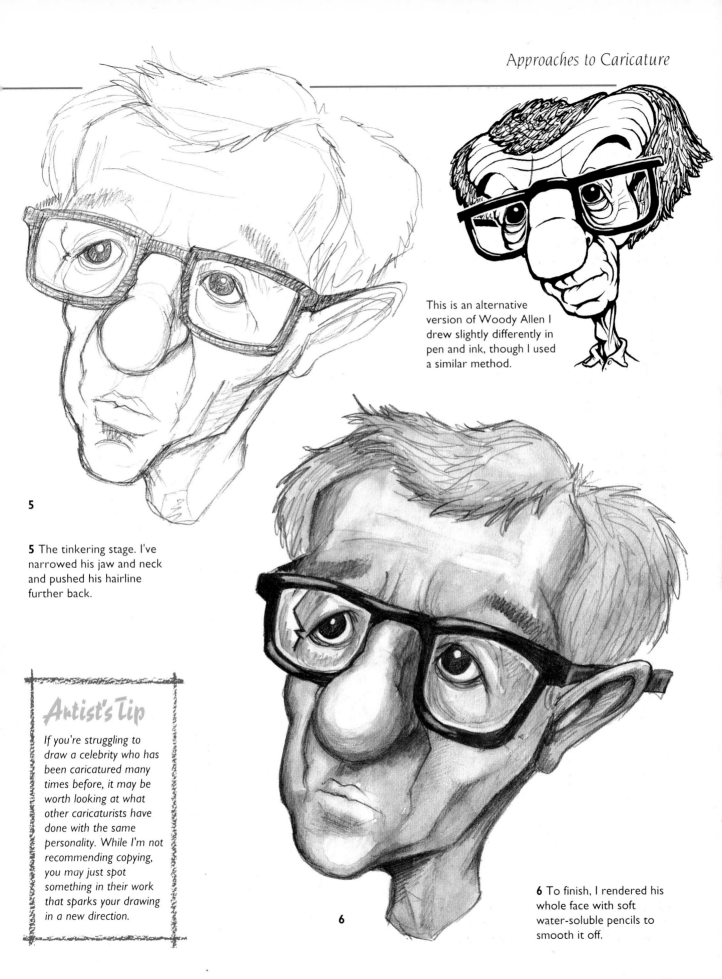

This is an alternative version of Woody Allen I drew slightly differently in pen and ink, though I used a similar method.

5

5 The tinkering stage. I've narrowed his jaw and neck and pushed his hairline further back.

Artist's Tip

If you're struggling to draw a celebrity who has been caricatured many times before, it may be worth looking at what other caricaturists have done with the same personality. While I'm not recommending copying, you may just spot something in their work that sparks your drawing in a new direction.

6

6 To finish, I rendered his whole face with soft water-soluble pencils to smooth it off.

Quick sketch method
This is a good method for tackling someone with an especially animated personality. The idea here is to get as many photographs of your subject as possible and sketch a lot of quick thumbnail-sized drawings. Try different poses, angles, expressions, small studies of particular features and so forth. You should find as you go on that you are picking up certain characteristics from one sketch to the next.

From these you can build up a pretty good idea in your mind of the overall shape of the subject's face and how it moves and flexes under the influences of different emotions. The idea then is to compose your finished caricature from a combination of these sketches, incorporating a bit from this one, an element of that one. With practice you will be able to produce lively caricatures that capture plenty of the subject's personality.

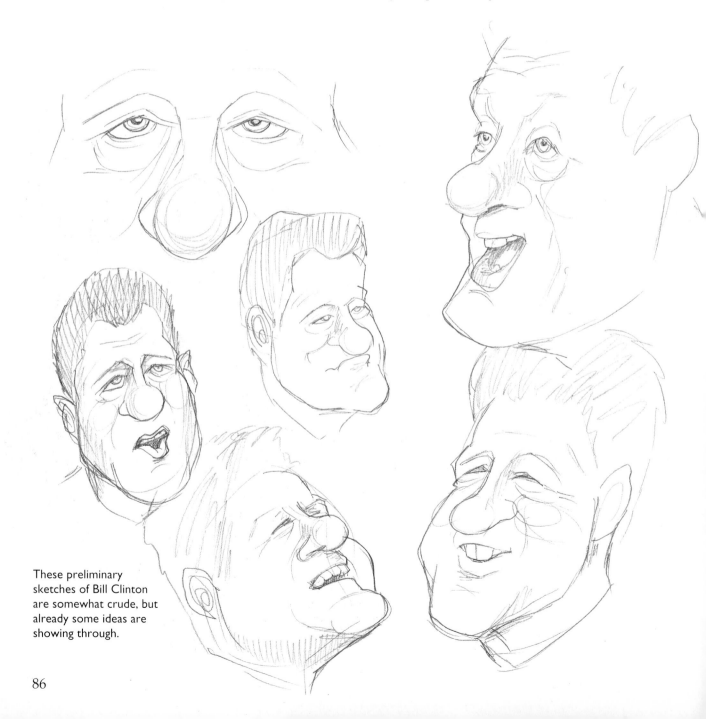

These preliminary sketches of Bill Clinton are somewhat crude, but already some ideas are showing through.

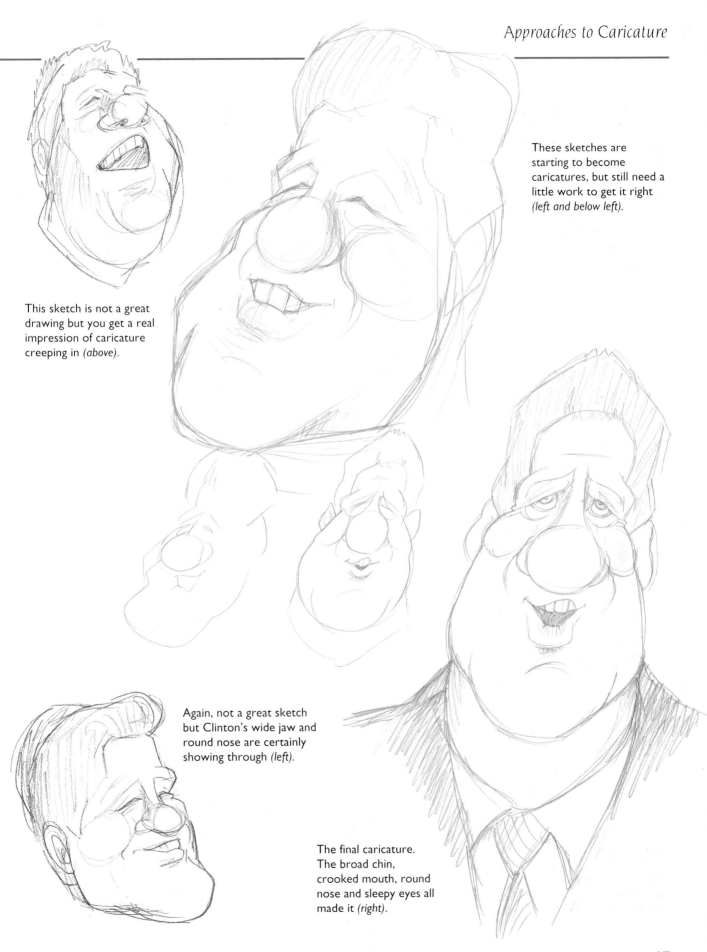

These sketches are starting to become caricatures, but still need a little work to get it right *(left and below left)*.

This sketch is not a great drawing but you get a real impression of caricature creeping in *(above)*.

Again, not a great sketch but Clinton's wide jaw and round nose are certainly showing through *(left)*.

The final caricature. The broad chin, crooked mouth, round nose and sleepy eyes all made it *(right)*.

Cheats and Tricks

Sometimes, no matter how hard you try, you just can't get a caricature to work. It is for this reason that most caricaturists have a few tricks up their sleeve for just such an eventuality. The results are rarely particularly impressive, but they may trigger an idea of how to tackle the caricature. A basic tip is to try tracing an outline of the subject's features on tracing paper, or, simplest of all, just take a break and come back and try again later.

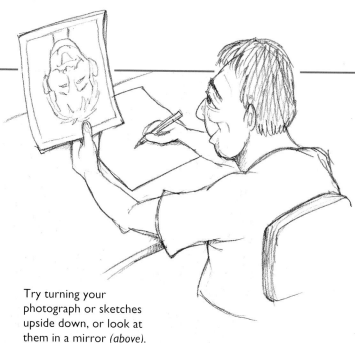

Try turning your photograph or sketches upside down, or look at them in a mirror *(above)*.

If the features look right but are spaced badly, try cutting up the drawing and shuffling the bits around *(right)*.

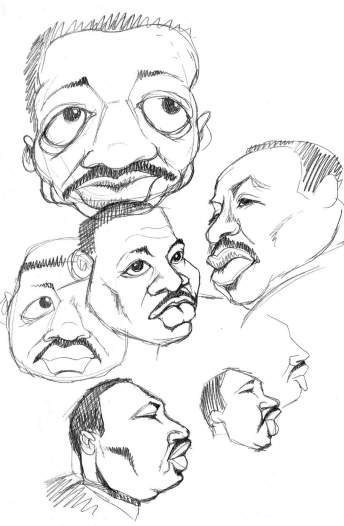

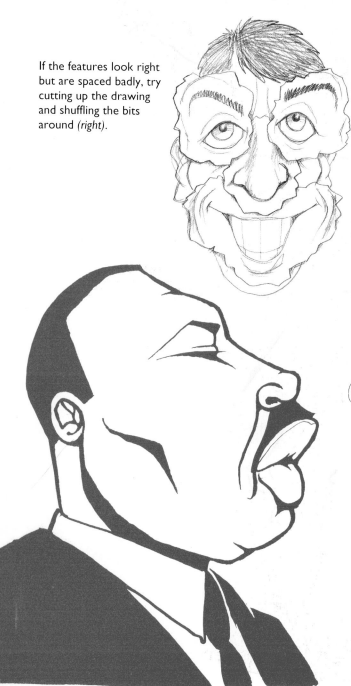

Try a different angle. I had trouble getting Martin Luther King to appear truly statesman-like, so I hit upon drawing him in profile, and it worked *(left and above)*.

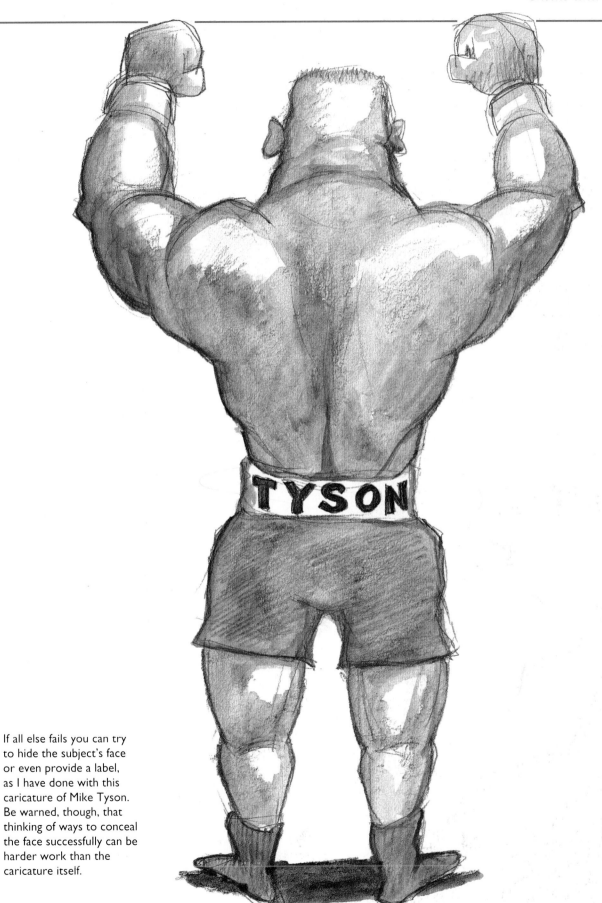

If all else fails you can try
to hide the subject's face
or even provide a label,
as I have done with this
caricature of Mike Tyson.
Be warned, though, that
thinking of ways to conceal
the face successfully can be
harder work than the
caricature itself.

Body Shapes

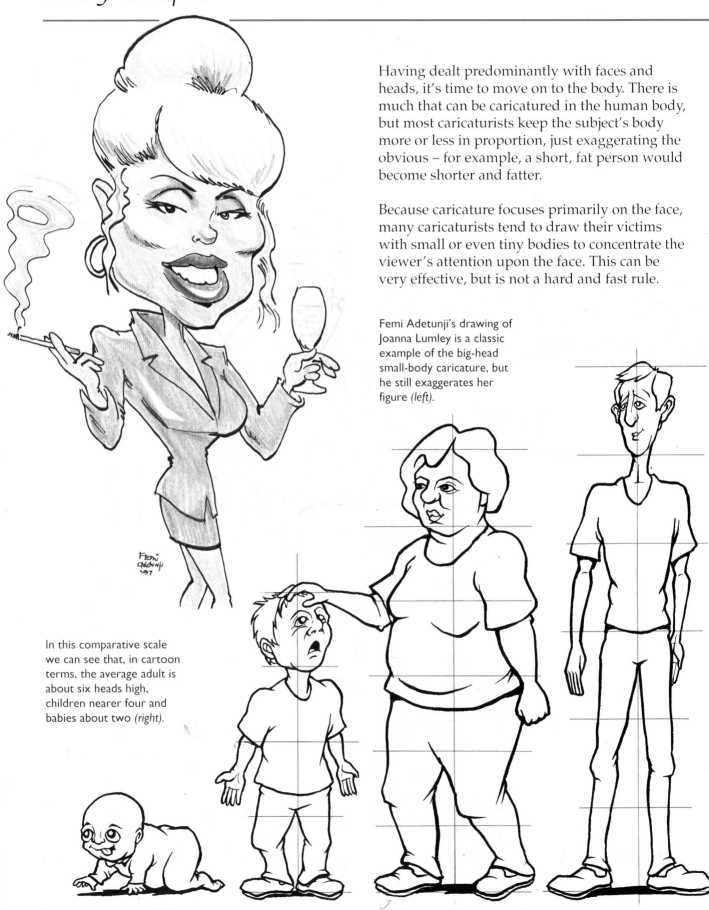

Having dealt predominantly with faces and heads, it's time to move on to the body. There is much that can be caricatured in the human body, but most caricaturists keep the subject's body more or less in proportion, just exaggerating the obvious – for example, a short, fat person would become shorter and fatter.

Because caricature focuses primarily on the face, many caricaturists tend to draw their victims with small or even tiny bodies to concentrate the viewer's attention upon the face. This can be very effective, but is not a hard and fast rule.

Femi Adetunji's drawing of Joanna Lumley is a classic example of the big-head small-body caricature, but he still exaggerates her figure (left).

In this comparative scale we can see that, in cartoon terms, the average adult is about six heads high, children nearer four and babies about two (right).

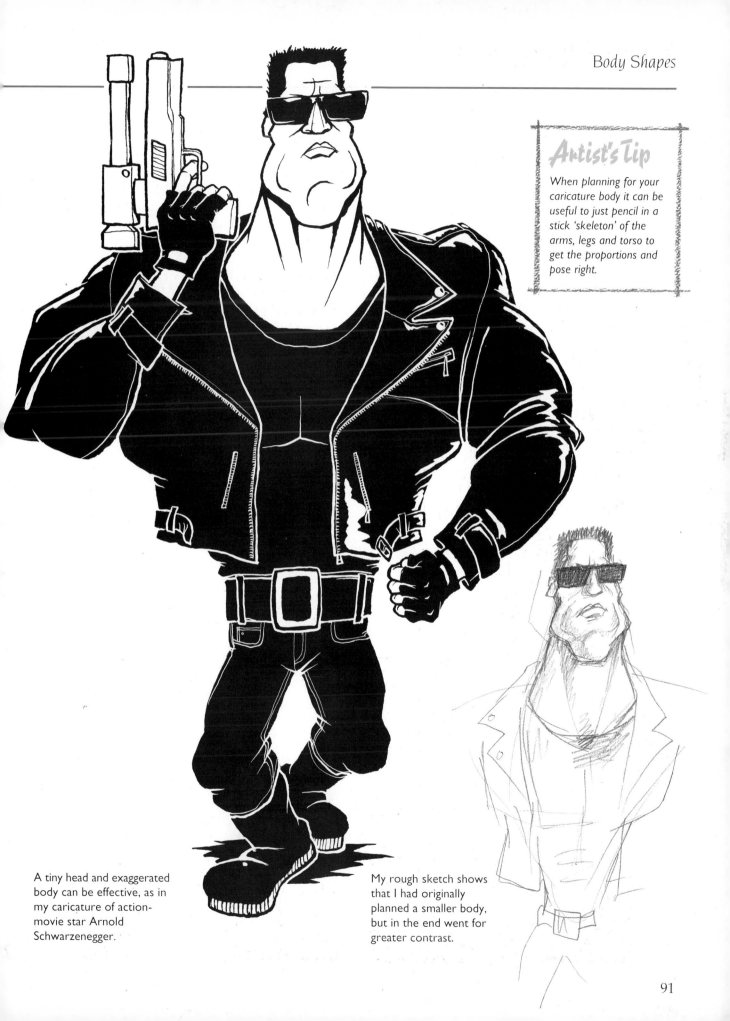

Artist's Tip

When planning for your caricature body it can be useful to just pencil in a stick 'skeleton' of the arms, legs and torso to get the proportions and pose right.

A tiny head and exaggerated body can be effective, as in my caricature of action-movie star Arnold Schwarzenegger.

My rough sketch shows that I had originally planned a smaller body, but in the end went for greater contrast.

Posture and Gesture

As the face has expressions, so the body has posture. You can similarly read a lot from the body language of the way someone stands or sits. From the caricaturist's point of view there are two main sorts of posture: observational and character. Observational postures are obtained by watching how your subjects move and hold themselves, whether they slouch or stand bolt upright.

With a character pose, on the other hand, you may be trying to imply something through the subject's posture – for example, someone known for their intellectual prowess may be pictured in

the pose of Rodin's *The Thinker*, sitting deep in contemplation. Again, this is caricature, so don't be afraid to exaggerate the poses.

It is possible to convey a lot of meaning with just a gesture, but don't forget one gesture or hand signal may seem harmless to you but may imply something entirely different to someone else.

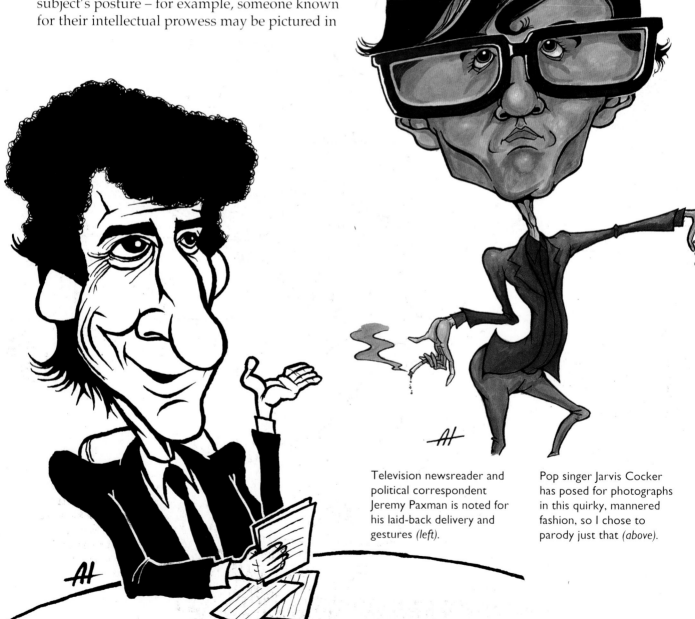

Television newsreader and political correspondent Jeremy Paxman is noted for his laid-back delivery and gestures *(left)*.

Pop singer Jarvis Cocker has posed for photographs in this quirky, mannered fashion, so I chose to parody just that *(above)*.

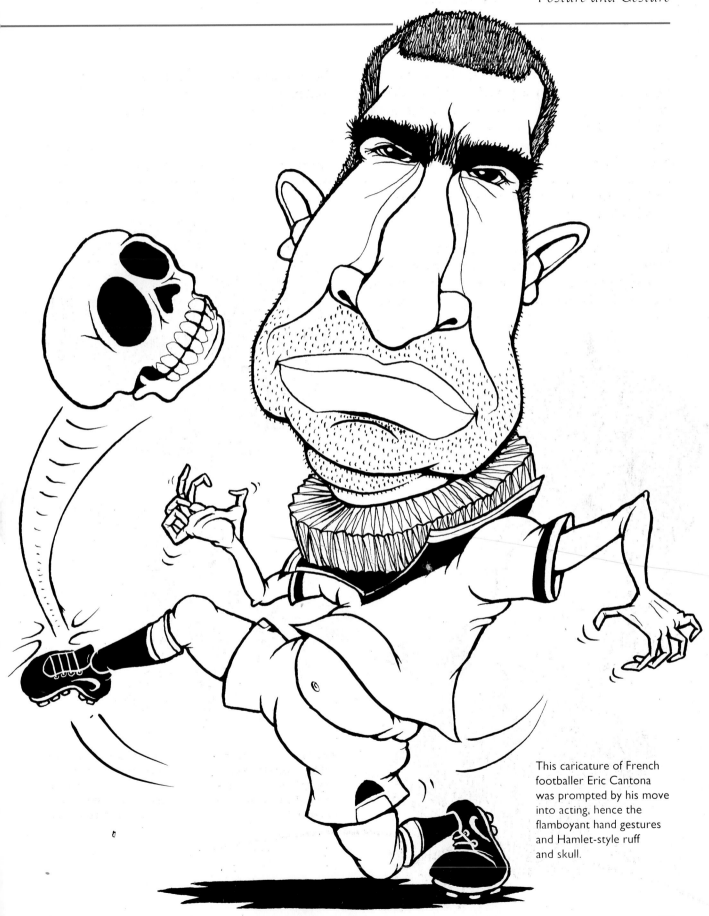

This caricature of French footballer Eric Cantona was prompted by his move into acting, hence the flamboyant hand gestures and Hamlet-style ruff and skull.

Clothes and Costume

They say clothes maketh the man (or woman), and this is even more true for caricature. Unless you draw all your caricatures naked (and you might), you will need to consider how to clothe them appropriately.

There are basically two types of clothes: the ordinary, everyday clothes people may wear, and costumes you choose to imply comment with. For instance, someone prone to making very public mistakes could be drawn in the outfit of a medieval court jester or fool.

Pay particular attention to detail in military uniforms or showy stage costumes as these are usually designed in a particular way for a reason. It is worth doing a little research to get this sort of information right, but don't forget you can still exaggerate those details – such as adding a ridiculous number of medals to a high-ranking military officer.

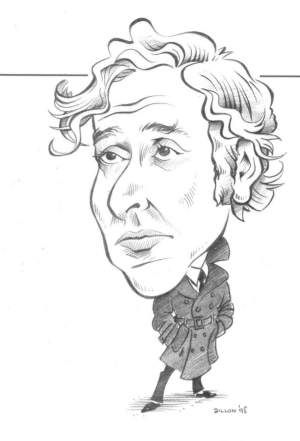

Gary Dillon's subtle caricature of film star Michael Caine pictures him in his spy movie days, overcoat and all (above).

This caricature of the older Las Vegas Elvis Presley by Jonathon Cusick gets his jump suit spot on. Note the cheeseburger designs (below).

This lady represents a sales company that covers Russia, so I chose to draw her in a full Cossack dancer's costume (left).

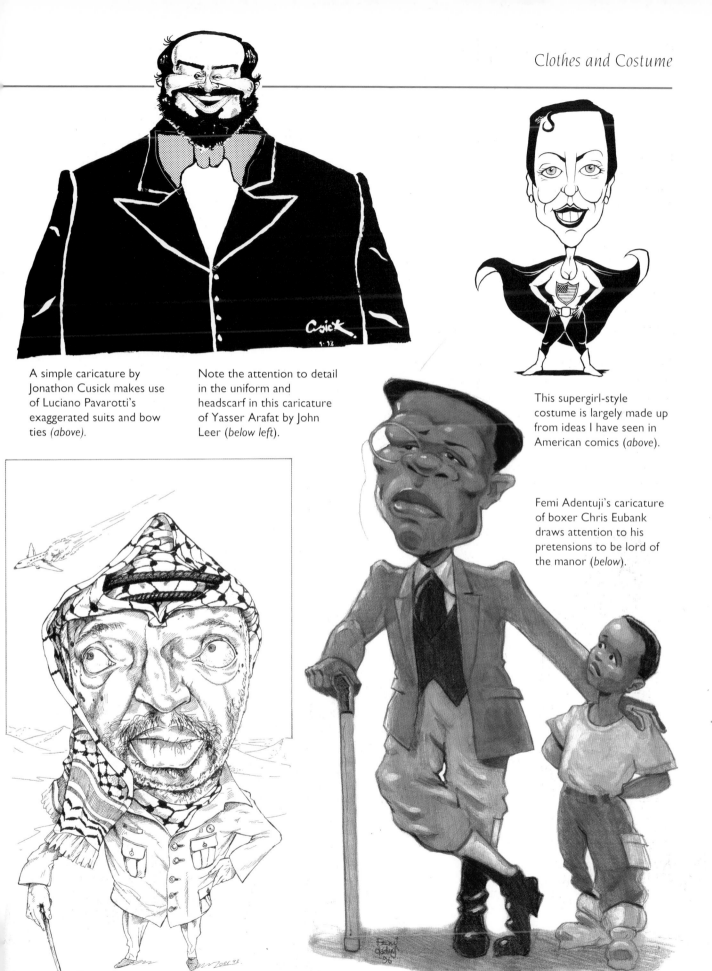

A simple caricature by Jonathon Cusick makes use of Luciano Pavarotti's exaggerated suits and bow ties *(above)*.

Note the attention to detail in the uniform and headscarf in this caricature of Yasser Arafat by John Leer *(below left)*.

This supergirl-style costume is largely made up from ideas I have seen in American comics *(above)*.

Femi Adentuji's caricature of boxer Chris Eubank draws attention to his pretensions to be lord of the manor *(below)*.

Symbols and Props

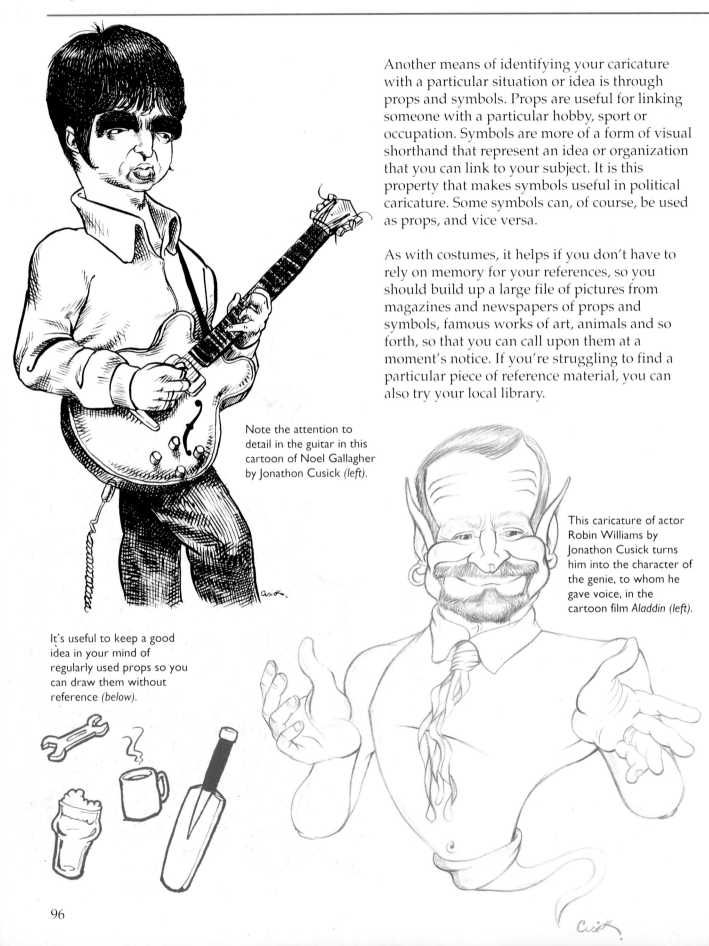

Another means of identifying your caricature with a particular situation or idea is through props and symbols. Props are useful for linking someone with a particular hobby, sport or occupation. Symbols are more of a form of visual shorthand that represent an idea or organization that you can link to your subject. It is this property that makes symbols useful in political caricature. Some symbols can, of course, be used as props, and vice versa.

As with costumes, it helps if you don't have to rely on memory for your references, so you should build up a large file of pictures from magazines and newspapers of props and symbols, famous works of art, animals and so forth, so that you can call upon them at a moment's notice. If you're struggling to find a particular piece of reference material, you can also try your local library.

Note the attention to detail in the guitar in this cartoon of Noel Gallagher by Jonathon Cusick (left).

This caricature of actor Robin Williams by Jonathon Cusick turns him into the character of the genie, to whom he gave voice, in the cartoon film Aladdin (left).

It's useful to keep a good idea in your mind of regularly used props so you can draw them without reference (below).

Props such as these can link someone to a particular hobby or occupation *(right)*. These readily recognizable symbols hold strong connotations. Flags, signs and badges are easy ways to sneak a symbol into your caricature *(below right)*.

Dame Edna Everage's Aussie credentials are reinforced by the use of a koala earring and a map on her bracelet in this caricature by Janet Nunn *(above)*.

The subject of this caricature is a sales rep, so Gary Dillon depicted him in his sports car *(below)*.

In this caricature of Mikhail Gorbachev I turned his distinctive birthmark into a hammer and sickle *(above)*.

Some props act as symbols as well: the cuckoo clock, lederhosen and ice pick place this caricature in Switzerland *(below)*.

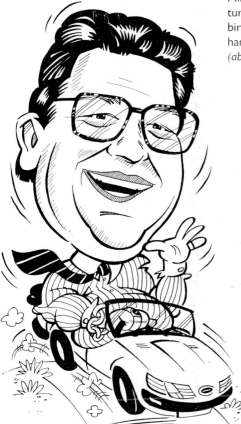

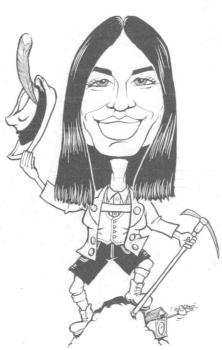

People As Objects

One useful trick you have in your armament is to draw your caricature as an animal. There are several reasons why you might do this. Some animals hold symbolic significance, for instance the bear often represents Russia and the owl represents wisdom. Your subject may own a pet, or they may merely resemble a particular animal – for example, someone with a beaky nose could be drawn as a bird of some description. It is even possible to draw your subject as an inanimate object.

The hard part can be identifying the features on your caricature with features on the object you intend to draw them as. This can be easy with animals, however, as they have corresponding eyes, noses, mouths or beaks. Nevertheless, you will almost certainly have to make a few compromises, either with your caricature or the thing you're turning it into.

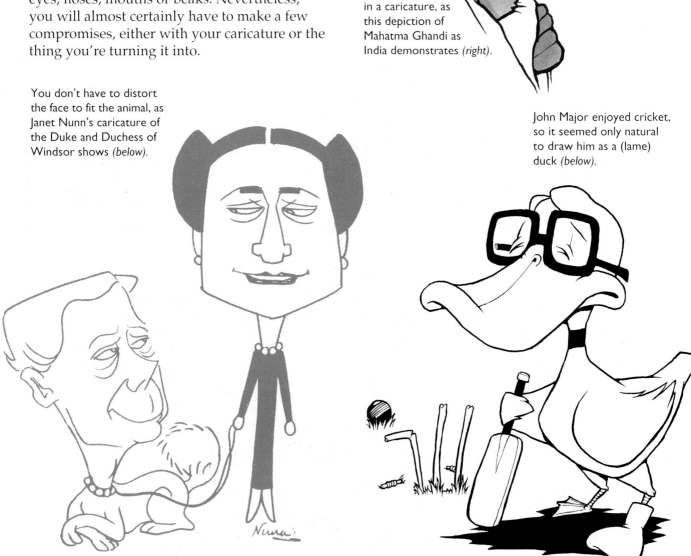

You can incorporate maps in a caricature, as this depiction of Mahatma Ghandi as India demonstrates *(right)*.

You don't have to distort the face to fit the animal, as Janet Nunn's caricature of the Duke and Duchess of Windsor shows *(below)*.

John Major enjoyed cricket, so it seemed only natural to draw him as a (lame) duck *(below)*.

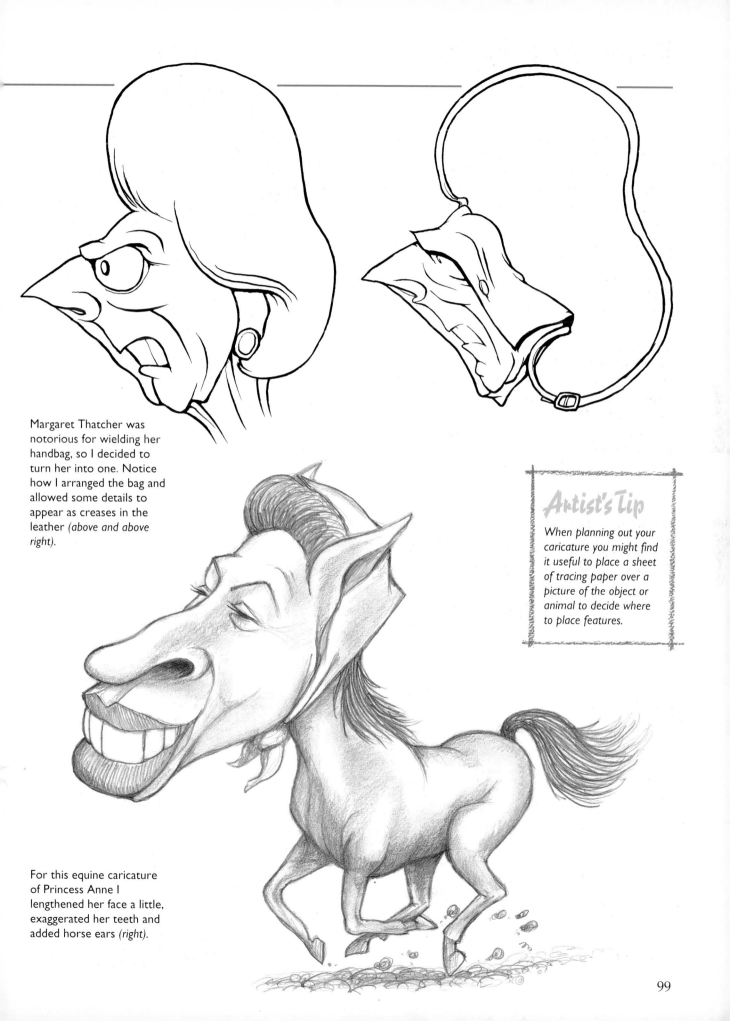

Margaret Thatcher was notorious for wielding her handbag, so I decided to turn her into one. Notice how I arranged the bag and allowed some details to appear as creases in the leather *(above and above right)*.

Artist's Tip

When planning out your caricature you might find it useful to place a sheet of tracing paper over a picture of the object or animal to decide where to place features.

For this equine caricature of Princess Anne I lengthened her face a little, exaggerated her teeth and added horse ears *(right)*.

Caricatures in Setting

The setting of your caricature can sometimes be all-important, especially if you are drawing a political caricature. Backgrounds or scenery can place the caricature in a particular place or time, or you can locate your caricature in all manner of situations, real or imaginary, to make a point or comment.

If you're going to include other people in the caricature, try to keep them in proportion. Also, if these people are 'imaginary', make them look in keeping with the style of the caricature, rather than just using cartoon-style figures. One way of finding models for this purpose is to use caricatures of friends and family, or even of yourself, to 'fill out' crowd scenes.

You can add text to your caricature using speech bubbles, captions or even signs and labels. While I prefer wordless caricatures, sometimes text is unavoidable to get the message across.

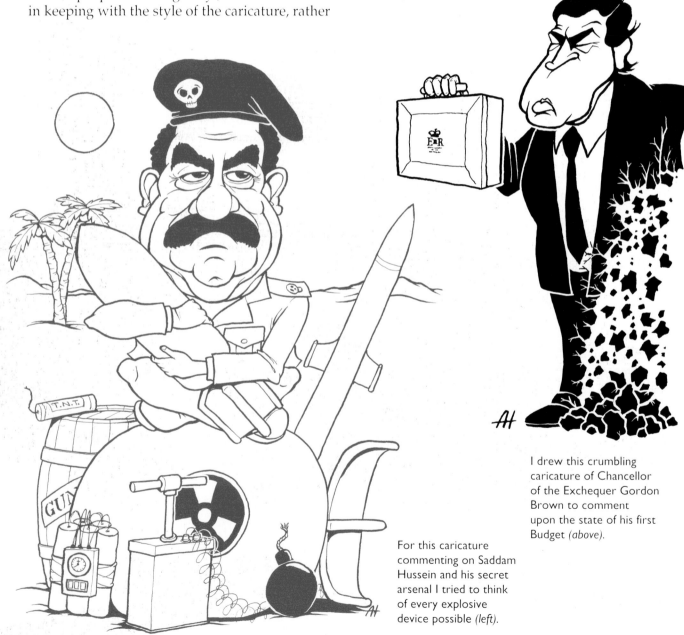

I drew this crumbling caricature of Chancellor of the Exchequer Gordon Brown to comment upon the state of his first Budget (above).

For this caricature commenting on Saddam Hussein and his secret arsenal I tried to think of every explosive device possible (left).

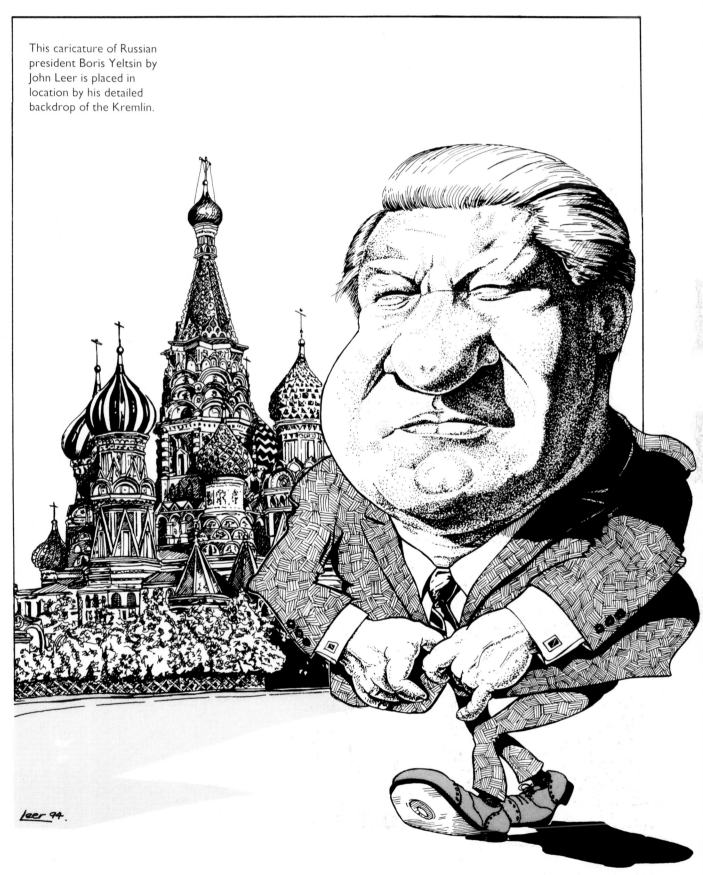

This caricature of Russian president Boris Yeltsin by John Leer is placed in location by his detailed backdrop of the Kremlin.

Leer 94.

COMICS

John Byrne

Body Movement and Gestures

Two elements which separate comic strip art from single panel cartoons are movement and gesture. Certainly you can show characters in individual cartoons participating in all manner of activities, but the whole idea of comic strips is to create the illusion that the characters are moving and coming to life as our eyes move from panel to panel. The illustrator has both to create the illusion of movement and also keep the characters looking the same as they move from panel to panel and pose to pose.

By now it should be obvious that even if you can draw figures 'out of your head', you need to take the time to build them from basic shapes. The shapes will always remain the same no matter what poses your figures are drawn in. It follows, too, that figures based on these shapes will also be much easier to keep recognizable.

Just as the most complicated figures can be broken down into their basic shapes, so the essence of each movement and pose can be captured in a line or two. If you can pin down the sense of a movement in a simple 'gesture drawing' – a quick sketch is sufficient – the sense of movement will remain, no matter how detailed your final artwork.

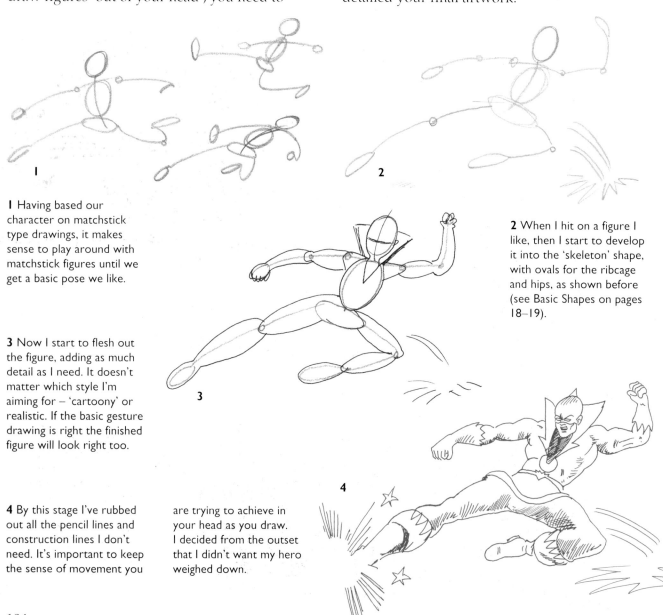

1 Having based our character on matchstick type drawings, it makes sense to play around with matchstick figures until we get a basic pose we like.

2 When I hit on a figure I like, then I start to develop it into the 'skeleton' shape, with ovals for the ribcage and hips, as shown before (see Basic Shapes on pages 18–19).

3 Now I start to flesh out the figure, adding as much detail as I need. It doesn't matter which style I'm aiming for – 'cartoony' or realistic. If the basic gesture drawing is right the finished figure will look right too.

4 By this stage I've rubbed out all the pencil lines and construction lines I don't need. It's important to keep the sense of movement you are trying to achieve in your head as you draw. I decided from the outset that I didn't want my hero weighed down.

Take action

It's often said that most comic strip artists and writers are secretly performers at heart. If you really want to get realistic movement into your drawings, it's time to stop hiding this side of your personality. One of the best ways to work out how to draw a particular movement or gesture is to actually act it out for yourself, or persuade someone else to do it for you. You can then use the 'matchstick people' shown here to capture the spirit of the movement. This will give you a frame onto which you can then build your finished drawing. Fear not, no one need ever know that the soaring super hero or marauding barbarian in your finished strip is actually you leaping around your bedroom!

Good gesture drawing isn't just important from a technical point of view, either. As we've already seen, comic strip art isn't solely about producing good drawings – it's about telling stories, and gestures play just as important a part in bringing your characters to life and describing how they are feeling as their expressions and what they say. Try to become a keen observer of how real people walk, talk and move and you'll find many useful gestures that you can use in your comic strip world.

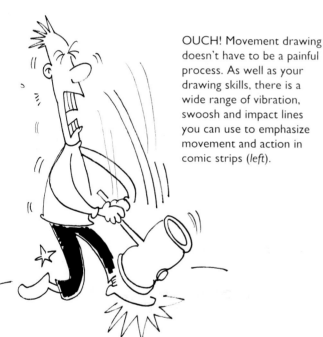

OUCH! Movement drawing doesn't have to be a painful process. As well as your drawing skills, there is a wide range of vibration, swoosh and impact lines you can use to emphasize movement and action in comic strips (*left*).

Don't be afraid to accentuate movement. Our characters don't just run, they run as if their lives depend on it (*above*).

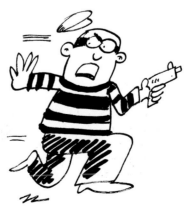

As well as getting your characters from place to place, movement and gesture can be important storytelling elements in themselves. Can you suggest what these characters (*left*) might be saying just from the gestures they are making?

Creating Your Own Characters

Super-heroes with amazing powers are, of course, a standard ingredient of many comic books. The only problem when it comes to creating new ones is that over the years it seems that virtually every variation on the theme has been explored! Don't worry – it's not just the basic idea of your character that will make it stand out. It's how you bring your individual drawing style to bear on that idea. Don't worry either if you don't get your character's 'look' right at the first attempt. If possible, take a look at some early editions of comics featuring world famous characters. Compare the initial drawings of these figures with those in the latest issues on sale today and you'll see that even the most recognizable characters have changed subtly in appearance through the years. Like any fine wine, a good character needs time to develop.

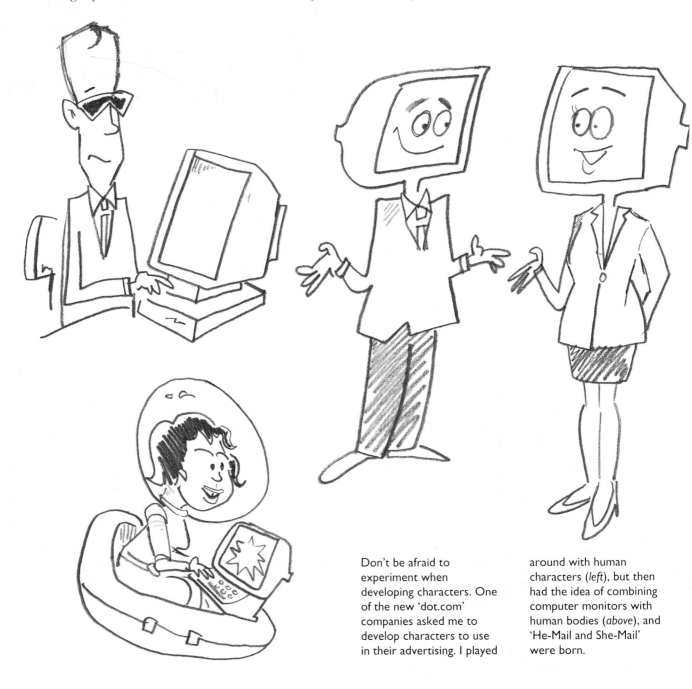

Don't be afraid to experiment when developing characters. One of the new 'dot.com' companies asked me to develop characters to use in their advertising. I played around with human characters (*left*), but then had the idea of combining computer monitors with human bodies (*above*), and 'He-Mail and She-Mail' were born.

Be ambitious

Perhaps one day a character of yours will be just as famous as one of the big comic stars. For this to happen you'll need to play around with lots of ideas until you get a character who fascinates and excites you. It is very important that you should feel this strongly. After all, the two of you may have to live together for many years to come.

To develop a character with the strength of a gorilla, I went back to basics, or rather to the zoo, where I did this quick sketch of a gorilla to give me ideas (*above*).

It's not just the size of the gorilla that's distinctive – the stance is, too. I adapted my basic gesture drawing accordingly (*left*) ...

Artist's Tip

Don't simply copy existing comic characters. Use them to inspire you to create distinctive characters of your own.

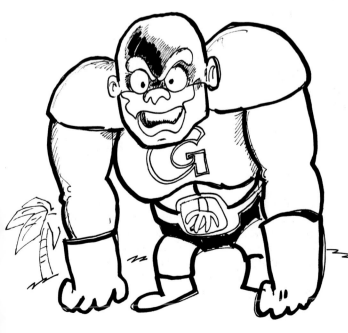

... and it was then easy to build my character on top. As you can see (*left*), wrong-doing drives him bananas.

Expression

I like to think of the characters in my comic strips as actors, and the more emotion they can convey the more exciting, funny or moving my comic strip stories will be. Yes, of course we use words in our comic strips too, and later on we'll be looking at how speech balloons and lettering can help tell the story, but comics are still primarily a visual medium and space for letters is always limited, so the more you can convey emotions through the actual character drawing the better.

Just as a good comic artist uses their own body as a model for movement and character poses, the best reference material for your character's expressions is your own expressions. Use a small mirror to help you capture them. Don't be afraid to experiment with expressions, by pulling faces. The comic artist routinely uses these methods.

That 'larger than life' aspect also applies to the expressions of your characters. In real life there may not be much difference between, say, our expression when we're interested in something or when we're bored, unless we're at the extremes of these states. In comics, any uncertainty as to how characters are feeling will confuse the reader and take away from the illusion of reality. It's important – and much more fun! – to exaggerate expressions and leave no doubt about the feelings they are communicating.

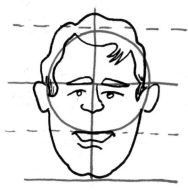

Before we learn to draw expressions, we have to master drawing heads (*above*). Luckily, just like the basic figure, the head can be broken down into simple parts. Start off with a circle and divide it into four, then draw another line a half circle's distance below to mark the chin. We can now use this guideline to draw our face. Note that the eyebrows fall on the line that goes from the tips of the ears across, while the tip of the nose lands on the line that touches the bottom of each ear. If you were to draw a straight line down from the pupil of each eye, it should hit the corners of the mouth. Faces can be round, square, fat or thin, but these basic positioning rules apply whatever the shape of the face.

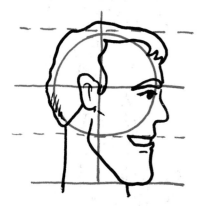

For the comic artist, keeping to the rules of proportion is particularly important, because once you establish your proportions you can turn the head left, right and in any position between while keeping your character looking the same.

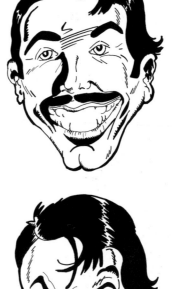

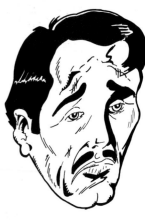

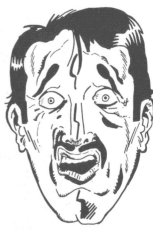

Happy, sad, angry, scared – these basic emotions are very easy to portray, as you can see from the above. The trick is to keep your character recognizable throughout a range of expression changes. Distinctive facial features, such as a moustache, help.

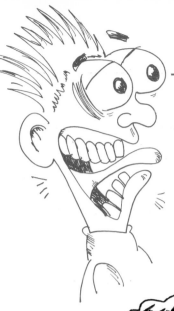

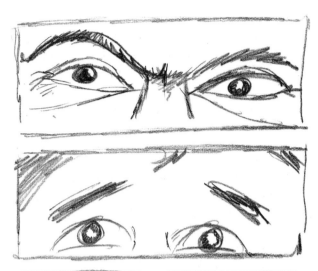

Humour comics allow you to go to town on creating larger than life characters. Here is 'surprise' taken to an extreme. Now see if you can surprise yourself by taking some of the expressions on these pages and exaggerating them. See how far you can go.

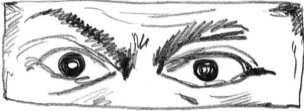

Comic panels often focus closely on individual details for dramatic effect. Once you've experimented with full-face expressions, try to convey equally strong feelings using one feature alone (*above*).

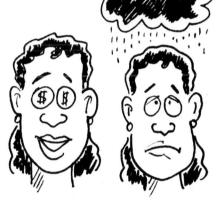

It's good drawing practice to try to convey emotions using expression alone. Comic artists have come up with a whole vocabulary of symbols to instantly communicate emotions and feelings, from greed to depression, from being in love (*above*) to being lovesick (*below left*). When looking through your collection of comics, keep your eyes open for such symbols. Learning them will help you in future work.

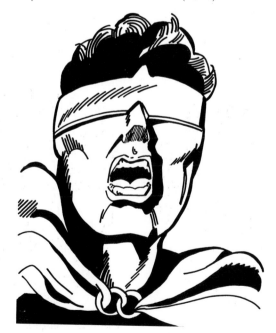

Next, try putting the 'message' across using only the bottom half of the face. Practise this technique so that you are able to convey emotion even when a character is masked or, as here (*above*), blindfolded.

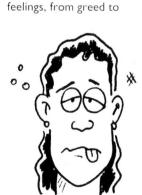

In reality animals don't own the same rich expressive possibilities as humans. In comic strips they tell us as much as any human can.

'Human' Animals

While you can create an endless range of human 'actors' for your comic strips using the simple techniques in this book, your casting doesn't have to be limited to super-heroes, barbarians, football players and detectives. In the comic strip world talking mice, rabbits and big bad wolves are just as likely to pop up as these staple characters. In fact, some of the most famous and enduring characters in cartoons and comic strips are animals.

1 We start our animal drawings just the same as our human ones – with a basic figure in whatever pose we desire.

2 Once we have the basic figure, it's easy to develop the animal characteristics.

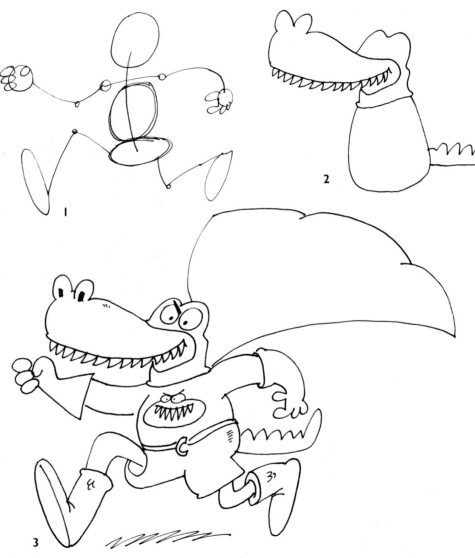

3 How much like a human or an animal you want your character to behave is entirely a matter of taste.

Once you've mastered human expressions, it really isn't very difficult to apply the same expressions to animal faces (*right*).

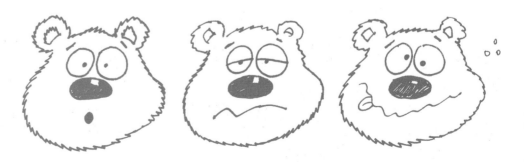

Anthropomorphism

We have already looked at the basic methods of anthropomorphism – giving animals human characteristics (see pages 36–7). As you'll see from the pictures on this page, the same techniques you have been using to draw people can be adapted to the animal kingdom with very little extra effort. This process can also be extended to virtually any inanimate object. You can play around with them in the same way, bringing them to life and weaving comic strip stories round them.

From an apple (*above*) to an entire building (*below*), no object is too big or small to benefit from a touch of anthropomorphism!

Story ideas can arise from putting several different animal characters to work on one task – for example, decorating – and seeing how anteaters, lions, octopuses or whatever creatures YOU pick would bring their individual talents to bear on the job.

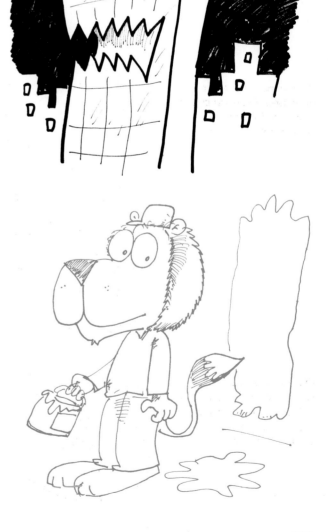

Perspective and Foreshortening

If you want to bring your comic strip world fully to life, you'll have to create the illusion that it has depth and distance, just like in the real world. That's where the rules of perspective come into play. Very simply, perspective means that objects which are nearer to us will look larger, while those which are further away will look smaller. In comic strips characters, objects and backgrounds float around, so you'll need guidelines for keeping them in place.

As you can see from the pencil sketch (*below, top*), all lines in the picture vanish at a single point on the horizon line which is known as the 'vanishing point'. This is called 'single-point' perspective. If you construct the buildings using the same lines as guidance the illusion of depth is easy to achieve. If you want to show angles and corners you will need to use 'two-point' perspective (*bottom*). Once again the sketch on the right shows that the drawing is constructed on lines vanishing to two points on the horizon line, on either side of the scene.

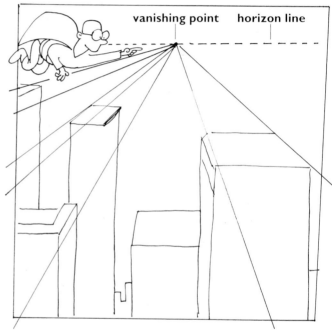

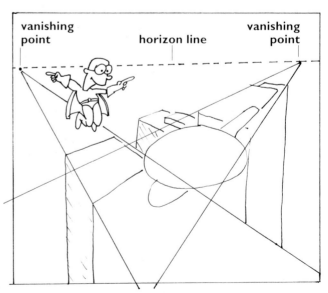

Vanishing points

The best way to achieve perspective in your work is to imagine that you are standing inside your drawing and think about where the horizon or eye-level line will be. That's the point at which objects in the distance seem to disappear and is referred to by artists as the 'vanishing point'. Once you have established where your vanishing point is, it's a relatively easy matter to rough in guidelines to ensure that everything in your drawing stays properly in perspective. In comics, of course, some pictures may have more than one vanishing point, but don't worry – the basic principle remains the same. In the pictures on these pages you'll see three different kinds of perspective which are routinely used in comics, with guidance on how to get the most from each of them. To add drama and excitement perspective can be exaggerated and distorted. This is a technique often used in comics.

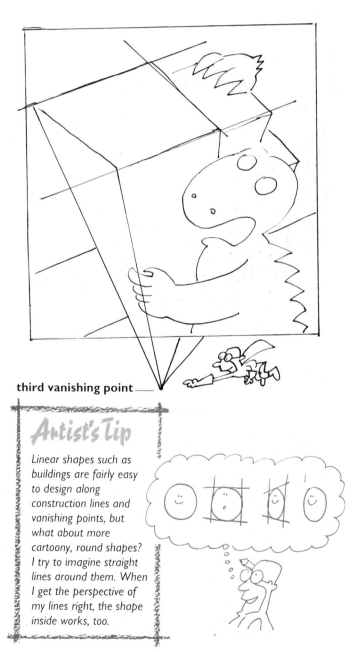

third vanishing point

Since the world of comics is larger than life, it is often necessary to show taller-than-tall buildings, extra-large monsters or simply to view the action from a highly dramatic angle. That's where 'three-point' perspective comes in handy. In addition to the two vanishing points we have used before there's a third vanishing point, which, as shown in this picture (*above*), is placed outside the picture frame. See if you can use the same technique to construct dramatic drops or dizzying heights in your strip.

Artist's Tip

Linear shapes such as buildings are fairly easy to design along construction lines and vanishing points, but what about more cartoony, round shapes? I try to imagine straight lines around them. When I get the perspective of my lines right, the shape inside works, too.

Perspective is important when it comes to making your comic strip world look more 'real'. But comic strips aren't real, and quite a lot of the techniques we use as comic artists are basically tricks to fool the eye and the mind into seeing drama, action and excitement in what are essentially flat, static drawings on a white sheet of paper. The 'larger than life' aspect of comics is one that I've stressed throughout. In order to achieve exciting effects, it's often important to exaggerate the techniques that are at our disposal. Now you have seen the benefits of perspective in practice, let's look at a very important technique associated with it.

Foreshortening

The term foreshortening is used to describe the fact that objects which are closer to us are drawn larger than objects which are further away. It follows that foreshortening also applies to parts of objects: if a super-hero swings his fist in our direction, the fist which is nearer to us will be drawn bigger then the rest of his arm. In comics, though, this simple rule is taken to extremes to produce dramatic effects. As you can see from the examples shown here, although the final effect may be exaggerated, it is achieved using the same basic, logical steps employed on more realistic drawings.

Now this is what I call road rage (*above*)! Subtle use of foreshortening helps make scenes like this one more believable ...

Artist's Tip

It's best to experiment with perspective and foreshortening in rough before finally inking in your drawing. But, it's still easy to make a mess of one drawing and ruin the whole page. If this should happen, simply redraw the panel and carefully stick it over the original.

... unlike this blobby science fiction creature (*right*), whose limbs have grown alarmingly bigger.

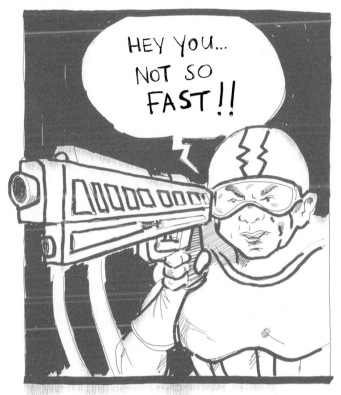

The classic 'looking down the barrel of a gun' shot uses foreshortening to good effect. Note here (*above*) that having the gun protrude from the panel enhances the effect. The pencil version (*above right*) shows how breaking the gun into simple geometric shapes makes the end result possible.

Experimenting with foreshortening will help you to judge what looks right. It's obvious that the exaggerated hands and feet of this hero (*right*) look bigger to emphasize that he's rushing towards us.

Backgrounds

Backgrounds in comics are a lot more than just locations in which your stories take place. The right background can add tremendously to the mood and feel of your story – it can even change the effect of your story altogether. Imagine a murder mystery where the climax is set in a spooky old mansion, and then consider the same plot being played out in a bouncy castle.

Study backgrounds and locations

Just as with clothing and props the trick with comic backgrounds is to make them an important part of the story without having them overpower either the characters or the plot. Once again it's important to study as many backgrounds and locations as possible, both in published comic books and in real life. This will help you identify the kind of telling details that will immediately set the scene and plant the location so firmly in the reader's mind that, later in the comic strip, you may be able to play up the important action and drop the background.

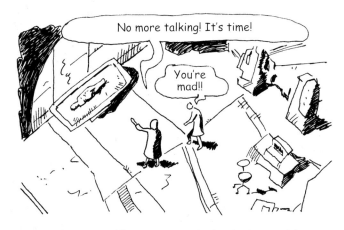

Less is often more. The establishing scene at the top of the strip opposite shows a cityscape. As we 'zoom in' through the strip, the background detail recedes. In the panel from later in the same story (*above*), we get another look at the location, but from a different angle, heightening the drama.

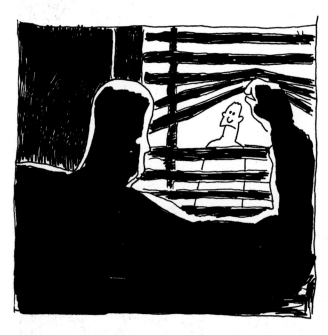

As well as the details of the scene, you can use shadow and lighting effects to add to the mood (*above*).

Since space is at such a premium in comic strips, it's useful to be able to set a scene with a minimum of detail. In this series (*above and right*), distinctive windows create a church, ship and prison scene.

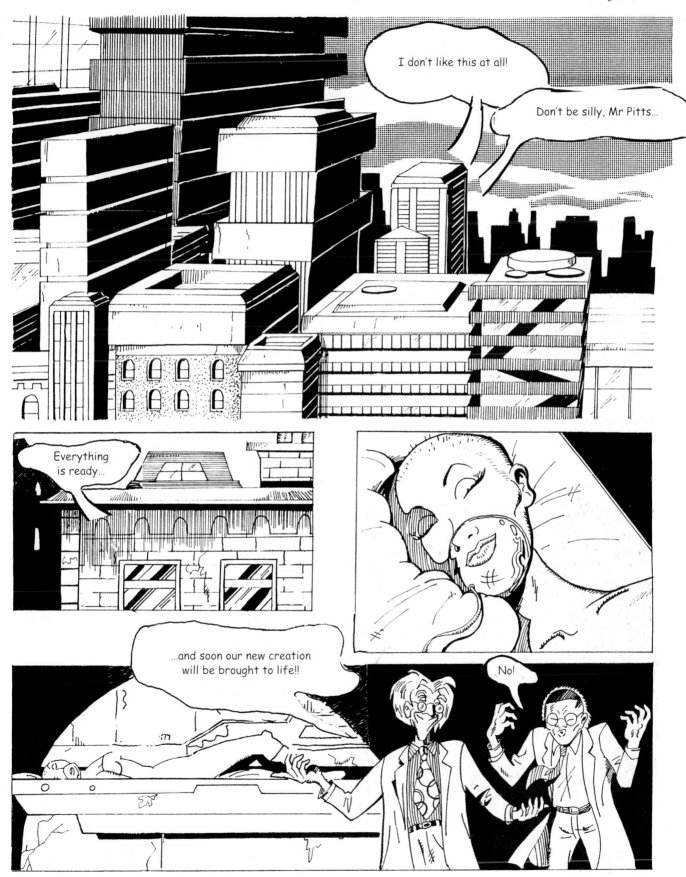

Speech Balloons

Although there have been some very successful comic strips created using pictures alone, it is in its ability to combine words and pictures that the comic strip really comes into its own. Most people associate 'speech bubbles' or 'speech balloons' with comics. In fact, artists have been using these devices to convey dialogue for a very long time, certainly since the days of the Bayeux Tapestry, and back even further into Ancient Egyptian times. Speech balloons have become an important – and expanding – part of the comic artist's tool box. A whole range of different balloons has been developed and is available for you to use to convey feelings and

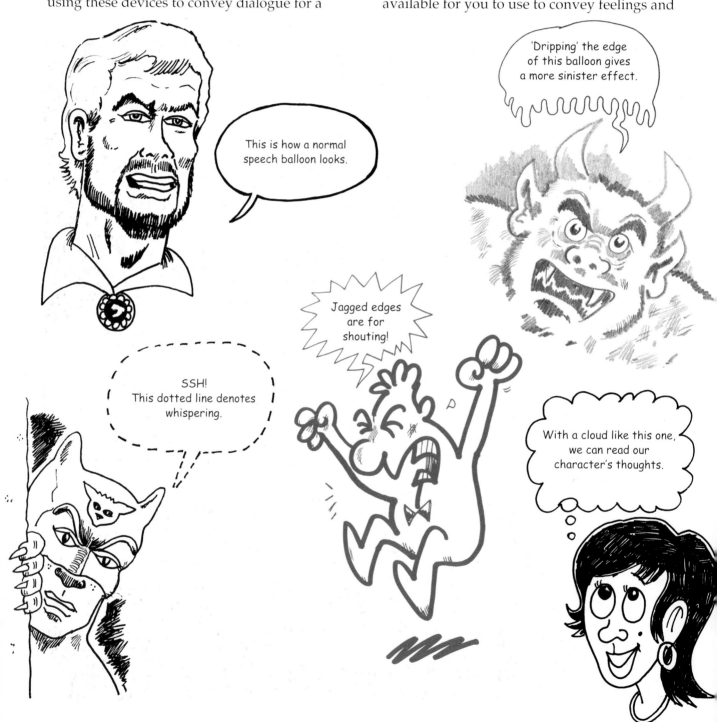

emotions. As with cartoons, the design of the balloon can tell us how a character is feeling, even before we get round to reading the words. On these pages I have shown some of the most common types of speech balloon, but you will come across many others. When you see a new balloon device that you like, consider its effect and then try using it in your own work. Don't be afraid to attempt creating new balloon designs of your own, either. After all, comic strips are a living artform and you are just as entitled as anyone else to have your say as to how the artform should develop, through every aspect of your work, including speech balloons.

This is one of the most common mistakes rookie comic artists make with speech balloons (*above*) – confusing the sequence of speech. Always put the formation you want read first on the left, unless you have room for this sneaky trick (*right*).

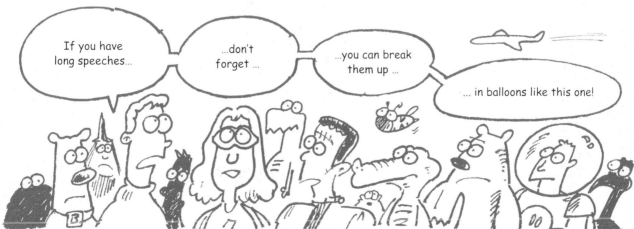

Lettering and Type

Comic strip lettering isn't just confined to speech balloons. In comic strips we try to portray every aspect of our imaginary worlds visually, and that goes for all the Whams! Pows! Crashes! and Bangs! that occur there, too. When lettering your comic strip, you should strive to be every bit as creative as you are when you are drawing the pictures. Once again, these pages show just a small fraction of the different lettering effects and types available to help you tell your story more effectively.

It goes without saying that an exciting or innovative lettering effect is not always the most suitable for conveying meaning. Your lettering won't work – and you won't have achieved what should be your main aim – unless the reader can actually see what the word is. Spending time on basic planning and preparation in this area will give you the freedom to be creative.

You can build your letters in the same way as you draw your figures.
Start off with basic shapes in pencil (1). Then firm and straighten up the edges (2). You can add extra effects, such as flashes, to suit your story (3), or a 'drop shadow' to make your letters appear more three-dimensional (4).

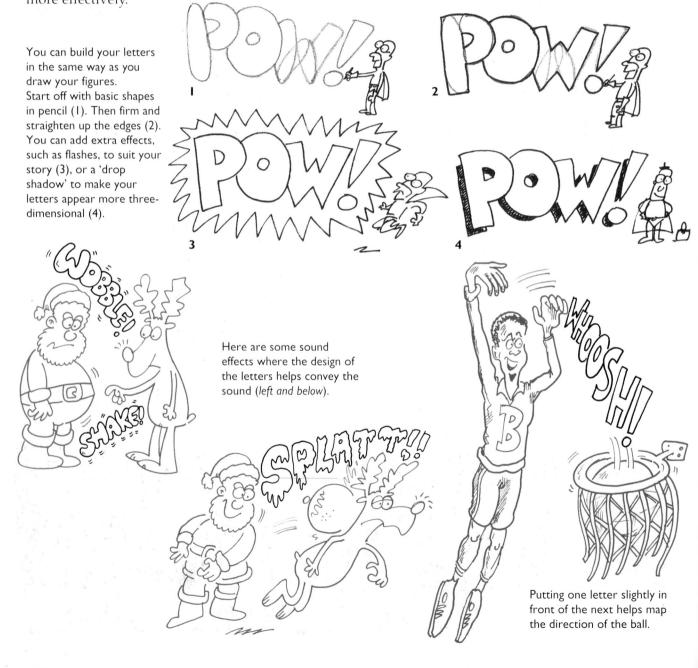

Here are some sound effects where the design of the letters helps convey the sound (*left and below*).

Putting one letter slightly in front of the next helps map the direction of the ball.

DYNAMO!

WOODEN MAN!

These comic characters (*above and right*) have logos which match their distinctive costumes and super powers. Note how wood and steel effects may be created simply by adding a few lines and dots.

HORROR STORY

With a little imagination sound-effects lettering can almost become part of the story, as in the horror effect here (*below*). If you try this, don't 'drip' the letters so much that they are unreadable.

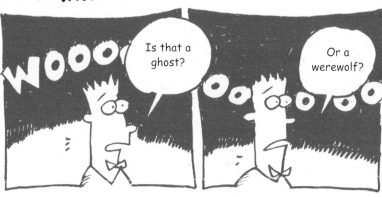

WOOOO

Is that a ghost?

Or a werewolf?

It's worse...

A vampire with toothache!

Special Effects

Who can say how many comic strips have been drawn over the years and how many amazing adventures and fascinating tales told? The need to make each new comic story fresh, different and visually exciting means that artists have developed an amazing range of special effects to bring the two-dimensional world of the comic strip to life on the page.

In this section you'll come across some of the most common effects, but the more comics you study the more visual devices you'll add to your collection. From a planet exploding to a journey into the heart of an atom, no matter what visual challenge your story poses, you can be sure that some artists will have found a way to capture the effect in pen and ink.

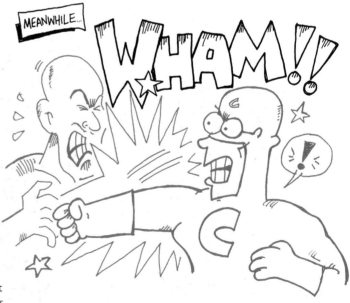

Tracing this figure several times gives the impression of great speed (*above*); the weight of the lines becomes lighter as the images recede.

OOPS! Drawing multiple arms gives the impression of frantic waving (*above*).

In comics it's not just the visual sense that's visual – here's how to show a particularly smelly piece of cheese.

Impact flashes don't just help emphasize punches, kicks and elbows. By masking any real violence, they let the reader's imagination do the work.

Going it alone

If there is an effect you want to portray and you can't find an existing visual device, you can always have a go at creating something of your own. Bear in mind that all of the 'standard' cartoon symbols – from speech balloons to lightbulbs over the head – had to be created by someone, somewhere. If you are wanting to convey a new effect, you may have to try several different versions before you find one that works. Try your ideas out on potential readers, but bear in mind that what you say when you test your work has a big impact on the usefulness of the answers you get. The question "Does this picture show that the person is dizzy?" will usually get a polite "yes", no matter what your 'guinea pig' actually thinks. A more telling way of gauging the effectiveness of your style is to ask, "What do you think the person in this picture is feeling?".

Here's a transformation effect (*below*) that works by showing each stage of the change simultaneously.

Here's a thought balloon special effect (*above*) which not only shows us what the character is dreaming but actually illustrates it as well!

Artist's Tip

Don't let what you think you can or can't draw limit your story ideas. No matter what you need to draw, every object can be broken down into simple shapes!

Specialist special effects

Even beginner readers should be able to work out that diagonal lines slashed across a picture indicate driving rain or sleet, but unless you have seen the 'dotted line' method of indicating invisibility used in another comic strip it might not be clear from the picture alone exactly what is going on. In fact, you could be forgiven for thinking that the artist is using a faulty pen. If you're unsure whether the visual image alone is getting your message across, for clarity it might be worth adding a reference to what's going on in one of the speech balloons as well.

A special visual language

When you are searching your comic collection for special effects you can use in your own work, bear in mind that precisely because comic strip art has a special visual language all of its own, not all effects will be understood by everybody.

Comic books have always been full of mysterious rays, such as laser beams or 'power vision'. Make sure you put enough detail in your drawings to show up the white space and straight lines of your ray effects (*above*).

Here's a pretty shocking effect that should be familiar to fans of cat-and-mouse type cartoons.

This character (*above*) is literally 'blowing his top'. How many well-known expressions can you turn into cartoon effects?

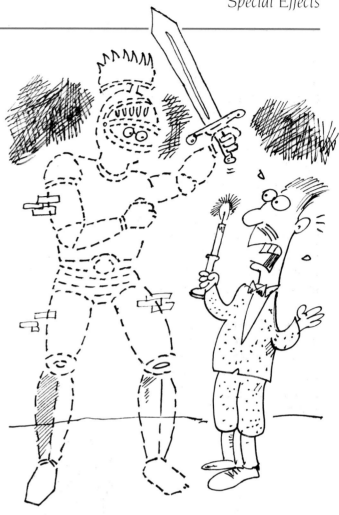

As the saying goes, two heads are better than one (*above*), especially if you want to draw someone looking rapidly from side to side doing a 'double take'.

Whatever the weather – hail, rain or snow, your friendly neighbourhood super-hero is always on the job. Don't forget to draw the rain with a thin nib so you can still see him through the storm.

A dotted line (*above*) is standard cartoon shorthand for invisibility. It's simpler to draw the character in continuous line first and then, to achieve the effect, trace the dotted version over the top.

Artist's Tip

There are no rights or wrongs in cartooning. Look at enough comics and you'll find quite a few different ways of showing the same effect. If the classic 'dotted line' effect isn't good enough for your drawings, try inventing your own way of depicting invisibility.

Creating a Grid

By now it should be clear that almost anything can happen in a comic strip story. Of course, everything that does happen has to happen within the confines of the basic comic page, and that's why creating a grid beforehand makes life so much easier.

If you're like me and straight lines are your least favourite artistic elements, you might feel that having to work with a ruler is closer to maths homework than creative expression. Believe me, the short time you spend drawing up your grid will allow you a lot more freedom when it comes to telling your comic story. Whether you're using many regular-shaped panels, throwing in a couple of 'widescreen' or special-effects type pictures, or even dispensing with panel outlines altogether, basing all your pages on the same

grid will ensure that the story as a whole hangs together visually. It will also ensure that you don't forget vital details – such as page numbers – and, most importantly, that you don't run out of space just before your dramatic closing scene (or, worse, have a whole lot of blank space left AFTER your story has ended).

You can draw up your grid using the model provided on the opposite page, adjusting the size to suit your requirements. Alternatively, you could design your own grid completely from scratch. The grid can be used as a guideline for your artwork, and reused for each page.

When you have your grid, lay a sheet of drawing paper over it and map out the shapes for each frame of your story.

The number of ways you can design your comic page, and the combinations of panel size you can use, are almost infinite. Don't be afraid to try different approaches for the same scene to see which one works best. The comic strips on pages 138 and 139 show how versatile a grid can be.

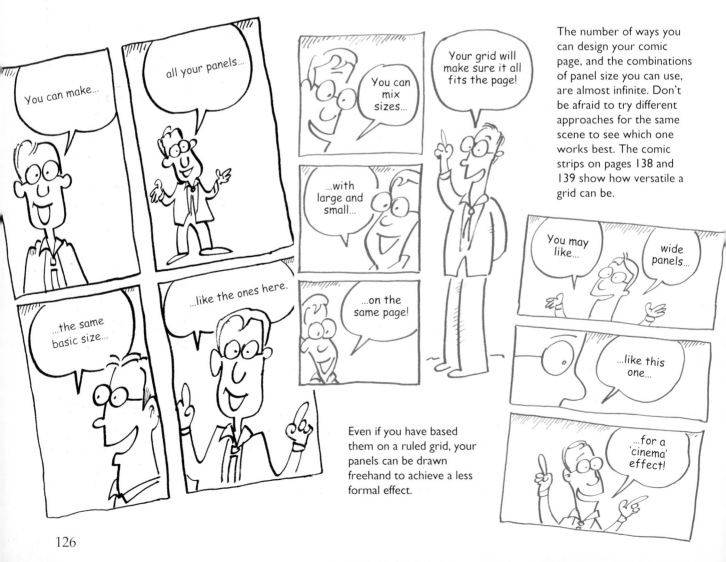

Even if you have based them on a ruled grid, your panels can be drawn freehand to achieve a less formal effect.

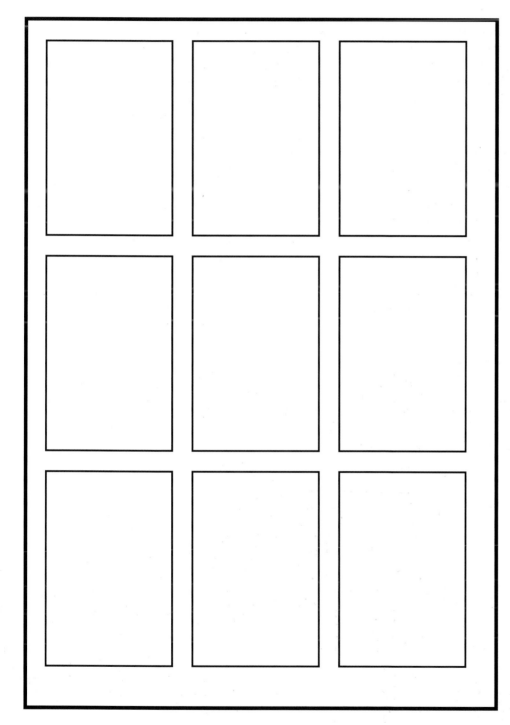

The grid shown above is based on a reduction of an A4 page. It represents a single, right-hand page. The top margin and the left (inside) margin are smaller than the right (outside) margin and the bottom margin. This will make the double-page spread look balanced when the left-hand and right-hand pages are seen facing each other. You can use some of this margin space and the space between the panels to incorporate jagged edges or other special effects in your strip. Don't forget that the panels can be joined or split up to vary their size.

Creating Time

Throughout this book we have observed the ways in which comic strip storytelling is similar to movies and TV. But there is one thing that the comics medium can do even better than moving pictures, and that is to play with time itself. Speeding up time, slowing down time, freezing a moment or object, even showing several things happening at once – all these things are possible in a comic strip with creative use of the grid. As well as being a useful story-telling device, being able to stretch out or condense actions or periods of time can come in handy when you are trying to make sure that your comic story exactly fits the number of pages you have available to tell it in.

Of course, like any 'box of tricks' it is possible to spoil the effect you are trying to create with these techniques – for example, by using too many of them at once or using a number of them one after the other. Even the best device can lose its novelty value. Practise some of the 'time' effects on these pages and you'll be able to use them in your own strips appropriately.

Another job for our hero (*below left*) but how fast he gets there depends on how much space you have and how you want to tell the story. We don't need to see him flying to the scene of the crime (*below right*) ... on the other hand, this extra panel (*below centre*) might be ideal for showing that he's missing his dinner.

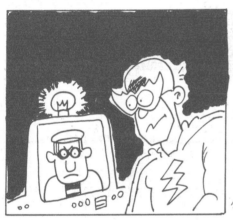

Keep experimenting with your panel arrangements to see what effects you can achieve. Here's how to show the inside and outside of a spaceship in the same time frame. This approach is particularly useful in science fiction stories where there is a danger of the reactions of the characters being upstaged by the hardware.

This design (*above*) allows you to show two things happening at once. Note that the two characters are holding their phones in their own individual ways.

You can emphasize the significance of vital story elements – such as the film canister in this frame (*above*) – by 'freezing' them in mid air.

Leaving out scenes can speed up the action. Here's a way to slow things down – by stretching the progress of this lumbering beast across three panels.

Story and Script

Although this book primarily covers the drawing aspect of comics, and there are several very successful comic artists who work only in pictures, you should be aware of the close linkage between words and images in this genre, for this is a unique aspect of comic strips in relation to other visual media.

In the world of professional comics there are two kinds of artist. Some of the best artists work from scripts and ideas that other people produce, allowing them to concentrate completely on the drawing side of the process. Other, equally successful, artists do both the writing and drawing, with very little input from anyone else.

Whether you are interested in writing full time or not, it is useful to attempt making up your own comic stories. Knowing something about the art of storytelling is important, even if you end up only drawing from other people's scripts. The printed word and the visual image are separate areas, and to turn a written story into pictures often involves minor changes and compromises that only an artist and writer working closely together can make.

THE ADVENTURES OF LIGHTNING MAN

Panel One:
It's evening – Sam Citizen leaves the newspaper office.

Dialogue:

Sam (thinks): Another day over and still nobody suspects I'm really LIGHTNING MAN

Panel Two:
A stranger is lurking in the shadows behind Sam.

Panel Three:
Sam's super sixth sense tells him about the stranger

Dialogue:

Sam (thinks): Wait! My super sixth sense tells me I'm being followed!

Panel Four:
Sam rushes around a corner, the stranger gives chase

Dialogue:

Sam: Let's see just how fast this stranger can run!
Stranger: Hey! Come back here! You know there's no escape!

Panel Five:
Sam changes into Lightning Man.

Dialogue:

Sam: Maybe not for Sam Citizen – but what about for Lightning Man?

Panel Six:
Lightning Man grabs the stranger in a powerful grip.

Dialogue:

Stranger: Hey! Let go!!

Lightning Man: Not until you answer some questions...

Panel Seven:
The stranger is Sam's Mum, complete with birthday cake, cards, balloons, etc.

Dialogue:

Sam: ...Sure, Mum, but do we have to go through this every birthday?

On these pages are my original script for a short comic strip (*above*) and the finished artwork (*opposite*) by Leonard Noel White.

Here are my comments after seeing Leonard's version of my script. How would you have put the story into pictures?

Panel I

This picture has been drawn pretty much as I wrote in the script. As this is a parody type story, Sam Citizen has been drawn as the classic 'mild mannered' reporter type. His pin-striped suit enhances this impression. Note the reflections in the glass of the building to get that 'early evening getting darker' effect.

Panel 2

The trouble with a black and white comic strip is that sometimes a shadowy figure can get lost among the shadows, but comic strips are about words and pictures working together so I added the caption on top of Leonard's picture to make sure we spot Sam's stalker.

Panel 3

A close-up of Sam with a specially created lightning effect to show his sixth sense working. Note that the background has been dropped for this picture.

Panel 4

There's a lot to show in this picture, so the speech balloons overlap. Note that the larger speech balloon overlaps the smaller one. This helps to direct the reader to read the larger speech balloon first, followed by the smaller one. This links the sense of the dialogue in panel four to the words in panel five.

Panel 5

Comic strips, as we have noted before, are about exaggeration and being larger than life – why simply say something when you can SHOUT it?

Panels 6 and 7

There was no way to fit all the dialogue I'd written plus a full-length figure drawing into panel six. But I liked the way the artist had shown both figures while managing to avoid giving the stalker's identity away. I cut the speech so that what needed to be said could be contained in the last panel.

While this book presents the basic steps involved in putting together comic strip drawings, it is important that your drawings should not end up looking like John Byrne's, Leonard Noel White's or those of any other comic artist you care to name. That would be very disappointing. Just as you will develop your own individual style of drawing the more you practise, your writing and storytelling skills will also develop the more you use them.

Another similarity between creative writing and drawing is that the whole process is one of trial and error. At the outset you try developing an idea in a certain direction and if that doesn't work you go back to the beginning and develop it in an entirely different way. I have found that rather than attempting to get one perfect finished drawing or complete story down on paper in one go, it is better to play around with ideas until you tease out something that really works. Polishing up an idea from this point is then relatively easy. You can come up with a comic strip story, funny or dramatic, long or short, simply by taking any situation or image and asking yourself, "What happened next?"

Artist's Tip

Here are three 'instant story' ideas on which you can practise your comic strip skills.

1 Take a well-known fairy tale and retell it in a modern setting.
2 Retell your most exciting/embarrassing/ frightening experience.
3 Take a dramatic story and retell it in a humorous way.

The strips shown below and at the top of the following page are my versions of the 'what happened next' technique.

Each stage of this drama can also be shown from a different visual pespective. For example, looking up at the action (*below*), looking down, or viewing it in close up or from far away. Such decisions have a direct bearing on how a story is told and the type of impact it achieves. They are central to the work of the comic strip artist, and you will find yourself making them all the time.

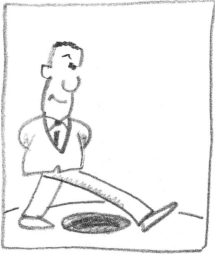

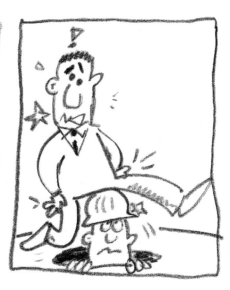

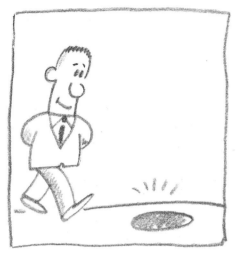

The previous strip depicts a fairly standard open manhole sight gag. For this second version (*above*) I've

used the same two pictures as previously to set up the joke, but opted for a surreal ending.

If you try as many different variations of your strip as you can come up with, you'll end up with something really interesting.

In the final panel (*above right*) I decided that the character would

unexpectedly leap into a void. Now create your own ending for this strip or alternatively expand it into a complete story.

Start by roughing out different viewpoints. This will help you to find the

best way to develop the story and work towards a suitable funny or dramatic ending.

Don't worry if you do not manage to complete two wholly different versions as I have done.

Developing Roughs

Now that we've looked at everything that goes into making a comic strip page, it's time to put them all together and use them to produce a finished strip. On these pages, I've broken down into individual stages the way I would draw a humorous strip and a dramatic story. Before proceeding, though, it's worth pointing out once again that just as no two artists' drawing styles look completely alike, no two working methods are exactly the same either. There's no real 'right' or 'wrong' way to work – the only 'right' way is the way that works for you. And the only way to find that 'right' way is to try as many variations as possible.

Whichever kind of strip you're planning to draw – a short three-picture strip to appear in a newspaper or a 150-page 'graphic novel', whether you intend it to be humorous or just plain exciting, or whether you prefer to work with brush, pen or pencil – everything starts with a blank sheet of paper. It must also be said that for many artists, including professionals, everything sometimes ends with a blank sheet of paper, too – or at least looks as though it might, until you put in that extra bit of hard work.

Here's my first rough version of the strip for which final ink drawings are shown on page 138. The basic joke is about the lengths to which we pros are sometimes driven to meet a deadline. My original (*above left*) was in danger of turning into a 'person gets stuck in the photocopier' gag. To avoid this I decided not to show the actual copier, so I could make the ending more of a surprise (*above right*).

That sinking feeling ...

The best way to turn this blank page into a good comic strip is not to worry about turning it into a good strip. The feeling of "what on earth shall I draw/write today" will be familiar to many, and this feeling is all the more scary if there's a pressing deadline. You're not under this pressure – yet – so don't pile it on unnecessarily. At the outset simply concentrate on making the page less blank. The 'rough' stage is when you can play with ideas, experiment with story lines, approaches and, if you're lucky, discover new ideas that you would have missed by going straight to finished artwork.

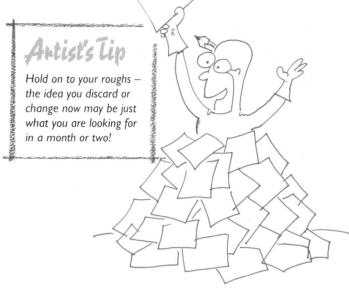

Artist's Tip

Hold on to your roughs – the idea you discard or change now may be just what you are looking for in a month or two!

Leonard Noel White's graphic strip shows a dramatic helicopter accident. When the artist had finished the first version, he felt there was too much 'hardware' on show (*below left*). The developed version increases the drama by putting the emphasis more on the people involved (*below right*).

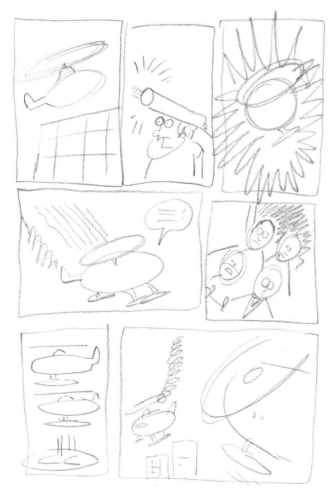

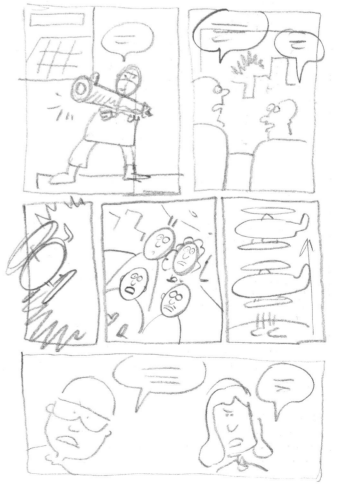

Final Pencil Drawing

It's a simple point but well worth repeating that every kind of drawing medium has its own strengths and weaknesses. As I pointed out at the beginning of this book, you can do your comic strips in whatever medium suits them best or suits the particular style or characters you are trying to develop. Commonly, comic strip artists produce a finished drawing in pencil and then go over it in ink to assist reproduction – this is the kind of 'finished pencil drawings' we are referring to on these pages. That said, there is absolutely no reason why you shouldn't do your strip entirely in pencil (not to mention poster paint, pastel or mascara, if you so desire!).

One of my main aims when I'm taking a cartoon or comic strip from a 'rough' through finished pencil stage to the final ink version is to keep the energy of the original idea. While it's important to pay attention to detail, it's the energy and humour of silly ideas (as here) that give them their appeal. Try to keep that feeling in mind while you're drawing.

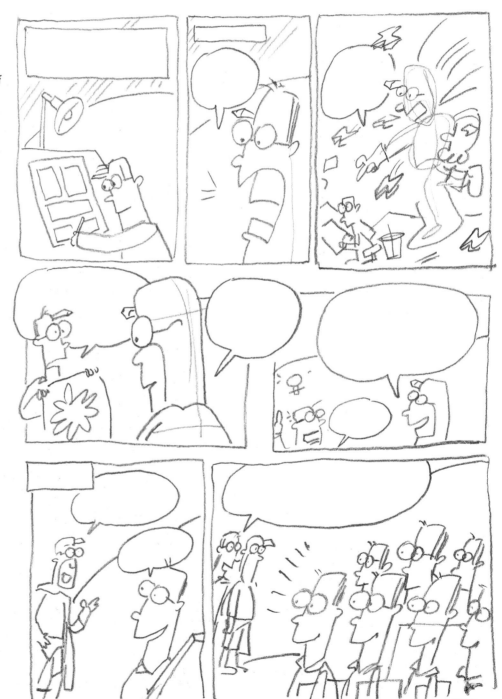

If your panel area is small and you're worried about getting proportions right, draw full figures at pencil stage and later rub out the bits you don't want.

Other media

If you are planning to use another medium to finish off, bear in mind that some of the qualities of your pencil version – for instance, pencil's ability to give different weights of line and shades of grey depending on how hard you press – may not be evident in the finished version. You must aim to create a solid framework on top of which you can do your final inking job. It's advisable to take advantage of pencil's ability to be corrected relatively easily to iron out any late problems or mistakes so that you can approach the ink stage with a confident line that will make your strip distinctive.

Artist's Tip

To stop your pencil strokes smudging while you're going over your drawings, it's a good idea to keep a small piece of paper or card under your drawing hand.

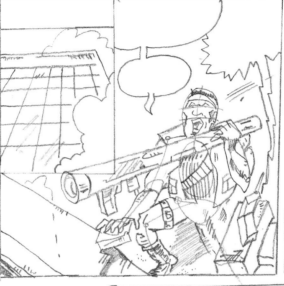

To maintain energy in action strips, I like to work through the page in 'sweeps', first putting in my light guidelines for each panel, then doing the basic drawings, then the fine details, building up to the finished pencil stage. Other artists may prefer to complete each panel before moving on – either way, your grid keeps everything in its place.

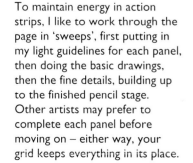
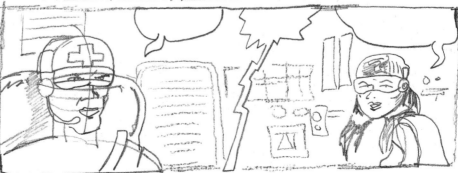

Final Ink Drawing

By the time you have worked through the rough and finished pencil stages of your artwork, you should be pretty sure of the finished result you want to achieve. Don't feel you have to slavishly go over each line of your pencil drawing in ink – if you do this you may well end up with a flat and lifeless drawing. Treat the pencil drawing as a guide for your inked drawing. Don't be afraid to add variations and details or, conversely, to drop details. Do whatever you think will produce a more striking overall image and your finished page will have a liveliness and sparkle all of its own, rather than seeming like a copy of a copy of a copy.

In this strip there's little or no background, so I've used some solid blacks to give the impression of shadow and also to make sure the main characters stand out. Note that I traced the figure in the last panel over and over again, to make sure that it really was identical. (To see how the idea for this strip started out, see pages 134 and 136.)

Artist's Tip

Finally, don't forget to do a quick check of your finished artwork for any errors that may have crept in and need to be corrected. Although most of these should have been caught at the rough or pencil stage, the nature of more detailed work is that we often focus so intensely on small things that we lose sight of the bigger picture. I have seen an artist work for hours to get just the right 'metallic' effect while lettering the title page of a futuristic science fiction comic, only to discover that while the letters looked wonderful, the title was spelt incorrectly.

Hedging your bets

It goes without saying that when you ink your pencil drawing it's pretty hard to go back to the original if the results aren't what you wanted. It's a good idea to photocopy your pencil artwork several times to give yourself at least a couple of chances to get the inks just right.

It's a good idea to ink the strip in outline first before adding the black areas or cross-hatched shading, so you can get the balance right. If you use too little black the strip won't hang together, but if you apply too much you could end up making the whole thing look murky and detracting from the drama.

Although there's no set order for inking your strip, many artists like to ink in the lettering first to make sure it's legible and that no vital words are left out in the excitement of drawing. You can rub out the guidelines before inking the rest of the strip.

139

Using Reference

It's always amused me that one of the most prized skills artists have – at least to people who don't consider themselves to be good at art – is the ability to draw things 'out of their heads'. Comic strip artists certainly need to have this ability because so much of their work – from huge starships to talking chickens – involves illustrating figments of their imagination and not images from the real world. The reason I find the 'drawing out of your head' thing funny is that as a professional artist I'm aware that, amazing though the human brain is, it's virtually impossible to keep an accurate record of every thing you want to draw inside your head.

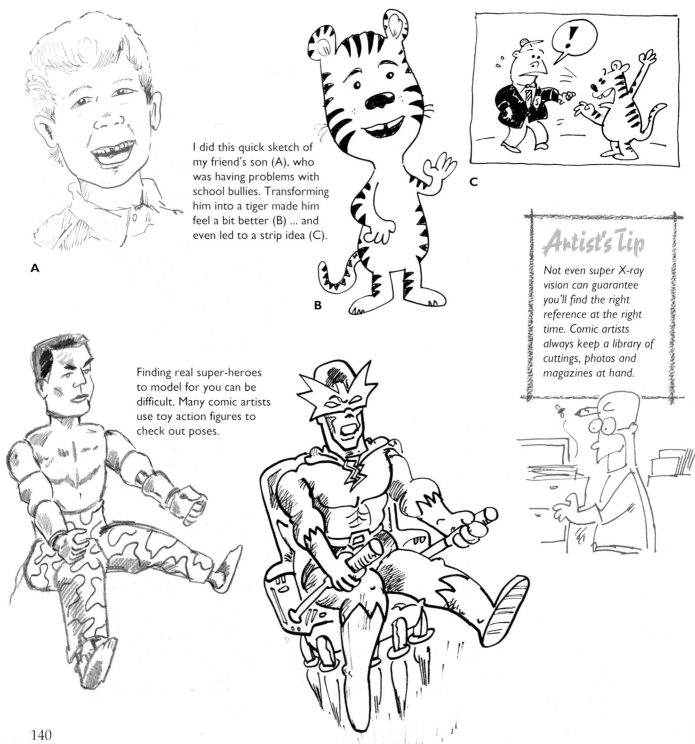

I did this quick sketch of my friend's son (A), who was having problems with school bullies. Transforming him into a tiger made him feel a bit better (B) ... and even led to a strip idea (C).

A

B

C

Finding real super-heroes to model for you can be difficult. Many comic artists use toy action figures to check out poses.

Sourcing reference material

Most working artists, from fine art painters to fashion designers, rely heavily on reference material, life drawings and sketch books. Of course, it's a little easier to set up an arrangement of fruit in your studio or go and photograph your local high street than it is to find three armed alien giants to pose for you or a haunted castle to sketch. As well as realizing how useful reference material can be in improving the impact of your comic strips, you need to put your creative thinking to work on ways to make 'ordinary' references relevant to the world you are creating in your comic strips.

A

Drawing from life keeps your work up to date. I was drawing a baby pram in standard cartoon style (A) until on one of my sketching trips I noticed that many babies were travelling in these flashy modern baby carriers (B). I just exaggerated a little for the revised cartoon (C).

B

C

After I'd drawn this chest of drawers, I decided to do a little 'interior redecoration', making it into a prop (or a character?) more suitable for a horror comic.

Other Ways of Using Comic Strips

One of the biggest frustrations for comic strip artists is constantly having their work referred to as 'kids' stuff'. Not that there's anything wrong with children's comics – visual storytelling appeals to the child in all of us. However, I hope that by now in your research you have looked at enough comics and strips to realize how versatile and powerful they can be as vehicles for conveying messages, and not just in advertising. Comics can be just as effective when used for educational purposes or for getting across important public information.

Now that you have developed your skills, don't just limit yourself to drawing for comic books. Think about other ways in which you can put your new abilities to work. Whatever you decide to do with the opportunities ahead of you, happy writing and drawing, and good luck!

The comic-strip format can be used for educational purposes, as in this poster, Using three pictures means that the message is pretty clear even without the text.

Cartoon greetings cards (*above*) always go down well, especially when they are personalized. The fold-over design of this type of card allows me to do a 'two-panel' joke where the punchline doesn't become visible until the card is fully opened.

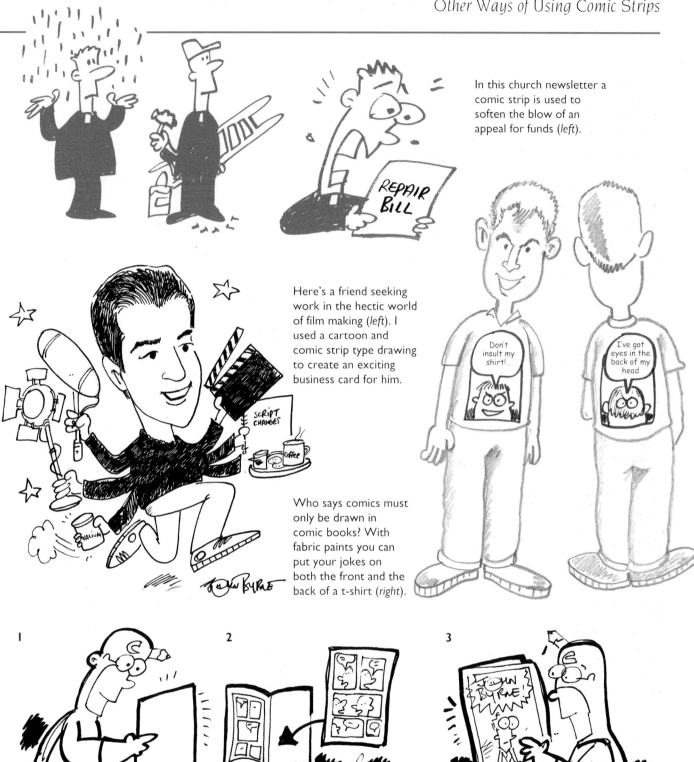

In this church newsletter a comic strip is used to soften the blow of an appeal for funds (*left*).

Here's a friend seeking work in the hectic world of film making (*left*). I used a cartoon and comic strip type drawing to create an exciting business card for him.

Who says comics must only be drawn in comic books? With fabric paints you can put your jokes on both the front and the back of a t-shirt (*right*).

Even if your aim is not to become a professional comic artist, it's still fun to be able to 'publish' your work.

1 Start by folding some blank sheets of paper into comic book size.
2 Photocopy each individual page of your comic art down to size and paste it into your comic.
3 A cover adds the finishing touch. You can use one big image or repeat a number of pictures from inside your comic to whet the appetite of your readers. (See page 102 for an idea for your comic cover.)

ANIMATED CARTOONS

IF IT MOVES...SHOOT IT!

Janet Nunn
with Graham Garside

Tools and Equipment

You don't need to buy a lot of sophisticated equipment at the outset. You can begin with a small sketchpad, an old loose-leaf ring-binder, or even some sheets of paper held together by paper-clips. On this page you'll find the simple materials and pieces of equipment you'll need to get started. If later you find that you enjoy drawing animation, and would like to experiment further, you may be interested to know what kind of equipment is used by professional animators. You'll find a selection of these on pages 148–9.

PENCILS

It is important to feel comfortable with the materials you use. No-one wants to waste time with scratchy pencils or brittle leads, so take time to find a good range of pencils.

Blue pencil You will find that a soft blue 'roughing out' pencil will help you to get a feeling of movement as you draw. Your local art-shop will probably stock special designers' non-reprographic blue pencils. These are fine, but you can also use an ordinary pale blue pencil-crayon.

Black pencil When you have finished roughing out your work, you will need a sharp black pencil to 'clean it up'. Leads vary quite dramatically, but an HB is a favourite. If the HBs you try seem too hard, try a B in the same range. There are black lead pencils designed for animation, but these are not strictly necessary.

Propelling pencil A propelling pencil does not need sharpening, and produces the kind of clean, even line required for computerized animation. The drawbacks are that it is a rather 'clinical' instrument, and the leads are not robust. That said, it is worth mastering the technique of using this type of pencil. Find one which takes a size 0.5 lead, and try either HB or B grades.

PAPER

Remember that the paper you use should not be opaque, because you will need to work on several layers of drawings at a time. A layout pad, obtained from any good artists' suppliers, is ideal for your purpose. Start at the back of it, and work forward, laying one drawing over another and improving on them as you go.

Animation paper This is more opaque than layout paper, and rather stronger, because it gets more handling and needs to withstand extra wear and tear. It is designed for use on a light-box (see page 149). The most widely used size is '12 field', which measures approximately 266 x 330mm.

Tracing paper is not suitable for animation, because it is too transparent and also damages easily.

OTHER ITEMS

Pencil sharpener (*above*) If you do a lot of drawing, think about investing in an electric sharpener – you won't regret it.

Eraser (*below*) You should have one, but keep it a little out of reach, so that you only use it when you really need to. You would be surprised how seldom an eraser is used in an animation studio.

Mirror (*right*) It's not unusual to see an animator making fearsome faces at himself in a mirror placed alongside his desk. It is particularly useful when you want to make characters 'speak', and can be a great aid in helping you to capture elusive expressions or movements.

Masking tape (*above*)This is used for taping down your paper or peg-bar, and is easily removed from both.

Ruler (*above*) Preferably choose a good metal one. In my experience wooden and plastic rulers usually end up looking rather 'chewed' and the gradations can become difficult to read.

Your work station

Once you've assembled your tools, you'll need somewhere to work. Find yourself a quiet corner – away from the normal household 'traffic' – that is large enough for you to set up a firm, stable work top on which you can place a drawing board. You can buy these or construct one yourself. Any smooth, firm surface that can be angled to suit your requirements will do. A good desk-lamp is also vital: the adjustable clip-on types are excellent, cheap, and easily available. A chair which supports your back is essential too. Many hours spent stooping over your work can cause 'animator's hump'!

Registration systems

In order for a sequence of drawings to create the illusion of movement, they all have to be viewed in a fixed spatial relationship to one another. For this reason they need to be secured together and held physically in place, either by clips or a binding, or a special animation peg-bar.

peg-bar

I've already emphasized that you don't have to go to great expense equipping yourself for making your own animations, and it should be possible, with a little ingenuity, to rig up a perfectly acceptable registration system by cannibalizing an old loose-leaf ring-binder, and using punched paper from a pad. If you remove the metal spine holding the rings from the binder, and tape it down firmly, it will do the job quite well. Take care when you are working not to tear or distort the punched holes in your paper, or your drawings will soon slip out of register. Peg-hole reinforcing patches are to be found in any good stationery shop, and are a worthwhile buy.

You may feel that you would prefer to use a purpose-made peg-bar; any good stockist of art materials should be able to sell you a lightweight plastic peg-bar, or order one on your behalf. From the same source you will get boxes of ready-punched animation paper, and paper reinforcements for animation pegs. The good news is that the peg-bar will be fairly

inexpensive; the bad news is that the paper and peg-reinforcements will not! All these animation products meet the professional 'ACME' specifications, which were developed long ago in the United States. The 'ACME' standard peg-bar system is now used throughout the world, from Hollywood to Shanghai. Hence Bugs Bunny's frequent 'Acme' jokes

Animation disc

Professional animators work on a revolving glass or perspex disc, set into a slope, over a light-box. This disc can be swivelled easily, in order to bring the various parts of the drawing nearer to the artist as he works. The registration peg-bar is either taped to, or slotted into, the disc. The best of these 'set-ups' (see Jargon Buster, page 151) include a pair of sliding peg-bars at the top and bottom of the disc, which enable the animator to rehearse his camera-moves and move his drawings to right or left as necessary. Although this precision equipment is indispensable to a fully fledged animator, it is not cheap. Nor, you will be pleased to learn, is it absolutely necessary. Instead, you can simply tape your plastic peg-bar to a light-box. Then you'll be all ready to go!

animation disc

Light-box

If you're particularly bold and resourceful, or you want to save the expense of buying ready-made, you can make your own light-box. You will need the following:

• 50 x 100 cm (20 x 40 in) sheet of MDF (medium density fibreboard) or plywood, 15 mm thick, for the wooden frame; available from a DIY store.

• 30 cm (12 in) cold neon striplight, with fitting, wire flex, switch and plug; obtainable from any good electrical or lighting shop.
• Sheet of 6 mm (¼ in) thick opaline perspex, cut to size; a glass supplier should offer this service, and be able to cut extra thumbholes for the disc.
• Wood-glue, tacks and screws for assembly.

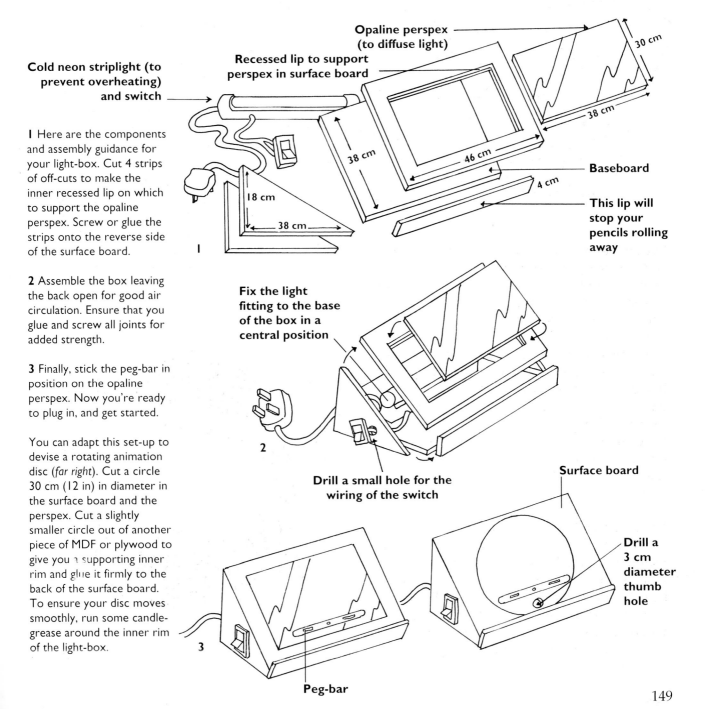

Cold neon striplight (to prevent overheating) and switch

Recessed lip to support perspex in surface board

Opaline perspex (to diffuse light)

30 cm

38 cm

38 cm

46 cm

18 cm

38 cm

4 cm

Baseboard

This lip will stop your pencils rolling away

1 Here are the components and assembly guidance for your light-box. Cut 4 strips of off-cuts to make the inner recessed lip on which to support the opaline perspex. Screw or glue the strips onto the reverse side of the surface board.

1

2 Assemble the box leaving the back open for good air circulation. Ensure that you glue and screw all joints for added strength.

Fix the light fitting to the base of the box in a central position

2

Drill a small hole for the wiring of the switch

3 Finally, stick the peg-bar in position on the opaline perspex. Now you're ready to plug in, and get started.

You can adapt this set-up to devise a rotating animation disc (*far right*). Cut a circle 30 cm (12 in) in diameter in the surface board and the perspex. Cut a slightly smaller circle out of another piece of MDF or plywood to give you a supporting inner rim and glue it firmly to the back of the surface board. To ensure your disc moves smoothly, run some candle-grease around the inner rim of the light-box.

Surface board

Drill a 3 cm diameter thumb hole

3

Peg-bar

Jargon Buster

Animation has an arcane language all of its own. Here are a few expressions that are commonly used by professional animators. With the advent of the computer some of these will soon be obsolete, but we have no doubt that more will soon evolve to take their place.

ACME
The world-wide standard animation registration system (see page 148).

ANTIC
Abbreviation of 'anticipation'. A drawing which precedes and accents an extreme movement.

BG
Background, against which the action takes place.

CAM
The camera; a few years ago this would have been a rostrum camera, mounted vertically above the artwork, but today it is more likely to be a computer system.

CC
A colour card, often used instead of a BG for close-ups.

CELS
Celluloids; now mostly things of the past, these are transparent sheets on which animation drawings were traced and painted.

cel

CU (also **BCU**, **ECU**, and **MCU**)
Close-up shot; also Big Close-up, Extreme Close-up, and Mid Close-up.

CU

BCU

ECU

MCU

CYCLE
A sequence of drawings which can be repeated endlessly to give the impression of continuous movement, such as walking or running.

DOPE-SHEETS
The vital link between the animator and the camera/computer operator. The chart on which the numbered drawings are tabulated, showing where, and for how many frames, each one should be exposed.

dope-sheets

DRGS
Abbreviation for 'drawings'.

FIELD KEYS
The areas within which the action takes place (see Layout and Graticule).

FLIP
There are two meanings to this one: either the flipping of the drawings by the animator, to check the action, or the reversal of the drawings under camera, to show the action going in an opposite direction. (Also see Artist's Tip on page 165.)

FRAME
An isolated segment of film. Animators work to a discipline of 24 frames per second of film.

frames

FX
Special effects, such as water, fire, rain or snow.

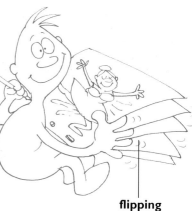

flipping

GRATICULE

A grid which corresponds to the camera's field of vision. Usually this is produced in two sizes: 15 Field, or the commoner 12 Field. Within this grid the layout artist can plan the action and any camera moves required.

graticule

IN-BETWEENS

The 'filling-in' drawings which are created between 'key' drawings and help to smooth out – and slow down – the action where necessary.

KEYS

The important main position drawings which form the bare bones of any action.

LAYOUT

A set of staging drawings which tell the animator the action in any given 'scene'. An animation 'scene' is often less than five seconds long in real time, so the planning has to be precise.

LIP-SYNC

A set of drawings of mouth movements which are synchronized with the soundtrack to give the appearance of speech.

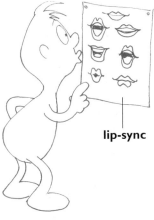

lip-sync

MIX

One picture fades out as the next fades in, so that the change of scene is almost imperceptible.

MORPHING

Gradually changing the form of a character by a series of drawings.

PAN

The lateral movement of a character or a background to right or left (as in walking, when a character walks 'on the spot', as the background pans from east to west behind it, giving the impression of forward movement).

PANNERS

This term usually refers to the extended backgrounds needed to perform the panning operation (see Pan above), but it also refers to the extra long peg-bars on which they are mounted.

PEG-BARS (also PEGS)

The flat bars, with centrally placed round posts flanked by oblong blocks, which hold drawings (done on specially punched paper) in perfect register under the camera. (See 'Acme' system and page 148.)

REGISTRATION

The organization of animation drawings under camera (see page 148).

ROUGHS

The first rough drawings planning the keys and in-betweens (see above).

SET-UP

Again this term has two meanings: it refers either to all the elements of a piece of animation ready to shoot, complete with background, as often used for publicity 'stills', or simply to the animator's work-desk, complete with animation disc, peg-bars and light-box.

SPLAT

The special effects that emphasize an object falling from a great height, or hitting another object at speed, usually accompanied by an appropriately descriptive sound-effect!

splat

SQUASH

The drawing which comes before a 'stretch'; see 'antic'.

STORYBOARD

A visual comic-strip style breakdown of all the action in a film. The jumping-off point for the whole production. On a major project, the storyboard artist visualizes the action, in consultation with the director, the script-writer and the key animators.

STRETCH

Essentially a stretched key drawing, which comes after and contrasts with a 'squashed' drawing, and gives more of a punch to the movement portrayed.

THANX

How most polite inter-studio notes end!

TRACK

Either the soundtrack of the film or a move in which the camera focuses on a different part of the main set-up. It can move further away from the subject (tracking out) or closer to it (tracking in). The speed of the move can vary, too, between a 'fast-track' and a 'slow-track'.

ZOOM

An extra-fast camera move, either panning or tracking.

Give It Body and Weight

Every drama needs a hero. The beauty of animation is that you don't have to audition hundreds of actors for the Mr Right for the drama you are creating. You can simply invent your own. Your animated hero is incredibly versatile too, able to suffer all kinds of indignities – from squashing to slicing and dicing – and still come up smiling in a way that a James Bond, for example, never can, no matter how sophisticated his hi-tech toys.

In the series of drawings shown on this page, you can see how easy it can be to evolve a character. Everyone can draw a rough square, so let's just start moving along from there.

It is common practice these days to call drawn animation '2D animation'. There is nothing two-dimensional about it at all, as the following series of drawings shows – an animator always thinks 'in the round'.

Here is a flat square; think of it as an empty bean-bag.

When you start to fill it, you are giving it body ...

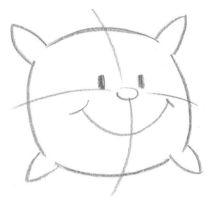

Give it a face, and it starts to take on a character all of its own.

Now that we think of it as three-dimensional, it can be squashed ...

... and stretched ...

... and begin to develop a personality.

152

One of the first things we must do when we are drawing movement is to think about the weight of the character or object we are portraying. Naturally, creatures and objects have varying weights as well as sizes. We can, of course, make a visual joke and turn the whole question of weight upside down, by, for example, making an elephant float on air, or bringing a sparrow in to land on the roof of a bus and flattening it. But we can't play either of these little tricks until we have considered the way to deal with weight.

The bouncing ball principle

Below is a simple illustrated explanation of why an awareness of weight is so important to movement. It's called the bouncing ball routine and it's one which you can experiment with to your heart's content. Start by putting a piece of paper on your peg-bar, draw a couple of arcs and a ground-line on it and then, following this guide, start bouncing!

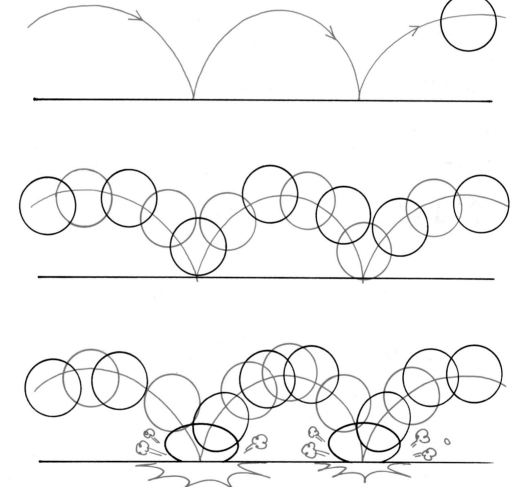

We all know that a bouncing ball will follow a set pattern as it travels and will progress in a series of arcs. We also know that at the end of each arc it hits the ground and then bounces up again (*top right*).

But if we simply draw the movement like this and forget about the weight of the ball, we will just show a mechanical progression and lose the vitality of the movement (*middle right*).

As the ball hits the ground, its weight causes an impact. In animated drawings we show this impact by exaggerating it, for example by showing the ball squashed and distorted as it lands. To really emphasize what is happening and also to remind the viewer that there's a hefty thump at this point, we also draw a 'splat' mark. This is a familiar device that we've all seen in action comics. When it is used in animated films, though, it actually moves (*bottom right*).

The force of the impact lifts the ball off the ground again, sending it soaring into the air. At this point we draw a ball which is stretched and streamlined, to emphasize the idea that it is flying. As it flies up we slow the movement, by putting in extra drawings. This gives the impression that the ball is virtually floating on air.

By the time the ball reaches the top of the arc, it has resumed its normal shape again. At this point, responding to the pull of gravity, it comes down to earth faster than it went up, and impacts again.

Check Your Speed

Some time ago, gravity introduced itself to the world by hitting Sir Isaac Newton on the head with an apple. History does not tell us which of them got the bigger bruising, but we do know that gravity continues to exert its pull to this day. Although we can bend the rules in animation, and let a character walk off a cliff and continue to plod along cheerfully in mid-air, sooner or later he will realize the error of his ways, look panic-stricken at the camera, and come down to earth with a bump!

Let us consider, then, the case of the anvil and the feather. To demonstrate the properties of these particular items, we have enlisted the services of two of animation's classic protagonists, the cat and the mouse. The mouse has drawn the short straw this time, as you will see from the sequence below, and is on the receiving end. Fans of the famous animation duo Tom and Jerry will know that this is not an unusual scenario in a cat-and-mouse movie, although the outcome is often unpredictable.

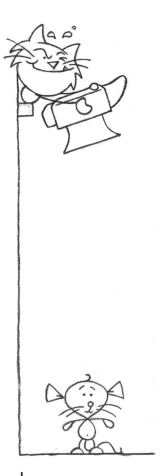 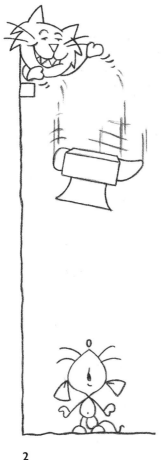 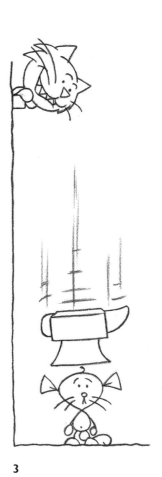 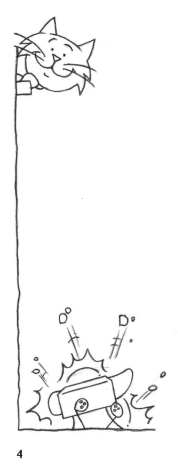

1 2 3 4

1 Our tomcat is poised to drop the anvil from a considerable height directly on to the head of the unsuspecting mouse.

2–3 You will notice that the anvil falls very fast and straight, indicating considerable weight. The speed of the move means you will need to make very few drawings.

4 The thud of the anvil hitting the ground can be emphasized by the use of a 'splat' and a cloud of dust. The 'splat' can be likened to a dry splash, which usually consists of three or

four drawings radiating out from the point of impact. It is a well-loved comic-book convention, often used in animation to add emphasis and a visual exclamation mark to the action.

Special speed effects

In addition to adding exclamation marks to any action in the form of 'splats', an animator can also call for a camera-shake. This is the familiar earthquake-like shudder when the whole picture vibrates. If done in combination with appropriate sound effects, it leaves nothing to the imagination. For the anvil sequence shown opposite, you would expect to see a vertical camera-shake. For a character running headlong into a wall the shake would be from side to side.

After downing a headache pill and a glass of water, our mouse has declared himself ready to take part in our next experiment (see below).

Reassurance for animal lovers: no animals were injured during the drawing of either sequence.

| I | 2 | 3 | 4 |

I The feather is about to be released on its slow journey earthwards. Who knows where it may land?

2 Because of its light weight the feather responds to the faintest side wind and follows a wavy trajectory.

3 The movement is so slow that you will need many more drawings to show the feather's progress than you did for the fall of the anvil in the first sequence.

4 At last the feather comes to rest, gently, with no distortion. And there you have it – a happy ending.

Developing a Human Character

When it comes to developing a 'human' character, there are lots of permutations to consider. The most obvious of these concern what the character looks like: tall or short, fat or thin? The possibilities are endless, but, for the purposes of this first exercise in character design, let us choose three basic body-types: 'short and fat', 'normal' and 'tall and thin'.

We'll keep these characters cartoony, and base them on a simple 'bean' shape, which can be easily squashed or stretched. This is not the only way to build up a character by any means, but using an organic form as opposed to a geometric one may help your first attempts. The idea is always to keep your shapes loose and supple and avoid stiffness.

Even our earliest 'pin-men' drawings reflect our observation of body-types.

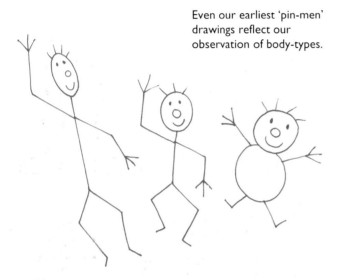

Start by tracing five 'beans' in a vertical line on a large sheet of paper (below). Together these beans denote the size of a tall, thin character. The first 'bean' represents the size of the head.

Beside it, repeat the process, this time using four beans. This will give you the rough proportions of a 'normal' body-type.

Lastly, tracing three beans onto the paper will give you the size of a short, fat character.

Use your 'bean' as a unit of measurement (below). Put a sheet of paper on your peg-bar, then draw your bean-shape on a small separate piece of paper, and slide it underneath.

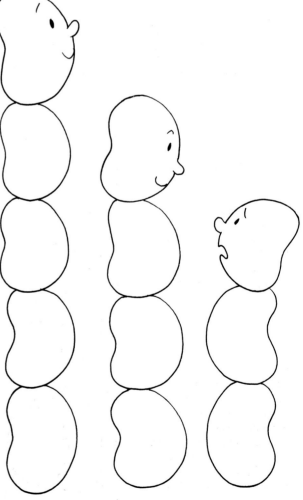

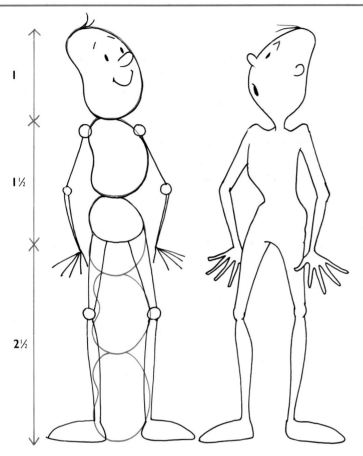

I

1½

2½

I

1½

1½

Take your five-bean column, and, counting downwards, allow one bean for the head (go on, give it a face, so that it can see what's happening!) and one and a half beans for the torso. The rest of the height belongs to a pair of long spindly legs. Now give it a pair of long spindly arms to match (*above*).

Now you can trim off any excess weight, and maybe add a skinny neck and some bony shoulders, just to accentuate the particular build of your character and complete the picture (*above*).

Next, tackle the 'normal' character (*above*). Again, allow one and a half beans for the body, but this time you will see that the legs will be shorter. When you clean up the drawing, do not add too much weight to the limbs and body.

The three-bean character has only a one-bean size body. If you add a bit of roundness to it when you clean up the drawing, you will notice that it looks quite cherubic (*right*). These are the proportions which are generally used when drawing cartoon children.

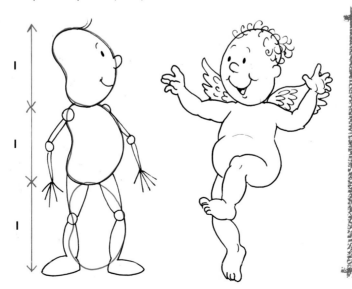

I

I

I

Artist's Tip

Once you have decided on the proportions of your character (the size of its feet, head and hands, and length of its limbs in relation to its body), you have made a set of rules which you must obey. If you don't keep to these guidelines when redrawing, you will gradually 'lose' the character altogether.

157

Developing Animal Characters

The fantasy zoo

You don't have to limit your drawing to the movement of bipeds. Remember, there is a whole natural world out there, padding around on four feet. In addition, there is also an unnatural world full of monsters and spooks, so you can utilize the stuff that dreams (or nightmares) are made of, too, and create creatures of your own. While pigs might fly, horses, bears and lions all walk in different ways, dependent on factors such as weight distribution and the structure of their feet. The permutations are seemingly limitless, and if you want to discover more a good series of wildlife videos should give you ample scope to study four-footed animals in motion, and will be a lot less hazardous than taking a walk with a polar bear!

Graham Garside's design, based on a North American Indian totem pole (*right*), incorporates five stylized characters standing on each other's heads. The chunkiness of these particular forms reminds us that they are animated woodcarvings. You may find it easier to build animal characters using rounder, more organic shapes.

Once again, a simple formula should produce a range of characters of different shapes and sizes (*right and below*). This time, it couldn't be easier. A small egg, a large egg and a leg at each corner. Now all you have to do is juggle the size ratios of the components.

A medium-sized body with a small head and a long neck (*right*) sets the pattern for the camel, the llama or, with a bit of a stretch, the giraffe. The same body with a shorter neck gives the framework for a horse or cow. Whether you give your creature a neck or no neck makes all the difference between an elephant and a giraffe.

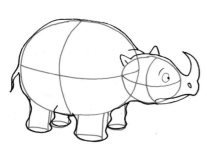

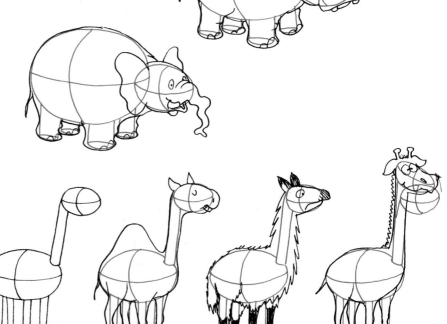

If you are intent upon portraying an animal for your animation sequence, you will need to use photographs or videos as reference to get an idea of its features as well as its movement. Even cartoon animals benefit from an eye to detail, so it is important to get them right. You may decide to emphasize one particular feature, such as a camel's flat feet, or a horse's big teeth, or you may invent a creature which combines the parts of several different animals. Mother Nature seems to have done just that on occasion – think of the duck-billed platypus.

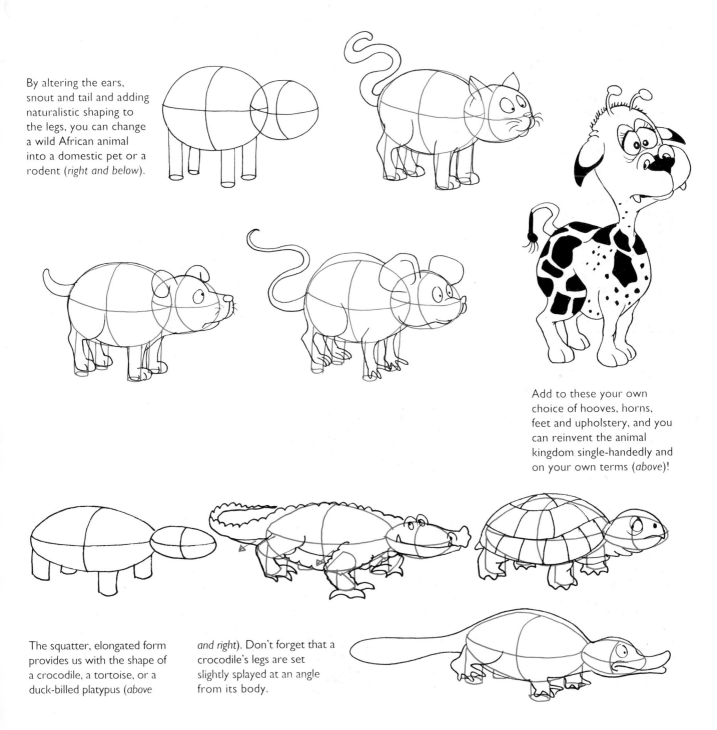

By altering the ears, snout and tail and adding naturalistic shaping to the legs, you can change a wild African animal into a domestic pet or a rodent (*right and below*).

Add to these your own choice of hooves, horns, feet and upholstery, and you can reinvent the animal kingdom single-handedly and on your own terms (*above*)!

The squatter, elongated form provides us with the shape of a crocodile, a tortoise, or a duck-billed platypus (*above and right*). Don't forget that a crocodile's legs are set slightly splayed at an angle from its body.

Expression and Emotion

How are you feeling?
Once you have understood the 'geography' of the face, you can begin to experiment with its choreography, too. The eyes and nose may be static, but you can make the other features work to express emotions without words.

Give your first 'face' (*left*) a button nose, basic round eyes, and lines for the mouth and eyebrows. This face will have a perfectly bland expression.

Now (*right*), by changing a line here or there, we can give the same face a whole range of expressions.

Angry Happy Sad Suspicious

Surprised Startled Grumpy Queasy

The same basic rules apply if you want more complex faces. When you are developing a character, it is always a good idea to do a sheet of expressions to show how that character will look in a range of different moods (*left*).

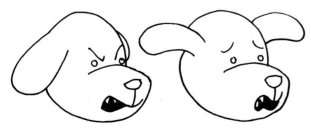

Remember that animals use their ears, teeth, and even their fur (*right*) to indicate how they are feeling.

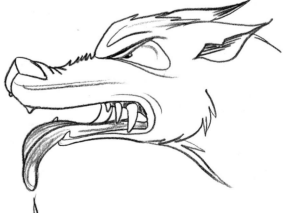

Let's have a show of hands ...
A gesture can be worth a hundred words. Until such time as they learn to speak one another's various tongues, man and beast have only body language as a means of communication common to them both. However, the hand, or paw, can tell a story all by itself, as you can see from the images shown below.

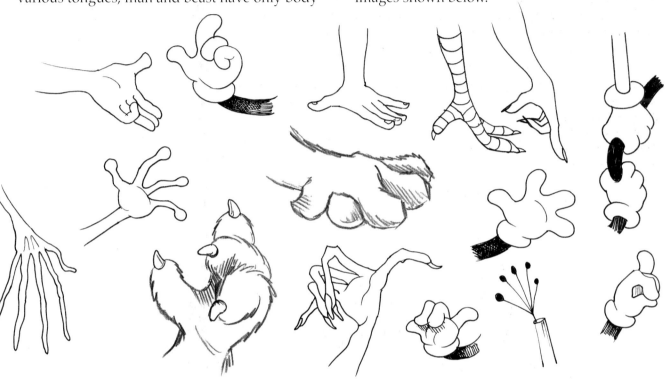

A three-fingered hand can be as expressive of mood and movement as a normal one. But there is no reason why we should not use the normal number of fingers either. Practise drawing hands as much as possible, and don't be scared of doing so.

Not only the hands but the whole body can convey a sense of character, even when static. The tense, brooding presence of this 'humanoid' demon (*below right*) contrasts sharply with the elephant's near-human expression of innocent amazement.

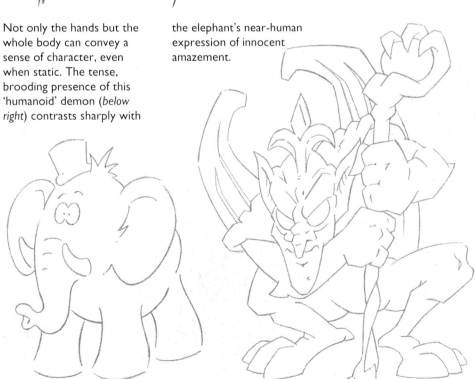

Give It a Spin

You have evolved a character. Maybe you have been drawing one favourite creature for some time. Can you move it? Or would it move better if you made a few alterations?

If you are happy with your 'hero', it's time to put together your first character-model, together with the related drawings which make up its profile. These drawings and notes will be a graphic reminder to you of all the creature's characteristics. They will be your 'character-bible'. Without such a reference, Daffy would not be Daffy, and Donald, Mickey, Popeye and Pluto would all have big personality problems!

The most important set of drawings is the one which presents the ground rules for any subsequent drawings of the character; this is known as the 'turnaround'. You may find that the trickiest drawing to do in a 'turnaround' is the profile. A lively-looking front-view can turn into something rather flat! If you find yourself with an overflowing wastepaper-bin and nowhere near a satisfactory solution, try making a plasticine model of the character.

In the system given below for creating the 'turnaround', pay special attention to the order in which the drawings are made.

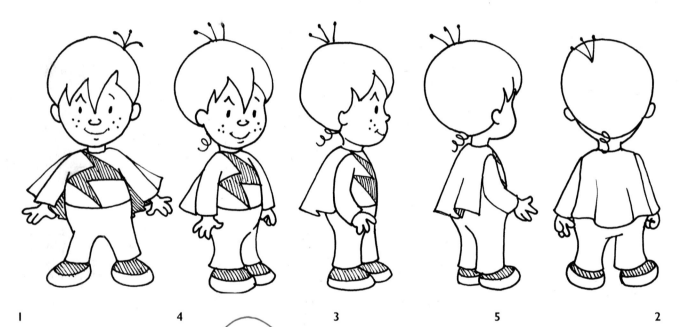

I 4 3 5 2

I Begin by drawing a full frontal view of your character.

2 Place a fresh piece of paper over the top of this full frontal. Now imagine the rear view, and draw it.

3 If you place the front view on top of the rear view, you can think about how the character would look in profile.

The easiest way to adapt a full-face view to a profile is to think of the head as an egg-shape or ball, and slide the features sideways around it (*above*).

4 Put the front view on top of the profile and draw the position in-between the two drawings to give a three-quarter front view.

5 Then place the profile on top of the back view, and repeat the process to make a three-quarter back view of the character.

You now have five drawings of your character from different viewpoints. If you leaf through them, the character will seem to turn, and you will get your first impression of your creation 'in the round' (see the sketch of 'flipping', page 150, and the Artist's Tip on page 165). At this stage you may want to 'tweak' or amend any details which don't look quite right.

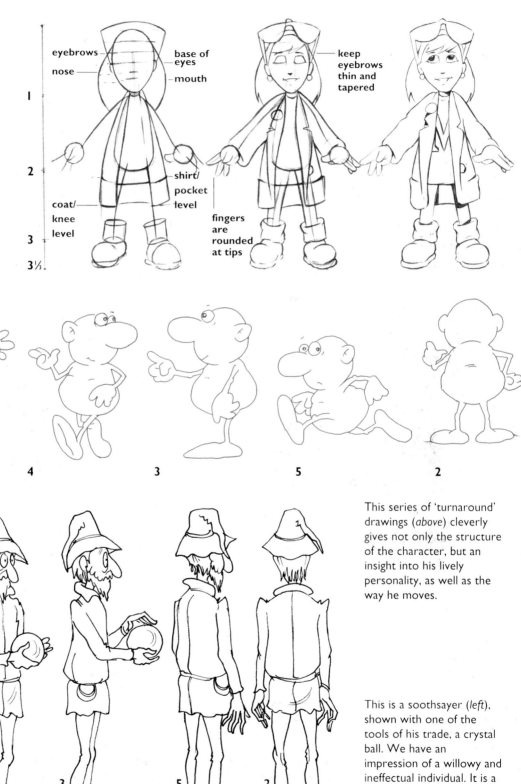

It is necessary to show how a character wears his or her clothes. This young heroine of an adventure series (*right*) is wearing an oversized jacket. Her designer has included information about it with the detailed instructions for drawing her.

eyebrows

nose

base of eyes

mouth

keep eyebrows thin and tapered

shirt/ pocket level

coat/ knee level

fingers are rounded at tips

1

2

3

3⅓

1 4 3 5 2

This series of 'turnaround' drawings (*above*) cleverly gives not only the structure of the character, but an insight into his lively personality, as well as the way he moves.

1 4 3 5 2

This is a soothsayer (*left*), shown with one of the tools of his trade, a crystal ball. We have an impression of a willowy and ineffectual individual. It is a good idea to incorporate some of your character's personality traits in the early drawings.

Key Drawings

Key drawings are the most important drawings in a sequence of animation. They are a series of poses which make up the skeleton of an action. If they do not work properly, all your effort will be wasted. These drawings must be strong and also show the direction of the movement.

When an animator has made a set of key drawings, he knows that the action will work efficiently, although he may wish to slow down or speed up parts of it to make it look more natural or, alternatively, to give it more 'punch'.

To 'smooth out' the action, and make it less violent, more drawings need to be inserted between the main key drawings. This will have the effect of slowing down the action.

In an animation studio, these 'in-betweens', as they are called, are usually made by an assistant animator, or 'in-betweener'. This work requires skill and an ability to visualize movement, and is by no means a 'mechanical' process. When an in-betweener has served his 'apprenticeship', he will be ready to graduate to the position of key animator. The best way to learn about animation is to work alongside an experienced key animator, and to watch what he does. Unfortunately, opportunities to gain experience in this way rarely arise.

1 Key animator's rough drawing.

2 Assistant animator cleans it up.

3 The revise is traced in ink on a sheet of celluloid.

4 The inked drawing is painted on the reverse side.

5 A sequence of key drawings, ready for in-betweening.

The way things were ...

Traditionally, the key animator used to make quite rough drawings which were 'cleaned up' by another artist before being in-betweened. After this, the drawings were passed on to the ink and paint department, where they were traced onto celluloid, then flipped over and painted on the reverse, using emulsion paints. Today, economics decree that an animator usually must do all his own work, including roughs, clean-ups and in-betweens. Instead of the large studios, which thirty years ago kept many people busy, there are now much smaller establishments where a handful of artists and a few computer operators turn out similar volumes of work, and few ink and paint studios exist.

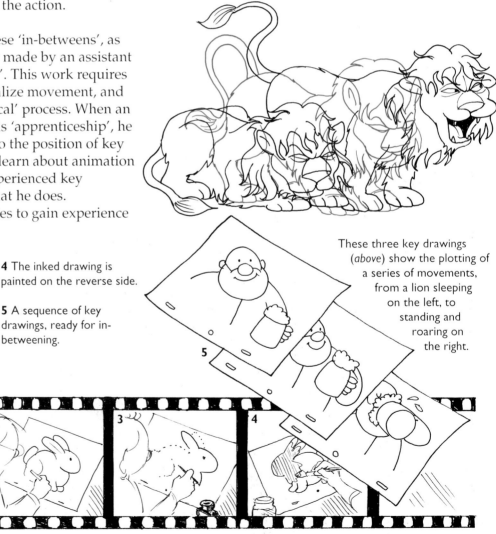

These three key drawings (*above*) show the plotting of a series of movements, from a lion sleeping on the left, to standing and roaring on the right.

Basic two-legged walk sequence

The walk is the trickiest piece of animation for a beginner to try because there are so many permutations. It is, however, one of the most important lessons to learn, and this first basic sequence will give you the pattern for all those that come after.

Your first set of keys

Put a sheet of paper on your pegs, and draw your character stepping out, with its feet at full stride (1). This is your first key drawing.

If the right foot leads the step (a), the right arm compensates for this by swinging backwards (b), and vice versa.

Now is the time to refer to your sketchbook, and look at those first rough sketches you made of people walking, because you are going to make your character walk 'on the spot'.

Notice that, as we have seen with the character-model, these drawings are not made in consecutive order, but there is a logic to this.

Place another sheet of paper over your first drawing, and rule a horizontal line beneath each foot (c). This gives you a walk-line guide for each foot, and should be kept beneath all the drawings as you work.

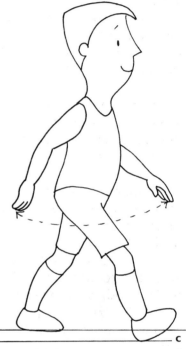

Artist's Tip

You will need to practise flipping your drawings, as it is crucial to your work. Some people become expert at this operation, and can grab a pile of fifty drawings or more and run through them like a flip-book, but that is a feat which remains well beyond most of us, so don't worry if you take time to become adept at flipping just a few. As long as you can control five pieces of paper at a time, you're winning!

Now make another drawing (*right*), similar to drawing 1, but with the left foot leading the step (d) and the left arm compensating by swinging backwards (e). You can trace back the head and body, but the leading foot will now be on the opposite walk-line. Number this drawing '5'.

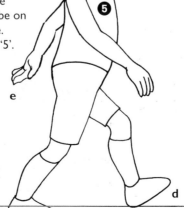

Background and 'slippage'

When a character is walking 'on the spot' a panning background (see page 151), moving in the opposite direction, runs behind it to give the illusion of movement. If the character is walking from left to right the background will have to move from right to left at the same speed. The distance the background is moved between each drawing will be the same as the 'slippage' distance. On the next two pages you will see that these 'slippage' calibrations are shown as marks on the walk-line. These help you to check the movement of the feet as you work through the sequence.

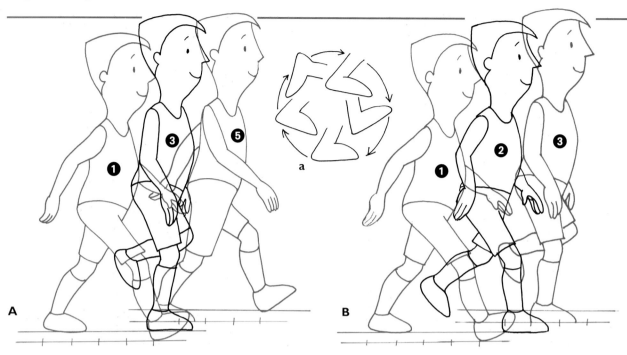

A

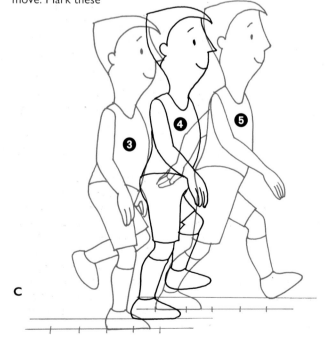

C

A Drawings 1 and 5 form the basis of the walk sequence. Before you proceed, you will need to calculate 'slippage' (see page 165). On your first drawing (1) measure the distance between the heel of the front foot and the heel of the back foot. Divide this by four and you will get the 'slippage' you have to allow for each move. Mark these calibrations on the bottom walk-line, as shown.

The next drawing to make is number 3, in which the legs will be in a midway position between 1 and 5. To do this, it may help you to think of the movement of pedalling a bicycle (a), because this is roughly the action of the feet when walking. Place drawing 1 on top of drawing 5, then put a fresh piece of paper on top of 1. You will be able to see the two images quite clearly, but 5 will have a greyer line. As you make the drawing (3) which goes in-between them (see page 151), remember that the back of the heel which is flat on the ground will be equidistant between drawings 1 and 5.

At this mid-step point, the load-bearing foot moves back to a position directly under the torso, slightly raising the whole body.

If you do not allow for this your character will do an eccentric 'Groucho Marx' walk. Over-exaggerating the movement will make it look equally ridiculous.

B When you are satisfied with this new in-between drawing, remove drawing 5 from the bottom level and put drawing 3 in its place, underneath drawing 1. Now draw image 2, which is the position halfway between 1 and 3. You will see that you are filling in the gaps in the movement.

C After drawing 2, tackle drawing number 4, which links 3 and 5. You have now completed half a step. At this halfway stage, it is a good idea to check that the drawings are moving smoothly. Stack them in order with drawing number 1 on the top and drawing number 5 on the bottom and put them back on the pegs. Now slide your fingers between each drawing, as in the sketch on page 150 showing 'flipping', and gently flip the paper so that you can confirm that the action is smooth.

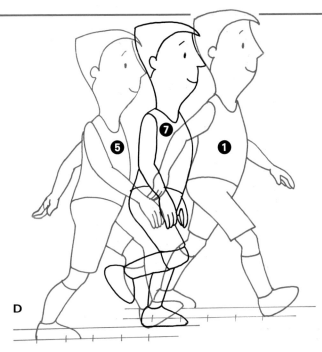

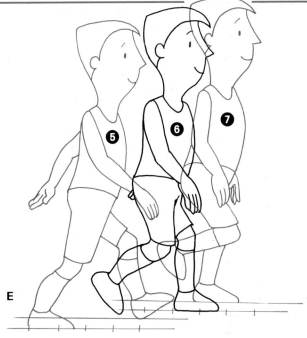

D Now go on to draw the other half of the step. This time you want to return your character to the position it started in, so place drawing 5 on top of drawing 1, and create drawing number 7, the pose midway between the two. Note that the body will be the same as in drawing 3, but the legs will be in reversed positions.

E Now remove drawing 1 from underneath, and place drawing 5 on top of drawing 7, in order to make drawing 6.

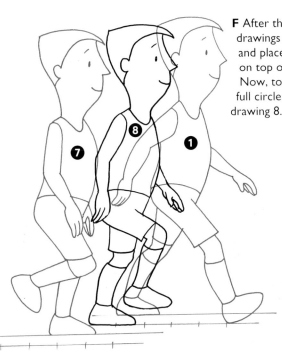

F After this, remove drawings 5 and 6, and place drawing 7 on top of drawing 1. Now, to bring you full circle, make drawing 8.

As you work through your sequence of drawings, make sure that the arms swing in a nice smooth arc, as their movement will help to enhance the action of the walk.

Now give yourself a pat on the back! The key drawings (*above*) form the basis of a complete 'cycle' of animation. As long as these same drawings are repeated in the correct order, your character can go on walking forever, like Felix the Cat! You can slow down the movement by inserting extra drawings between each of those in the cycle, but you now have the basic walk system.

Four-legged walk sequence

If, having accomplished the two-legged walk, you would like to walk the dog as well, the system is exactly the same, except, of course, that you are dealing with two pairs of legs instead of one. Compare the sequence of drawings shown below with those on pages 166–7. One basic point of difference – and one to note – is that diagonally opposite feet are on the ground at the same time. Zoologically, this particular dog operates like a pantomime horse, in that its legs owe rather more to human than to canine structure, but there are four of them, and they do manage to get him from A to B! Technically, this particular walk is better suited to a bear, which, like man, is plantigrade – that is, flat-footed. If you want to draw a more realistic representation of any animal walking, you should do some picture research on the anatomy of its feet. However, the cartoon dog shown in the sequence below shares his idiosyncratic gait with many other quadrupeds, Pluto included!

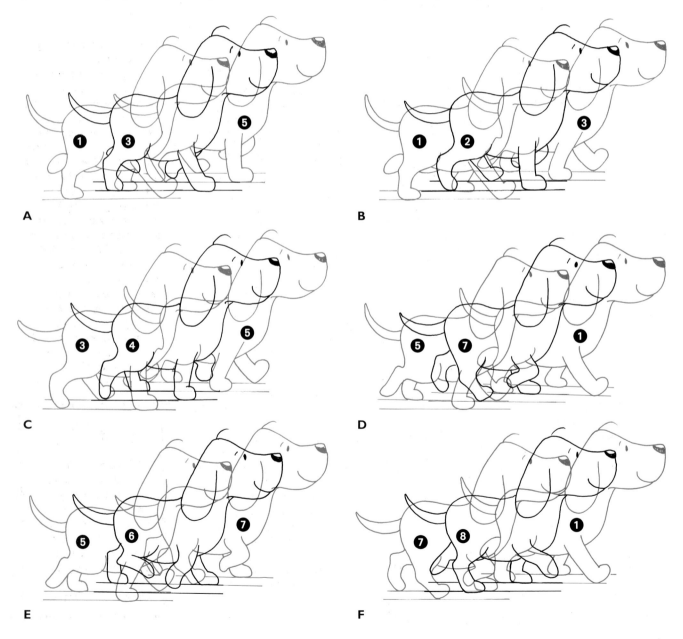

A

B

C

D

E

F

Cleaning up your character

Not every cartoon character is as easy to draw as Felix the Cat. Many characters come equipped with complicated costumes, replete with buttons, buckles and bows. All such items have to be reproduced faithfully during the animation process. Our example here is a pirate chief, who is obviously no stranger to dirty deeds. Notice that he sports not only a dashing frock-coat, frilly cravat, facial hair and spots (due, no doubt, to the poor diet onboard ship) but also a wooden leg, complete with a ball and claw foot!

An animator would need to make several rough drawings of a character like this, before producing the final cleaned-up version.

You will find it easier to use a light blue pencil when you start 'roughing out' a piece of animation, to ensure that your eye is not distracted as your drawings get messier. When you think the movement is looking right, take a sharp black pencil and start to make your final drawings.

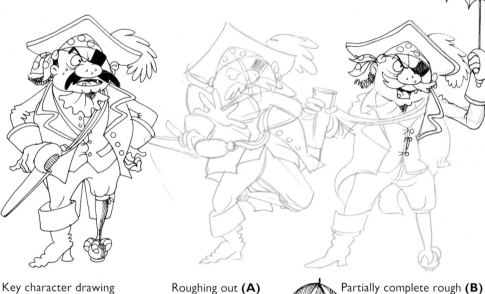

Key character drawing

Roughing out (**A**)

Partially complete rough (**B**)

Final drawing (**A**)

Final drawing (**B**)

Take the character model, and work through your drawings, remembering all the features you have to check, such as proportions, the length of limbs in relation to the body, the size of the head, ears, nose and hands. When you think you've got these elements in place, go through the drawings again, checking secondary details such as the numbers of buttons on clothing, adding or deleting them where necessary. Remember that any features which do not follow through properly will pop on and off the character as it moves, and distract the eye from all your hard work.

You will now have a set of lively drawings, showing the blue rough lines, and the more decisive black final drawings (*above and left*). Place a fresh piece of paper on top of each drawing, and carefully trace them all again using black pencil. Keep referring to your character model, and look out for any further mistakes. When you have finished, your drawings are ready to be shot.

Artist's Tip

All drawings which are to be coloured and shot using a computer system must be checked to ensure that the lines are clean, and that they all join up, otherwise the colours will flood from one area into another and ruin the effect.

Developing Movement

Ready, steady, go!

Everything starts somewhere, but in animation you sometimes have to go backwards before you can go forwards. Take an eager, Pluto-type hound, for instance, whose master has told him to 'stay!' He sits, quivering with anticipation, waiting for the word which will release him from his enforced stillness. His eyes follow every movement, every muscle is taut, waiting for the call, and when it comes he bounces joyfully away. In order to make the most of that happy moment, an animator would show the dog lunging backwards, and then forwards as a continuation of the same move. This ploy is known as 'anticipation', and is a very important part of the process of animation.

If you imagine yourself, like the dog, sitting, waiting for someone to call your name, you would also be tensed, ready to act. You would naturally lean backwards slightly, before transmitting the weight of your body forwards through your knees, and rising to your feet. In fact, we all do it without thinking about it.

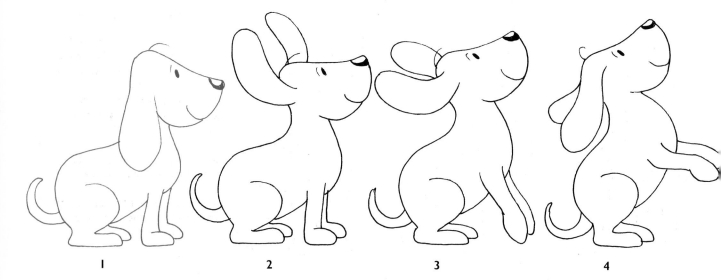

1 2 3 4

1 Seated, but alert, the dog awaits a command.

2 On hearing his master's call, he over-reacts, raising his head and flapping his ears happily.

3 Pushing off from the ground with his fore-legs, the dog rears upwards and backwards.

4 He is now sitting up, almost in a 'begging' position, but with his front paws extended ready to move forwards, his body balanced on his tail.

5 Raising his tail-end and pushing his weight off using

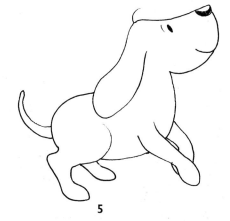

5

6

his rear legs, he bounces forwards. His nose describes an arc as he moves off.

6 His body and feet are now in the position of the first key drawing for a standard 'cartoon' four-legged walk.

Sit up and take notice!

When you draw action, you soon become aware of the way other people move. Some may walk confidently, with their heads up and their chests stuck out. Others may stoop and shuffle along looking at the ground. Between these two extremes there is a wide range of other postures, which can be due to anything, from a sprained ankle to a bad temper. Watch out for them.

Another point to remember is that if animated movement is drawn to a rigid mechanical formula, it looks jerky and unnatural. Nature and movement are full of curves. Always try to move your drawing along in an arc, and don't forget to show your characters preparing to make their movements. Your motto should be 'Anticipate everything – and go with the flow!'

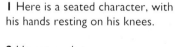

1 Here is a seated character, with his hands resting on his knees.

2 He responds to a summons, looking up, and raising his head.

3 He straightens his arms, and pushes his upper body backwards. His head moves further back, too.

4 Now he pushes his weight forwards onto his feet, and rises from the sitting position.

5 He shifts his weight onto one foot as he takes a step forwards.

6 This now brings him to the first key position of the two-legged walk cycle.

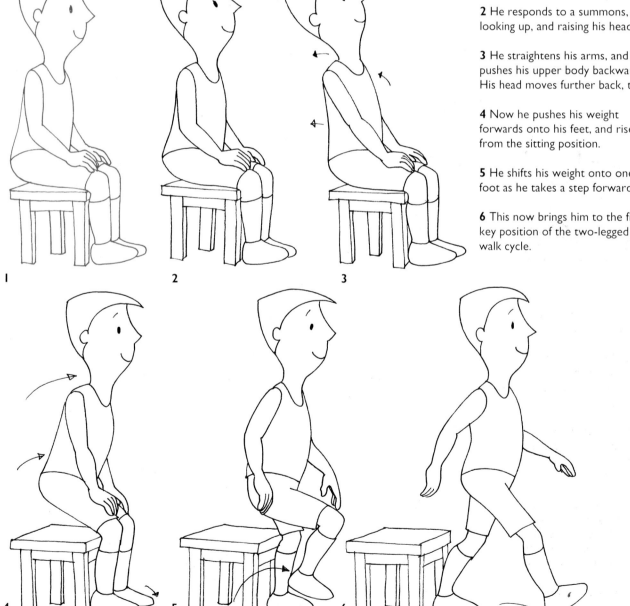

Running

As with the walk, the run begins with one strong drawing of your character in a full-stride running position. The body leans forwards, emphasizing speed and direction. The action of the arms is stronger, pumping the body along. The slippage of the feet is greater, too. As a general rule you might expect the slippage of the feet on a normal walk to be between 4 and 6 mm (⅙ and ¼ in). The slippage for a run would be between 15 and 18 mm (⅝ and ¾ in). On a really crazy 'motorized' run, you can thrust the body so far forwards that it is nearly horizontal, and give the legs a blurred fast-wheeling effect, but that's another lesson – the object of this exercise is to run before you gallop!

A

A The drawings in the run cycle are done in the same way as those in the walk cycle (page 165). First, do drawing number 1 and then draw the opposite position, and number it 5. Establish the run-line and draw position 3, which is in-between 1 and 5. Note that the circular 'cycling' movement of the legs is more exaggerated during the run, and that the feet are never flat. When they do touch the ground line, the heels are below the level of the toes.

B–C Now go on to make drawing 2, between 1 and 3, and drawing 4 between 3 and 5.

D Put 5 on top of 1, and draw 7 (the reverse of 3).

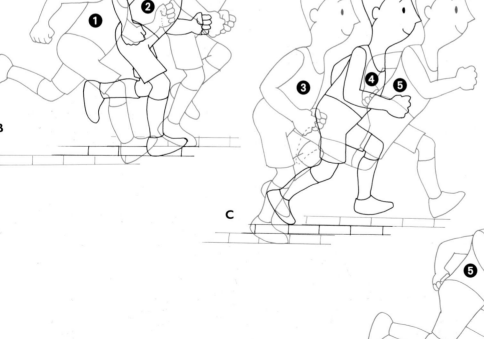

B

C

D

E–F Complete the procedure by in-betweening 5 and 7 to get 6, and 7 and 1 to get 8.

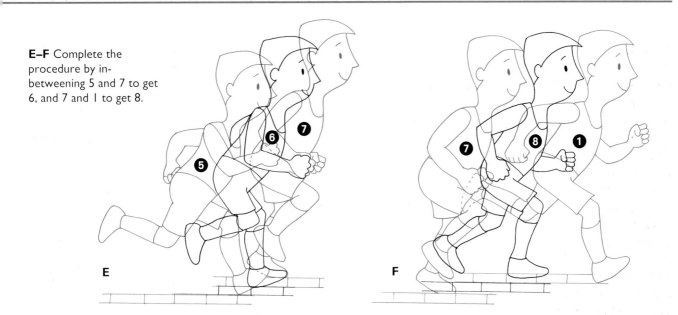

E

F

Animal run cycle

After that tour de force, you'll probably be wanting to take the dog for a run too. A dog's run is a lovely lolloping one. If you have ever watched a dog racing along, you might have wondered whether its feet touch the ground at all, and the answer is that they hardly do!

Start off with our hero at full stretch; this is drawing number 1, and one of the three main key positions in this move (A). At this point only one paw is in contact with the ground. The next drawing to do is number 3, in which all four paws are off the ground, with the two hind legs coming forwards in a leapfrog position and the two front legs going back in a circular motion. (Both front feet will hit the ground naturally in number 2, which is an in-between drawing.) The

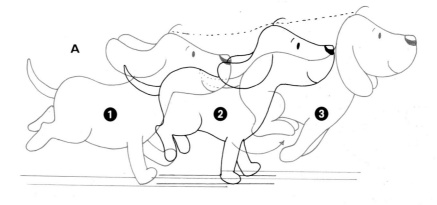

A

third key drawing is number 4, where the hind feet hit the ground, lifting the front feet and front part of the body into the air (B). Drawing number 5 is an in-between of numbers 4 and 1. Don't forget that if your dog has long ears, they should flap as he runs, to add to the illusion of speed.

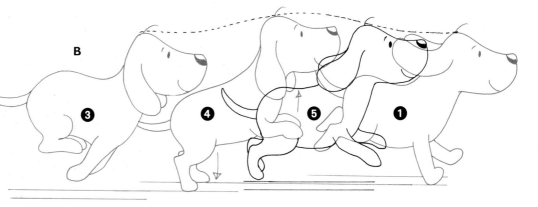

B

Jumping, 'taking' and stopping

The mechanics of jumping have much in common with the bouncing-ball principle which we considered earlier. The cartoon character, whether human or animal, also squashes on impact and stretches as it bounces out of the squashed position. The same sequence of movements is also used in that good old standard animation showpiece, the 'take'. This is a character's extreme reaction to an outside stimulus. As in the classic example shown opposite, the Roman citizen is minding his own business in a dim but relaxed fashion, when he sees or hears something shocking. He cringes into a 'squash' position, then leaps up into a 'stretch', before eventually settling back into a position close to his original one.

The great exponents of early film comedy were without doubt experts at the 'take' – just watch a few old Laurel and Hardy shorts, and you'll soon see what I mean.

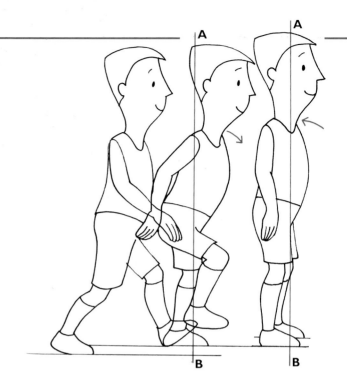

You may recall that we advocated the use of 'anticipatory' drawings when starting a movement (see page 170). To show a character stopping, we use the same process only in reverse. In the drawing above the character slightly overshoots the imaginary vertical 'finishing post' (A to B) as he comes to a halt and then settles into his final upright position, thus emphasizing the action.

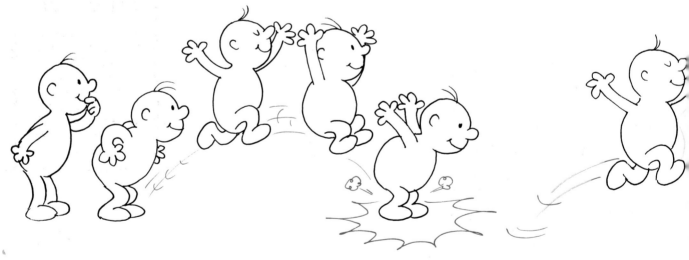

Some of the more dramatic methods of effecting a stop come into force when an animated object, travelling at speed, comes abruptly into contact with a static one (*above and above right*).

Fortunately, both elements usually survive! In the 'stopping' sequence shown above, note that the victim registers impending disaster just before he hits the tree, when the crunch is unavoidable. It would be nice to make his movement slow down slightly at this point in order to emphasize the drama. A little bit of desperate backwards 'pedalling' works wonders in such a situation! And after having one's progress so rudely interrupted, it only remains to 'do a wind-up' and zoom off in search of another mishap (*far right*).

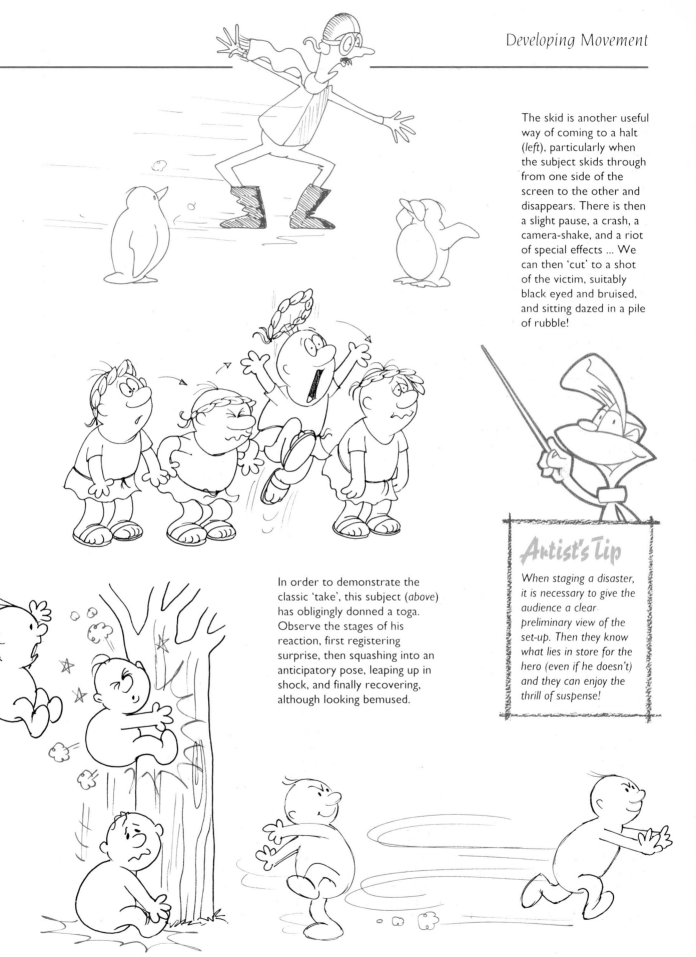

The skid is another useful way of coming to a halt (*left*), particularly when the subject skids through from one side of the screen to the other and disappears. There is then a slight pause, a crash, a camera-shake, and a riot of special effects ... We can then 'cut' to a shot of the victim, suitably black eyed and bruised, and sitting dazed in a pile of rubble!

In order to demonstrate the classic 'take', this subject (*above*) has obligingly donned a toga. Observe the stages of his reaction, first registering surprise, then squashing into an anticipatory pose, leaping up in shock, and finally recovering, although looking bemused.

Artist's Tip

When staging a disaster, it is necessary to give the audience a clear preliminary view of the set-up. Then they know what lies in store for the hero (even if he doesn't) and they can enjoy the thrill of suspense!

Flying

If you are a born flyer, as opposed to someone with a ticket to fly, the way you move depends on weight and shape. When a sequence of animation is filmed, each drawing is usually exposed for two frames, but an action like flying which is slow, graceful and balletic, can be shot on three-frame exposures, or even more. These slower movements are generally exhibited by larger birds, such as swans; the smaller the bird,

the swifter the movements. Birds with a wide wingspan tend to soar up into the wide blue yonder with scarcely a flap.

In the world of flying things we must not forget insects either – the flutter of a butterfly and the dizzy dance of the bee mirror the flight of smaller birds, and the swoop of the dragonfly is similar to that of the eagle. The longer the wingspan, the more regal the flight should be.

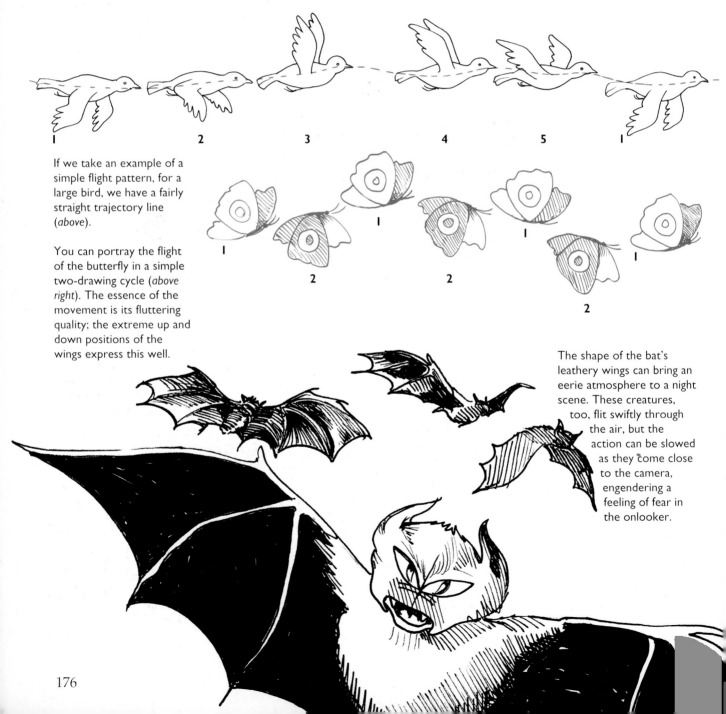

If we take an example of a simple flight pattern, for a large bird, we have a fairly straight trajectory line (*above*).

You can portray the flight of the butterfly in a simple two-drawing cycle (*above right*). The essence of the movement is its fluttering quality; the extreme up and down positions of the wings express this well.

The shape of the bat's leathery wings can bring an eerie atmosphere to a night scene. These creatures, too, flit swiftly through the air, but the action can be slowed as they come close to the camera, engendering a feeling of fear in the onlooker.

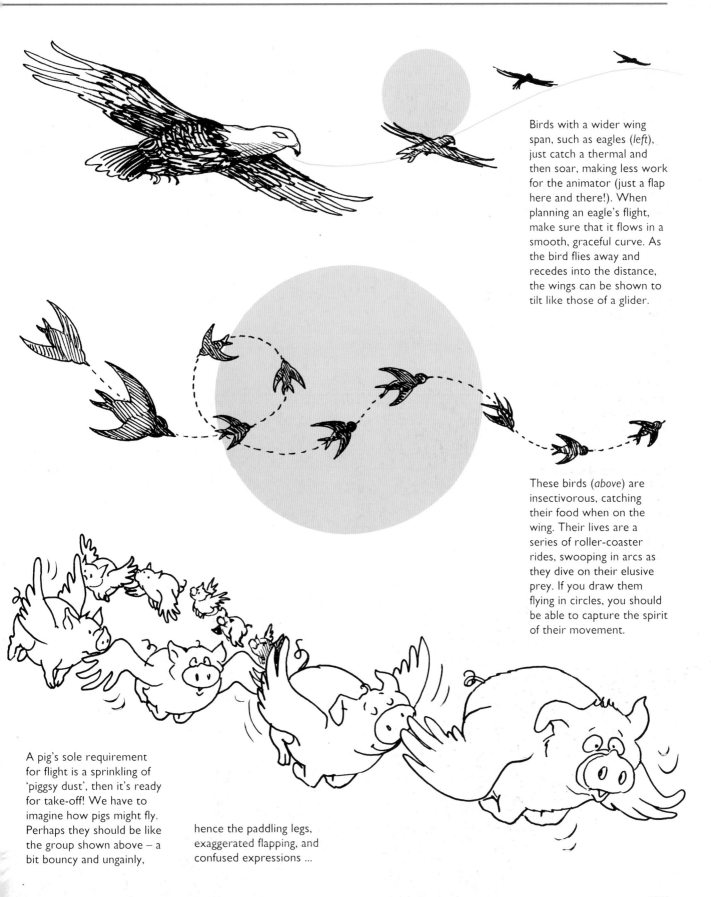

Birds with a wider wing span, such as eagles (*left*), just catch a thermal and then soar, making less work for the animator (just a flap here and there!). When planning an eagle's flight, make sure that it flows in a smooth, graceful curve. As the bird flies away and recedes into the distance, the wings can be shown to tilt like those of a glider.

These birds (*above*) are insectivorous, catching their food when on the wing. Their lives are a series of roller-coaster rides, swooping in arcs as they dive on their elusive prey. If you draw them flying in circles, you should be able to capture the spirit of their movement.

A pig's sole requirement for flight is a sprinkling of 'piggsy dust', then it's ready for take-off! We have to imagine how pigs might fly. Perhaps they should be like the group shown above – a bit bouncy and ungainly, hence the paddling legs, exaggerated flapping, and confused expressions ...

Morphing

This is about the most fun you can have in animation. Morphing is the process of changing one character into another by a succession of drawings. The permutations are limitless, although often a gradual change in size or shape is funnier than a sudden one. A good example to experiment with here would be the slow evolvement of a frog into a prince. Why not try it yourself? However, a 'pantomime' transformation such as this is usually over in a flash. Much more delightfully gruesome would be to show it happening slowly ...

Whichever character you start with, think about how one particular feature can be stretched to lead into the next form you have in mind. If you start with a two-legged character, it may be that the body will tilt forward, and the arms become forelimbs as it changes into a four-legged animal. If that four-legged animal becomes a bird, the hind legs might fold up to become wings. There are no rules for morphing, but there is a crazy kind of logic that demands a smooth transition from one state to the next, and you have to ensure that you provide just that.

Here is an example of a simply doodled morphing sequence. It continues across the opposite page, and then from left to right along the bottom line. We start with a basic small humanoid figure, who drops forwards onto his fore-limbs and becomes a quadruped ...

... The penguin doesn't remain a penguin for long. It elongates its neck and goes through a vaguely dinosaurish phase before becoming a kangaroo. How will it end? ...

A nodding acquaintance with anatomy is invaluable for the animator who likes morphing. If you begin to think of the muscles which control form and movement as a system of ropes and pulleys operating the frame of the skeleton, it will give you ideas about how to proceed

when changing the shape of your 'morphee'. Morphing is also an amusing way to practise the art of in-betweening, and you can surprise yourself if you start this particular form of animated doodling, as you never know where it might lead in terms of creating ideas.

... The newly transformed 'horse' now grows a hump and becomes a camel. The camel's hind legs fold neatly

up to become a pair of wings, and the fore-legs move further back along the body as a flamingo

evolves. This in turn shrinks its legs and lowers its undercarriage to become a penguin, which continues

the morphing process in the sequence at the base of the opposite page ...

... The kangaroo's tail thickens as it becomes a rabbit, which stretches to become a stoat. This loses its ears and limbs as it turns into a snake, which dives into a hole!

Special Effects

The undulating wave-like movement of a snake is mirrored in the movement of water. When we animate wave effects using either regular or irregular wave patterns, we create a repeating cycle of peaks and troughs which can move to left or right. As before when we created the walk cycle (see pages 165–8) the order in which the drawings are made is not consecutive. This method of working using one basic key drawing is known as a 'one back to one' cycle and is very common when drawing other special effects such as those shown here.

1–4 Drawing 1 is a line of waves each of an even size and shape. We want to make them move sideways across the screen from left to right so that peak (a) moves along to take the place of peak (b) and so on.

Put a fresh piece of paper on top of drawing 1, and make a drawing which shows the peaks moved to a halfway point, between (a) and (b). This will be your next key drawing; call it 3.

Then place 1 on top of 3, and in-between it to create drawing 2.

Place 3 on top of 1, and in-between it to create 4.

You now have a repeating cycle of waves. If they are filmed in forward sequence (1, 2, 3, 4 repeatedly) they will move from left to right, and if shot in reverse (4, 3, 2, 1 repeatedly) from right to left.

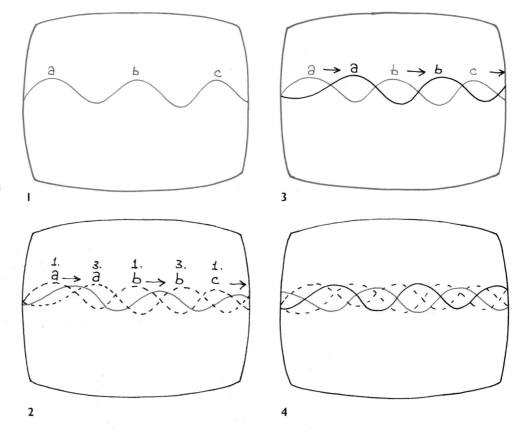

A–B For choppier seas you need a sequence in which the waves not only move from left to right, but also increase and decrease in size as they do so. In these two illustrations (*right*) A corresponds to drawing 1 above, and B to drawing 2.

Use the same principle if you want to produce animated drawings of a flag fluttering in the breeze (*far right*).

180

If you want a ripple effect (*right*), begin by making a drawing of the complete ripple area then place a fresh piece of paper on top of this. Starting with the centre circle and moving each circle halfway out towards the next one, draw the next key drawing. The outer ripples can break up into dotted lines and vanish

A

B

as they reach the outer edge of the area (A). The innermost circle can form again to fill the space left at the centre as the ripples

move out (B). Call this drawing number 3, then in-between 1 and 3 to get 2 and in-between 3 and 1 to get 4. For a more realistic

effect do extra in-betweens to slow the action. The impression should be of a constant movement outwards from the centre.

1

2

3

4

There are two distinct causes of a splash. The first (*shown above*) is a drop of water falling into a pool. This is an easy animation effect to achieve.

As the drop hits the water (1) a 'splash back' is formed (2) which dissipates in a few smaller splashes and bubbles as the drop is absorbed into the pond or puddle (3 and 4).

Bubbles (*left*) can give life to a glassy pond. They rise lightly on an undulating trajectory, reducing in size, and either divide into little clumps, or pop very satisfyingly.

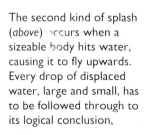

The second kind of splash (*above*) occurs when a sizeable body hits water, causing it to fly upwards. Every drop of displaced water, large and small, has to be followed through to its logical conclusion,

whether it flies up out of sight, or splashes back into the main body of the puddle. Drawing a splash sequence of this type can be labour intensive, so they are usually planned to be of very short duration.

The waterfall effect (*right*) combines elements of both wave and ripple animation. This time the water animates vertically downwards and 'disappears' into a rippling pool, which throws up bubbles. The cycle illustrated looks quite lively and impressive, but was achieved in only four drawings, after a bit of crafty planning.

Rain

When animating rain and snow we have to think about weight again. Rain is heavier than snow, and falls faster. The trajectories of rain and snow are also different. For the purposes of animation we usually portray rain falling as shown below. Snow follows a more eccentric pattern.

Rain rarely falls straight down from above, and usually follows a slanting course. If you are drawing a screenful of the stuff, you need to plot that course with some care. A convincing rainstorm can usually be produced in a cycle of three drawings, so it is well worth the effort of additional preparation.

A

B

A Using a light blue pencil, begin by ruling a screenful of guidelines for your rain.

B Now take a black pencil and draw lines representing the rain, each of a similar length and evenly spaced. You can simply rule a sequence of straight lines, but you will make the effect more realistic if you emphasize the weight of water at the base of each droplet by thickening each line at its lower end.

This diagram (right) shows the movement of raindrop (a) down its guideline to raindrop (b). Your second drawing should be positioned about a third of the way between the two extremes, and the third drawing is halfway between 2 and the last drawing. The dotted line on the far right shows the position of the raindrop above.

If you are drawing a whole screenful of rain, prepare your guidelines as shown in A above, then draw the lines representing the rain

(B). Place a fresh piece of paper on top of this, and make your second key drawing, moving each shaft of rain down the line, about a third of the way towards the one below it. Now place drawing 2 on top of drawing 1, and complete the cycle by making drawing 3, which is an in-between of them. Start at the top of the paper and work downwards, along each line of raindrops, otherwise you might find your shower of rain making a fateful directional change! (See Artist's Tip opposite.)

Snow

The animation of snow needs careful plotting. Snowflakes drift down through the sky on an undulating path, rather like the feather we considered on page 155. We need many more drawings to achieve a realistic effect of each flake floating languidly down to earth. Try to allow for six in a cycle. For a good screenful,

draw two different snow cycles, and shoot them together. Make one cycle of small flakes, well spaced out, and another of larger ones, set closer together. In order not to swamp the action or the background with the prevailing weather conditions, rain and snow effects are usually double-exposed; that is to say, they are shot twice, in order to give a transparent appearance.

A

B

A Begin by plotting the trajectory of each flake; this time the screen will be filled with wavy lines.

B Draw the snowflakes meandering along each line, allowing enough room between each flake for five more flakes, all fairly closely spaced.

When drawing snowflakes, follow each flake consecutively through

its fall (see circled area, *above*). Start by placing a piece of paper on top of drawing 1, and, working down the line, produce drawing 4. Put drawing 1 on top of drawing 4, and, placing a fresh piece of paper on top of that, make drawing 2, one third of the way between 1 and 4. Then put drawing 2 on top of drawing 4 and produce 3, halfway between them. Now put drawing 4 on top of drawing 1, make drawing 5 two-thirds of the way between them, then put 5 on top of 1 and in-between them to make drawing 6. You have now joined up the chain of snowflakes and arrived back at 1. Repeat the process for every snowflake in your blizzard and you should end up with a snow scene like this (*left*).

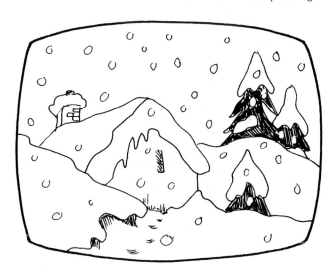

Artist's Tip

When drawing rain or snow, it is important to in-between all your drawings in the same direction. There is nothing more aggravating than watching an impressive-looking downpour of animated rain, only to notice that one of the drops is working its way merrily UP the screen.

A puff of smoke

There is no smoke without fire. Let's now consider puffs and plumes!

Here is a familiar scenario: out in the desert we hear the muffled beating of war drums; the Apaches are 'phoning home' – see below.

That distant column of puffs could be used equally well for smoke from a chimney stack or a steam engine. In the case of the latter, the smoke should stream out horizontally behind the engine, unless it is just an old 'puffer' chugging along. The method of producing it remains the same.

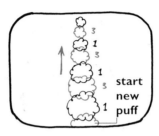

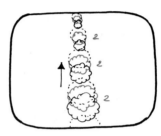

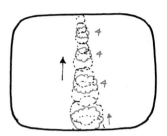

Drawing a cycle of smoke puffs has much in common with drawing rising bubbles. As they rise the puffs reduce in size and vanish (see Artist's Tip opposite). This is another 'one back to one' operation. Notice the order of drawing.

First of all, draw your rising column of smoke-puffs, then put a clean piece of paper on top of that drawing, and make the second drawing, moving each puff upwards to a position halfway between the puffs marked 1. Call this drawing 3.

Now place drawing 1 on top of drawing 3, and on a new sheet of paper in-between each puff on drawing 1 to the one above it on drawing 3. Call this drawing 2.

Then place drawing 3 on top of drawing 1, and on a new sheet of paper in-between each puff on drawing 3 to the one above it on drawing 1. Call this drawing 4.

A plume of smoke

You might see the type of plume of smoke shown below rising from the chimney of a quaint 'Hansel and Gretel-type' cottage, nestling in the middle of an enchanted forest. It could

equally well be seen coming out of a kettle-spout, or drifting lazily up from the crater of a dormant volcano (see opposite). The kind of smoke cycle used in these scenarios works on the 'wave' principle (see page 180).

Here is a nice rural retreat, with a wisp of smoke curling lazily from its chimney. If you replaced the cottage with Aladdin's wonderful lamp, the smoke cycle would still look appropriate.

Make drawing 1, then place a sheet of paper on top of it and make the second drawing, moving curve 1 halfway up towards the next curve 1, and call it drawing 3.

To complete the cycle, place drawing 1 on top of drawing 3, and on a new sheet of paper in-between each curve on drawing 1 to the one on drawing 3. Call this drawing 2.

Then place drawing 3 on top of drawing 1, and on a new sheet of paper in-between each curve on drawing 3 to the one above it on drawing 1. Call this drawing 4. Remember that the direction is upwards.

Fire

If your sleepy old volcano should decide to erupt, you are faced with the problem of drawing fire. Like rain and snow, fire requires a distinct track to follow, and then it will behave beautifully. Vary the organic, tongue-like shapes of the flames as they leap upwards, and follow the same procedure as you did when drawing the plume of smoke. As in the case of rain and snow, drawing fire requires some concentration, as the sequence needs to be followed through carefully in order to look effective. Flames are also double-exposed when shot, to give a realistic transparent effect.

Here is our erupting volcano, complete with billowing clouds of ash, flowing lava, and leaping flames. To see a stunning animated volcanic sequence, look at the 'Rite of Spring' section of Disney Studios' *Fantasia*.

These organic shapes are used to represent flames. Their colours vary; usually a combination of red, orange and yellow. Also in imitation of the changing nature of fire, the larger flames can split and separate as they pursue one another upwards.

If you are trying to follow a set of flames as it curves upwards through the screen, it is often helpful to shade in one line of the shapes in order to avoid confusion and having flames jumping across from one column to another.

Unlike rain or snow, which are 'all over' effects, fire tends to be confined to one area. Before you start, think about the shape of that whole area, and plan your fire-cycle so that you can make the flames dance up convincingly.

Combining puffs and plumes

The plume of smoke issuing from the spout of the kettle shown below, and puffs escaping as the lid bangs up and down, tells us that the kettle is boiling.

Clouds, and clouds of smoke, or dust, which hover in the same area for a time, behave in the same way and may billow on the spot. To achieve this effect draw your cloud, nicely curvaceous in outline, and, as with the wave cycle (see page 180), move each curve on towards the next one, clockwise around the body of the cloud. Make this into a cycle of four drawings, or in-between each of these drawings in turn to make a cycle of eight or sixteen, thus slowing the movement to a slow 'boiling' motion.

Artist's Tip

You may be concerned about what happens at the 'top end' of a smoke sequence, and wonder how to finish off the effect. In a column of smoke puffs, each one diminishes in size as it rises higher, and at its highest point it bursts rather like a bubble, into a cloud of tiny puffs which spread out and 'evaporate'. This can be done in the space of about three drawings.

Props

In this great big technological world of ours, we are very proud of our 'props' – the flashy car, the washing-machine, the power-shower, the big lawn-mower; the list is endless. Of course, things can – and do – go wrong with domestic machinery, but not half as wrong as they can go in 'Toon' world!

It is not impossible, and far from unusual, for a 'prop' to evolve into a character all by itself. You find yourself drawing some eyes on a watering-can, for example, and before you realize what is happening, a new and rare species of elephant is born! Even a gentle pastime like gardening becomes perilous when we meet the carnivorous lawn-mower, the garden hose that turns into a giant anaconda, rockery stones that rise up on little legs and walk away, and a host of other things too horrible to mention.

Necessity is the mother of invention. As man developed bigger and better weapons, he had to work out some way of getting them to the field of conflict easily and without using up too much energy.

From the primitive technology of the caveman, and the invention of the wheel, to the sophisticated laboratory equipment of the mad scientist, cartoon man has always required his props – and not just cartoon man, either. Where would Wile E. Coyote be without the ingenious contraptions of the Acme Company?

You will see from the few examples shown here that a nodding acquaintance with special effects can come in very useful when dealing with animating props!

This may look like a complicated way to make a cup of tea, but the gentle bubbling is better than a screeching kettle when you've got a sore head.

It is a short step from giving a mouse human attributes, to doing the same for a lawn-mower. When one of these machines gets bored with its vegetarian diet, and starts baying for human blood, the only thing to do is to cut and run!

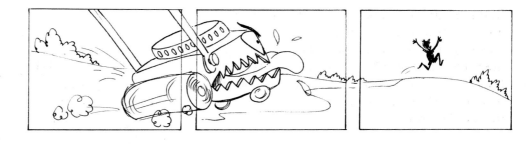

Here we see an old 'bone-shaker' throwing itself into lively locomotion. Notice that the body of the car stretches and squashes as it bounces along. This is quite a restrained vehicle – if there were any deeper ruts in the road it would be flying.

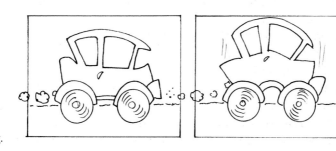

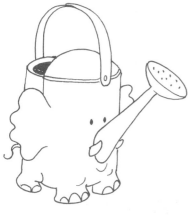

A simple wheelspin, as shown in the lower sequence above, consists of three drawings. Divide the wheel into six segments, and draw 'speed' lines in two opposite segments (1). Then work your way around the wheel, moving on to the next two opposite segments (2). When you have completed the third pair of segments (3) you will be back at 1.

Here is another example of how a prop can take on a life of its own (*above*). When the spout became an elephant's trunk, this watering-can also sprouted a set of stumpy legs, and is now contemplating a safari down the garden path.

Some 'props' even make it big and aspire to have their own starring roles in books and TV series, like Dennis the Digger here (*right*) – something a humble egg-cup may only dream about!

A Cunning Plot

What are you trying to say?

Now that you have assimilated some of the basic techniques of animation, you will want to have fun with them and put them to good use. It is quite possible for you to use the techniques outlined here to produce a two- or three-minute film, without recourse to complicated procedures. So consider what you want to do. Whatever you decide to tackle, careful planning of your work is essential.

If you're going for entertainment, do you have a plot? If so, can it be told simply and effectively? How many characters do you want to use? And most importantly, how long have you got? But cartoons have other uses besides entertainment. They can also be used to educate, to sell, and to promote propaganda. So consider your message, jot it down and start plotting the next move.

A question of timing

A cartoon film runs at a speed of twenty-five frames per second. This means that a minute of film contains fifteen hundred frames. It does not mean that you have to make fifteen hundred drawings, however, because each drawing is usually shot for two frames. Nor do you even have to make seven hundred and fifty, because the timing of the action often requires drawings to be 'held' for much longer, and even repetitive movements can be effective at a slower rate.

Staggered movements

One of the most complex aspects of the animator's art is timing. It is important to be aware of the fact that in normal movement not all parts of the body are in operation or move at the same time. You have to ensure that your drawings reflect this reality.

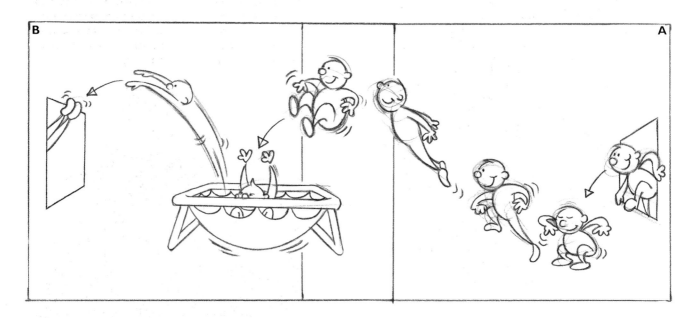

A layout for a complicated piece of animation is a kind of plot. If an acrobat were to attempt this move (*above*), he would need some rehearsal. Similarly a layout artist 'rehearses' the move for the animator, and assesses how much space will be needed.

This is a long running shot, in which the character moves swiftly through screen A on the right, and then the camera pans across with him in order to see him jump onto the trampoline and then bounce out of the window in screen B on the left.

Plotting the action is a way of planning the background. Now that we know where the windows should be in relation to the trampoline, it is easier to fit the rest of the background around them. The artist can fill the details appropriate for the style of the film.

The animator then thinks about the pace of the action. He may decide to hold the character after it jumps into the room, to give it time to look around before it spots the trampoline, or make the dive into the trampoline more acrobatic.

Splitting the levels. . .

The drawings of animated characters are split into different sections, known as 'levels', and layered in order on top of the background. By dividing a figure so that the head, arms and legs, eyes and mouth can move at varying times while the body remains in a held position, the drawing workload can be much reduced, but for this intricate system to work efficiently, careful note has to be made of every tiny move, on charts known as 'dope-sheets' (see Jargon Buster, page 150), which give the camera/computer operator clear instructions on how the film should be shot.

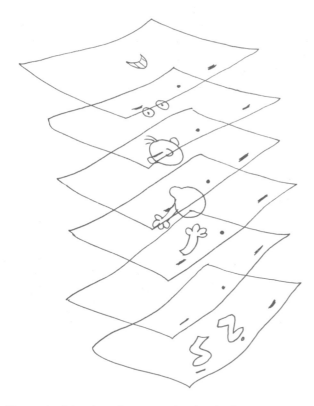

The stack of drawings above shows how an animator might divide a character into several different body parts, each of which can move and be re-used independently. Although this scheme saves a lot of extra work, it demands careful organization. Each drawing has to be numbered and noted so that it can take its place in the correct order when being shot. If a character is split in this way, while the body and one arm remain static (third sheet from bottom of the pile), the mouth can chat, the eyes can blink, the head turn from side to side, one arm can wave and the legs can dance a jig!

Here is a timely reminder that not every scheme works out according to plan, however well laid ... The tension builds as that tiny flame inches closer to the barrel of gunpowder, and tension should always be part of the animator's armoury.

As clients do not like to be kept waiting for their TV commercials, it is often necessary for the professional animator to burn the midnight oil. At such times it is important to evict the cat, remember where you put your coffee cup, and stay calm.

Creating a Storyboard

The storyboard is the plot of a film shown in comic-strip form. Each frame represents a piece of action, and no production begins before the storyboard has been thoroughly worked out.

The master plan
The storyboard is the film's master plan. It is used by the layout artist as a guide for his drawings, which set each scene, giving a plan of action to the animator, as well as a set design to the background artist. The storyboard is occasionally filmed itself, as a series of static shots, each of which corresponds in length to the scene it portrays. Whenever a piece of animation is completed, the moving scene is substituted for the still one, so that the director can monitor the progress of the whole film. In the hands of the storyboard artist the script first springs to visual life, setting the style and pace of the production.

Getting started
Storyboard pads are obtainable from good media and artists' suppliers. They come in a variety of designs, but all provide spaces below each frame, to enable you to give a description of the action and to write out the dialogue. You can also make up your own, simply by drawing a pageful of frames.

Making a scene
You will find that your plot divides naturally into scenes. Some scenes will be more complex than others, and will need several frames of board to describe them, but one frame will be sufficient for most. Sometimes the action may be repeated, and a scene can be re-used. Remember, in animation a 'scene' might last just a few seconds, and be only a few feet long. As to the plot, keep it simple, but try to give it a twist.

A Simple Storyboard

Frame 1 A country scene: the sun is shining, a pond ripples in the foreground, birds fly across from west to east ...

Frame 2 Repeat of frame 1, but up from behind the distant horizon whizzes an alien spacecraft.

Frame 3 The UFO comes right up to the front of the screen ...

Frame 4 ... which goes dark as the alien ship fills it. End of Scene 1.

Frame 5 Cut to a similar landscape as before. The spaceship has landed.

Frame 6 The same landscape ... the top of the ship opens like a lid, and a space creature climbs out.

Frame 7 The creature walks up to the front of the screen and stops. As it does so the lid of the spacecraft closes.

Frame 8 The creature looks to the left of the screen, then to the right ...

Frame 9 ... and walks out to the right. Cut. End of Scene 2.

Frame 10 On a background representing the sky, a looking-up shot, as the creature moves up and across the screen.

Frame 11 The creature's body fills and darkens the screen, causing a blackout (known as a 'wipe'). End of Scene 3.

Frame 12 Similar background to that of Scene 2. The creature enters and walks across screen from left to right. Cut. End of Scene 4.

Frame 13 This is a crafty bird's-eye view of the alien walking diagonally across the screen, over a hillocky background. Cut. End of Scene 5.

Frame 14 Much of the animation from Scene 3 is re-used here. Against a sky background, the alien creature comes into screen, and stops.

Frame 15 It raises its hand to its mouth, puzzled, and blinks. Cut. End of Scene 6.

Frame 16 A rear view of the creature; it has stopped in front of a cliff, at the entrance to a cave.

Frame 17 As it stands looking on, a huge eyelid slowly opens in the 'cave'. The creature reacts in horror. End of Scene 7.

Frame 18 Cut to a close-up shot of the creature's 'take' (see page 174.) End of Scene 8.

Frame 19 A long shot, looking up, which reveals that the creature is actually standing on the beak of a monstrous bird-like beast of prey ... End of Scene 9.

Frame 20 Whatever happens next? Over to you! There is scope for anything here: horror, comedy, a good old-fashioned chase sequence, a sneeze, a belch, a scratch ...

Index